Winslow Homer and the Pictorial Press

WINSLOW HOMER

and the

Pictorial Press

David Tatham

Syracuse University Press

Copyright © 2003 by Syracuse University Press
Syracuse, New York 13244–5160

First Edition 2003
03 04 05 06 07 08 6 5 4 3 2 1

Unless otherwise noted, all works are illustrations drawn by Winslow Homer
and published in pictorial weekly magazines.

The paper used in this publication meets the minimum requirements
of American National Standard for Information Sciences—Permanence
of Paper for Printed Library Materials, ANSI Z39.48–1984.∞™

Library of Congress Cataloging-in-Publication Data
Tatham, David.
Winslow Homer and the pictorial press / David Tatham.— 1st ed.
p. cm.
Includes bibliographical references and index.
ISBN 0-8156-2974-5 (alk. paper)
1. Homer, Winslow, 1836–1910—Criticism and interpretation.
2. 2. Magazine illustration—1836–1910—19th century.
3. I. Homer, Winslow, 1836–1910. II. Title.
4. NC975.5.H65 T383 2003
5. 741.6′4′092—dc21 2002153010

Manufactured in the United States of America

To Cleota
and to the memory of two friends,
Judy Whitaker of Harcombe Farm,
Syde, Gloucestershire,
and Stanton Loomis Catlin
of Syracuse and the Americas

David Tatham was born in Wellesley, Massachusetts, and educated at the University of Massachusetts, Amherst, and at Syracuse University. Since 1962 he has been a member of the faculty of Syracuse University's Department of Fine Arts. He is the author of books, exhibition catalogues, and articles on painting, sculpture, and the graphic arts in nineteenth- and twentieth-century America. Among his books are *Winslow Homer and the Illustrated Book* (1992) and *Winslow Homer in the Adirondacks* (1996), both published by Syracuse University Press.

Contents

Illustrations

Preface

THE DISTANT origins of this book run back to the late 1940s when I occasionally accompanied my grandparents on their Saturday drive to Boston from the North Shore. While they shopped for fruit and vegetables at stalls by Quincy Market, and for all manner of other things in department stores along Washington Street, I spent time in antiquarian bookshops not far away on Brattle Street and Cornhill. In Colesworthy's, while looking through a bin of prints, I found a portfolio labeled "Winslow Homer." I knew the name from visits to the painting galleries of the Museum of Fine Arts and even more distinctly from an art teacher who in a school close by the ocean talked much of New England's painter of the sea.

The portfolio I opened presented the artist to me in a new light—as an illustrator in black-and white-rather than as a painter in colors. It contained leafs detached from *Harper's Weekly, Ballou's Pictorial Drawing-Room Companion, Every Saturday, Appleton's,* and other magazines. Here were wood-engraved views that Homer had drawn in the 1850s of Quincy Market, of busy shoppers on Washington Street, and of other subjects that had little to do with the sea but a lot to do with the Boston I knew. My interest sharpened when I found an illustration by Homer from the 1860s depicting the summit of Mount Washington, a peak in the White Mountains with associations to my New Hampshire forebears. When on a subsequent visit I asked about Homer at the nearby Brattle Book Store, the proprietor brought out that shop's plump folder of pages removed from magazines.

On another Saturday I passed Goodspeed's antiquarian bookshop a few blocks away on Beacon Street. Its window displayed one of Homer's magazine illustrations handsomely framed. This was a portrait of the American painter Rembrandt Peale that Homer had adapted from a photograph—he was his subject's junior by nearly forty years. A display card made it clear that Goodspeed's had no doubt that the young Homer, even when copying from a photo for a magazine, was the more important of the two artists. This opinion confirmed what the portfolios at the other bookshops had suggested: that Homer's work as a magazine illustrator in

the middle of the nineteenth century was still of interest in mid-twentieth, at least among Boston's collectors and antiquarian book dealers. Goodspeed's was less dusty, better organized, and more professionally staffed than its nearby cousins, but it was also less tolerant of browsing adolescents and so I saw little more of Homer's work there at the time—but a good deal later on. The shops on Cornhill and Brattle Street passed into history in the 1960s and '70s as Scollay Square and its environs were transformed into the Government Center (though a twice-relocated Brattle Book Shop survives and flourishes elsewhere in the city). Goodspeed's closed in the 1990s. Many years after my first visits, I take pleasure in recalling the feeling that a new avenue of learning had opened when the proprietors and clerks of these shops gave me free rein to look at Homer's illustrations. I knew none of their names and none of them knew me other than as a kid engrossed in books and prints, but unknowingly they nurtured an interest that revived periodically over the course of half a century and, in time, led to this book.

Long before writing began I profited from discussions and correspondence about the magazine illustrations with many curators, collectors, dealers, librarians, and fellow scholars. For insights and helpful comments on particular points I owe special thanks to Linda Ames, Georgia Barnhill, Randall Bond, John Carbonell, Mavis P. Kelsey, Sally Kinsey, Samuel Morrill, Bettina Norton, James O'Gorman, Barbara Opar, Sally Pierce, Lyall Squair, and the late Emily Walton Taft. Well before their deaths in the 1980s, Lloyd and Edith Havens Goodrich encouraged me to move ahead with a study of Homer's illustrations; I remain grateful for their confidence. I am much obliged to Abigail Booth Gerdts, director of the Lloyd and Edith Havens Goodrich/Whitney Museum of American Art/City University of New York/Record of the Works of Winslow Homer, for providing me with access to the Goodrich notes on the illustrations. While those notes contained little that had not already appeared in the Goodrich publications, they reconfirmed the assiduousness of the original research.

A research leave provided by Syracuse University's College of Arts and Sciences freed me from teaching responsibilities for a semester and enabled me to all but finish the manuscript. The university's Office of Research funded much of the travel and most of the necessary photographic work. The Syracuse University–allied William C. Fleming Educational Unitrust provided a generous subvention toward publication costs. These three university sources have assisted other of my publications over several years, and I am again happy to acknowledge their support. I

am equally happy to thank The Gladys Krieble Delmas Foundation for its important contribution to the funding of this volume.

I remain grateful to the American Philosophical Society for a travel grant that made it possible for me to spend a month researching European pictorial magazines of the 1850s and 1860s as context for Homer's work. The same grant enabled me to examine drawings and illustrations in the collections of the Ashmolean Museum, the British Museum, and the Victoria and Albert Museum. In the United States much good work was accomplished in the rich holdings of the American Antiquarian Society.

Among Syracuse University students who assisted in details of research, I gladly record my thanks to Kate Lemay, Rahel Elmer Reger, and Ross Barrett III. For hospitality and encouragement during research and writing on both sides of the Atlantic, my best thanks (and those of my wife) go to Felicity Ashbee, Jim and Mary Cox, Cathy Huggins and Tony Herbert, Ann Hutchinson and Scott Lowe, Dean and Betsy Lahikainen, Ann Powell, and Malcolm and Diana Whitaker. I thank the Smithsonian Institution's Archives of American Art for permission to quote from James Kelly's unpublished memoirs and the Pierpont Morgan Library for permission to quote a letter written by Charles Parsons.

The Syracuse University Photo and Imaging Center has once again provided expert photographic work. I am grateful as well to David Prince, curator of the Syracuse University Art Collection, for help in securing photographs from that unit's extensive collection of Homer's illustrations. Through the good offices of Steven Smith, curator of Special Collections at the Cushing Memorial Library and Archives, Texas A&M University, I was able to obtain photographs of several of Homer's works from the Mary and Mavis P. Kelsey Collection.

At Syracuse University Press, it has been a pleasure to work with Mary Selden Evans. I thank Jill Root for her sensitive expertise in copyediting.

Cleota Reed has cast an expert eye on her husband's manuscript at various stages of its development, always with lucid observations. Two additional grandchildren entered our world during the book's progress, Jayde Lauren Martin and Florence Lucille Martin-Person. A great-grandchild arrived as well: Jerrall Quinton Corning. The buoyant spirit of all three eased the labors of finishing this book and may even have enlivened a few passages of text.

Abbreviations

Introduction

Winslow Homer's career as a magazine illustrator began in 1857, when he was twenty-one. It concluded in 1875, when he was thirty-nine and well-established as a leading American painter. For five years at the beginning of his career he had worked solely as a freelance graphic artist. He rapidly became a master in the new and burgeoning field of illustration for weekly pictorial magazines. After making his debut as a painter in 1863, he hoped to abandon popular illustration as soon as his canvases found a steady market. That point of self-sufficiency did not, however, arrive until 1875. The work of his last dozen years as an illustrator became a dialogue of never quite resolved tensions between the popular art of illustration and the fine art of painting, and is all the richer for it.

The present volume serves as a companion to my *Winslow Homer and the Illustrated Book* (1992). In that study I examined a relatively little known aspect of Homer's career as a graphic artist. Here I deal with a more widely appreciated body of his work: the illustrations he drew for publication in weekly pictorial magazines. Those magazines, sometimes called illustrated newspapers, were part of a class of publication known in Homer's time as the pictorial press.[1]

The two groups of illustrations differ in important respects. The book illustrations are small in size. Homer drew them with the understanding that they would be encountered in the course of the usually solitary act of reading a book. The magazine illustrations are much larger and, partly for this reason, more complex in design and content. In drawing them for popular journals of mass circulation that frequently passed from hand to hand in parlors, railway carriages, and countless other places, Homer gave these images a more public character. The two bodies of graphic art also differ in the quantities produced. The book illustrations came forth in printings that rarely amounted to more than a few thousand copies—in some cases, perhaps only a few hundred. The magazine illustrations flowed from presses in hugely greater quantities—many in well over a hundred thousand impressions.

An even more significant distinction between the two groups of illustrations rests in their subjects. The images Homer drew for books sprang

directly from the words of his authors. Those texts determined his subjects and, to some extent, confined the nature of his treatment of them. But when he drew for magazines he followed no written text. His subjects were most often of his own devising, and even when they came as suggestions from an editor he had great latitude in determining how the suggestion would be realized. His drawings needed always to be in harmony with his magazines' editorial policies, but the remarkable range of his subjects, and the provocative treatment he sometimes gave them, make it amply clear that his publishers encouraged his originality.

But if the drawings he made for the pictorial weeklies were not illustrations of texts, they were illustrations nonetheless. They communicated their meanings by reference to things beyond themselves. They depicted people, objects, places, manners, and customs of kinds that his viewers already knew and understood in various ways. His illustrations (more so than those of most of his colleagues) often enlarged upon, and sometimes altered, his audience's understandings of a subject, but what he drew remained dependent for coherence on that audience's comprehension of that subject. While he reported familiar things, he did so with a fresh, often playful, sometimes quietly subversive "take." The work of lesser illustrators in American magazines rarely rose above the level of self-effacing delineation, lacking in distinctive character. Homer by contrast consistently interposed himself between viewer and subject through the distinctiveness of his point of view and the individuality of his drawing style. As a result, his best work brought a vitalizing freshness of vision to images of familiar subjects.

We know little of what Homer or his contemporaries thought of his illustrations during his lifetime. Always a man of few words, Homer said nothing. The era's critics very largely ignored the graphic arts and the popular press. Then, in 1911, a year following Homer's death, William Howe Downes in the early chapters of his biography of the artist mentioned a number of the illustrations.[2] He invested them with a degree of historical importance when he observed that they "give us the clue as to what the artist was doing, what he was thinking about, what plans and purposes he was cherishing, and in what places he was working."[3] Downes's knowledge of the extent of Homer's contributions to magazines was far from complete, however, for he had no access to whatever records Homer or his publishers may have maintained concerning the illustrations, if indeed such records any longer existed.

Collectors and dealers soon embarked on searches of magazines for illustrations unmentioned by Downes. Checklists reached publication in

the 1930s, beginning with one complied by Edgar P. Richardson, who was then at the beginning of his distinguished career as a historian of American art.⁴ None of the lists was entirely complete or free of spurious works, but the one compiled by Allen Evarts Foster, published in the *Bulletin of the New York Public Library* in 1936, with a supplement in 1940, became the standard for a generation.⁵ It included well over two hundred items, including, as has since become clear, a few misattributions.

In 1944 Lloyd Goodrich, the preeminent Winslow Homer scholar of his day, offered in his monograph on the artist a fuller consideration of the magazine illustrations than had Downes. Though he touched on only a relatively few examples, he dealt with them more as art than as pictorial journalism or personal history.⁶ For the Smith College Museum of Art in 1951, Mary Bartlett Cowdrey organized a survey of Homer's illustrations and associated paintings and drawings. Her catalogue, *Winslow Homer, Illustrator,* remained an important reference tool for a decade and a half.⁷ In 1961, Albert Ten Eyck Gardner, in his notably original monograph *Winslow Homer, American Artist: His World and His Work,* devoted a chapter to Homer as an illustrator. He placed his graphic work within the context of English practice and Ruskinian aesthetic thought while also making an argument for the influence on Homer's style of his time in Paris in 1866–67.⁸

Between 1968 and 1970 Homer's work as a graphic artist gained the attention of a broader audience through an exhibition that traveled to sixteen museums throughout the United States. Formulated by Goodrich, the exhibition included nearly fifty illustrations from pictorial weekly magazines along with a selection of drawings, watercolors, and oil paintings related to them, and other graphic works as well—notably Homer's etchings. The catalogue of the exhibition, *Winslow Homer Graphics,* with an essay by Goodrich, sparked a fresh interest in the illustrations within a new generation of collectors, dealers, and curators.⁹ During the course of the exhibition's tour another book by Goodrich reached publication, *Winslow Homer's America.*¹⁰ This was a subject-oriented survey for general readers that reproduced selected examples of Homer's work for magazines and books. Also published at the time of the touring exhibition was Barbara Gelman's *The Wood Engravings of Winslow Homer.* This volume reproduced a greater number of the magazine illustrations than had any previous publication; its checklist duplicated Foster's.¹¹ In a doctoral dissertation (1970) concerning Homer in Boston in the late 1850s, I commented briefly on a few of Homer's early magazine illustrations.¹²

In 1977 the Museum of Fine Arts, Houston, mounted an exhibition of Homer illustrations from the Mary and Mavis P. Kelsey Collection. The exhibition's catalogue included Mavis Kelsey's revised and annotated checklist of Homer's printed graphic work. This list constituted the most important reconsideration of the corpus since Foster.[13] It added a few newly identified illustrations and questioned some on Foster's list. (The Kelsey collection is now part of the Cushing Memorial Library and Archives at Texas A&M University.) In 1979 Philip C. Beam's *Winslow Homer's Magazine Illustrations* followed the by-then outdated Foster checklist in reproducing most of the artist's original subjects, but it omitted the portraits.

Between the early 1970s and late 1990s came several exhibition and collection catalogues that discussed selected illustrations. Among a number of essays of interest in these publications were those by Raphael Fernandez in *Winslow Homer in the Clark Collection* (1986) and Lloyd Goodrich (more than half a century after his first publication on Homer) in *Winslow Homer in Monochrome* (1986).[14] In the year 2000, following the gift to the Brooklyn Museum of Art by Harvey Isbitts of his extensive collection of Homer's illustrations, another significant monograph reached publication: Marilyn S. Kushner, Barbara Dayer Gallati, and Linda S. Ferber's *Winslow Homer: Illustrating America*.[15]

Since the 1970s the scholarly literature in periodicals and exhibition catalogues on Homer's work for magazines has grown steadily. For the most part it has tended to approach the illustrations either as documents of social history or, in those instances when it has been possible to do so, as variants of painted subjects. In the first of these approaches writers have shown how attentive Homer was to the material culture of his times and, more broadly, how consciously and unconsciously he gave pictorial expression to a wide range of mid-nineteenth-century American middle-class ideologies. In the second approach, scholars comparing illustrations with paintings have often succeeded in illuminating Homer's creative process while bringing new light to bear on the distinctions he made in addressing audiences of different kinds. Both of these approaches to Homer's magazine illustrations have produced much of value, but neither has made a wholly satisfactory case for this large body of illustration primarily as graphic art.

Indeed, there has been a tendency in the Homer literature either to look past the illustrations as art in order to engage their historical context or to look around them in order to see their maker's paintings more clearly. Yet one of the things that distinguished Homer's illustrations

from those of his contemporaries was his wholly distinctive style. Few of his peers could match his skill in composing a drawing to lead and stop the eye. Few were able to energize images as Homer did through linear expression rather than only through depicted activity. A fully satisfactory account of precisely how Homer's style achieved its effects will need to be sought one day from a fuller comprehension of the biology of perception. But any works that reward repeated looking, as many of Homer's illustrations do, and that come from a visual intellect as original and fertile as his, need to be examined directly and intently on their own merits as graphic art as well as within their historical contexts.

An understanding of the context of Homer's magazine illustrations is, of course, essential to their explication. Oddly enough, little attention has been given over the decades to the most crucial part of that context, the world of magazine publishing within which Homer made his drawings. Before considering the connection of his illustrations to his paintings—always remembering that most of the illustrations have no such connection—his graphic works need to be placed, however briefly, in relation to those of other magazine artists and the publishing industry that supported them.

It would be a mistake, however, to think that Homer's magazine illustrations can be understood only in historical terms. The very best of them—a few dozen—offer rewards by vivaciously engaging the willing viewer's senses. In aesthetic terms these illustrations remain robustly alive. The others are lesser achievements, though often interesting for extra-aesthetic reasons. Despite figure drawing that was sometimes less than secure by academic standards, many of Homer's early illustrations have a freshness of vision that sweeps all before it. His better-drawn later work includes figures and passages of landscape of great charm. But there are also instances in which inconsistencies of scale and perspective seem to document haste or even indifference in composition. Homer's seriousness of intent faltered in some of his illustrations, as it never did in his paintings. It will be a matter of at least a little importance in the chapters that follow to consider why this wavering may have occurred.

The chapters of part 1 constitute a sketch of the world of the pictorial press that Homer knew, and of Homer himself as a graphic artist. Part 2 is a narrative account of the illustrations. In those pages I examine selected images in a little detail, considering them variously in terms of subject, style, and significance within Homer's career. Such a large body of work makes it impractical to discuss every illustration even briefly, but I have tried to treat equitably all stages of his years with the pictorial press.

Because his work of the late 1850s has received less attention in exhibitions and critical literature, I have considered it somewhat more fully than his later, better-known illustrations. I have not attempted to note comprehensively the sketches and studies in public and private collections that served Homer as sources for certain of the illustrations, though some of these preliminary works enter into the discussion. The forthcoming Goodrich/Whitney/City University of New York catalogue raisonné of Homer's work will include all such drawings. Nor have I thought it necessary in a study that is as much a work of criticism as scholarship to cite all the many, mostly brief, references to the illustrations in the Homer literature. A revised checklist follows part 2.

The pictorial press enabled Homer to launch and build a career. The drawings he made for the weeklies established him as an illustrator of national reputation when he was still in his early twenties. They later conveyed to a large public the essence of thought and style that brought him success as a painter. His illustrations provided him with an important source of income—at times his *only* income—for more than a third of his creative life. The world of weekly pictorial magazines shaped his thinking about the aims of art in an emerging culture of mass visual communication, and it also gave him opportunities year after year to try, test, and refine his growing powers as an artist. The influence of the pictorial press is not far beneath the surface of all that Homer did in his long career.

PART ONE: *The Background*

1

The Painter as an Illustrator

W HEN THE American sculptor James Edward Kelly put his memoirs to-
gether in the mid-1920s at the end of a long career, he described an event
that had remained vivid in his memory for half a century. This was a visit
by Winslow Homer to the art room of *Harper's Weekly* on Franklin
Square in New York in the spring of 1874.[1] Homer was then thirty-eight.
Though he was a well-regarded painter within the younger generation of
American artists, he was also a highly successful freelance illustrator.
Since 1857 he had contributed more than two hundred drawings to
Harper's Weekly and other pictorial magazines.[2]

At the time of Homer's visit, Kelly was eighteen and an apprentice
wood engraver at Harper & Brothers, the publisher of the *Weekly*. He
admired Homer enormously. He had first met him some months earlier
when he delivered a Harper's woodblock to the artist's 10th Street studio.
On one occasion Kelly had served as a model on short notice when
Homer needed to prepare an illustration of a decorously courting couple
for one of the *Weekly*'s sister journals, *Harper's Monthly*.[3] Homer later
gave Kelly a few pointers about the art of drawing and some elementary
instruction on how to set a palette.

Despite the passage of many years, Kelly's recollection of Homer's
appearance when he arrived at the *Weekly*'s art room remained crystal
clear. He described Homer as having been "slim, well-groomed, military
looking . . . [with] sparkling black eyes [and a] . . . dark moustache. His
black cutaway coat and steel gray trousers had the set and precision of a
uniform. . . . [He had] the movements and graceful bearing of a thor-
oughbred." Kelly also remembered that Homer's natural reserve made
him seem "coolly polite to all." Indeed, throughout his career Homer
would seem somewhat distant in his relations with others, men and
women alike. He was reserved but not retiring, confident but unassum-

ing, unfailingly courteous but nearly always businesslike, laconic in speech but amply clear in meaning. There was nothing of the Bohemian about him.

Kelly recalled that the *Weekly*'s art editor, Charles Parsons, greeted his visitor "with marked consideration." This consideration was hardly surprising, for even though Homer's illustrations appeared in the magazine only now and then, they had long been one of its distinctive features. After an exchange of pleasantries, Homer took from his portfolio a preliminary sketch for an illustration. When the wood-engraved version of this image appeared in print in June, it bore the title *Raid on a Sand-Swallow Colony—How Many Eggs?* (*HW*, June 13, 1874, fig. 1.1).[4]

Homer had adapted this sketch from a watercolor he had painted a year earlier: *How Many Eggs?* (fig. 1.2)[5] In the watercolor, two boys hunt for swallows' eggs in nest openings on the face of a sandbank. In revising this composition for publication, Homer increased the number of figures to four, added a glimpse of ocean at the margin, and brought the scene closer to the viewer. He translated the hues of his watercolor into black-and-white, for like all mass-circulation pictorial magazines of the era, *Harper's Weekly* could not print in colors. Even so, Homer preserved and even intensified the effect of brilliant sunshine reflecting off the expanse of bankside, and off the boys as well. When it reached publication, the printed image's orientation was the reverse of the watercolor's, for in drawing on the woodblock Homer had followed his watercolor's composition. After its engraving, the block printed a mirror image of its cut surface. At times Homer reversed an existing composition when he drew it on the block, as in the case of his wood-engraved reproduction in the *Weekly* (see fig. 12.6) of his oil painting "*Snap-the-Whip.*" This reversal preserved the orientation of a work already known to part of the public.

After examining the drawing, Parsons proposed one or two changes, presumably of a minor sort. Homer readily incorporated them into his study. He then moved to a vacant desk to execute the final drawing on the smooth surface of a woodblock. As he began to draw this new version of an old subject, Parsons, Kelly, and others of the art department's regular staff left their places and gathered around his desk to watch. Among them was Edwin Austin Abbey, then in his early twenties and already a rising figure in the field of American illustration. He would soon be a prominent painter and muralist. Charles Stanley Reinhart also looked on. At thirty he could count himself among the nation's best-known illustrators. Parsons was older than these two, well into his fifties. Like Homer, he had originally trained as a lithographic draftsman, made a

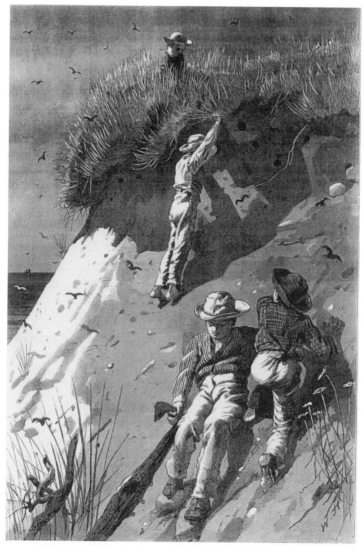

1.1. *Raid on a Sand-Swallow Colony—"How Many Eggs?"* 13³/₈ x
9¹/₈ in. *HW*, June 13, 1874. Syracuse University Art Collection.

specialty of ship portraits, and in the 1850s occasionally contributed
woodblock drawings to pictorial weeklies. He was also a painter, though
unlike Homer he had achieved nothing of distinction as an artist on can-
vas. Indeed, his major accomplishment in the world of American art was
in the performance of those functions that later in the nineteenth century
came to be subsumed under the title "art director." Soon after becoming

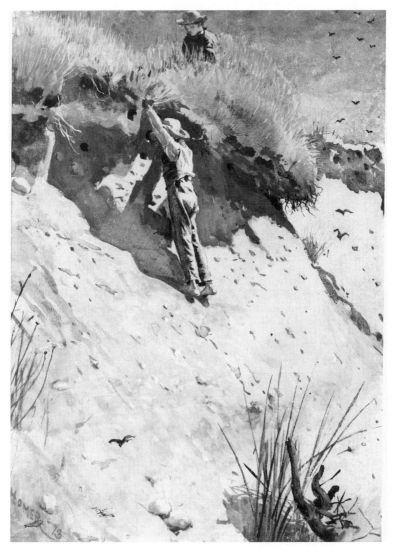

1.2. *How Many Eggs?* 1873. Watercolor, 12¹/₂ x 9¹/₂ in. Karen A.
and Kevin W. Kennedy Collection.

head of the Harper firm's art room in 1863, he had elevated its reputation
into the first rank among American publishing houses.[6]

Parsons and his staff watched as Homer drew rapidly, confidently, and
with a great economy of means. As fastidious in his work on the wood-
block as he was in his dress and demeanor, he drew lines whose clarity of
definition would leave no doubt in the minds of the *Weekly*'s engravers

about what he expected the finished wood engraving to look like in every detail. This precision in drawing was a matter of some importance not only for the engravers, who preferred not to guess about artists' intentions, but also for Homer. Determined that his distinctive graphic style survive its translation by these artisans as they cut away all of the block's surface except for his lines, he drew in a facsimile style. This style involved his putting on the block every significant line that was to appear in the printed version. With a brush he then added tonal washes to indicate a range of values that engravers would replicate as shade as best they could through hatching and crosshatching. Homer's close attention to such details accounts in part for the distinctiveness of his illustrations. The tendency of many woodblock artists of his era to draw loosely on the block and to leave the definition of the final image to engravers resulted in a largely uninteresting homogeneity of style within the pages of the pictorials.

Kelly's memoir leaves the impression that the group assembled around Homer's desk looked on with respect, and perhaps even awe. Homer, though he said little, probably found this attention satisfying, for by the mid-1870s he had become impatient with the equivocal responses of many critics to his paintings. They had tended to greet his new oils with praise qualified by reservations that often included complaints about what they perceived as a lack of "finish" in his painterly style.[7] (American critics in the mid-1870s would express similar reservations when they saw early examples of Impressionism in French painting.) But the men in the Harper firm's art room, illustrators and engravers alike, had no such reservations about Homer's graphic work. Their behavior made it clear enough that they viewed their visitor unequivocally as a master within their profession.

Years later, in 1922, the illustrator W. A. Rogers recalled that when he entered the Harper firm's art room in 1876, respect for Homer's work was still part of the atmosphere of the place. He wrote, "I believe that the first great impulse in the new American art of illustration came from Winslow Homer. When one considers how totally different was the style and mode of thought of Homer from Abbey or Rinehart it is hard to believe that they were greatly influenced by him. Nevertheless, he had one quality which he held up before them and which made a deep and lasting impression on the work of both of them. It was in fact the foundation on which their art was built. This was the quality of sincerity. . . . Homer had an artistic sight that was too honest to skirt difficulties."[8]

Of those artists who watched Homer draw, Parsons alone was old enough to appreciate the full extent of his visitor's achievement as a woodblock artist. None of the younger staff could have remembered how strikingly original many of Homer's early magazine illustrations had

been when they appeared in the late 1850s. Kelly would have been an infant then, Abbey a child, and Reinhart barely an adolescent. Those graphic works of the late 1850s differed in several ways from the ones Homer drew in the early 1860s and after. The early illustrations were products of a talent still immature, but they were highly effective on their own terms. As we will see, they seem to have exerted an influence for the good on the work of at least two other magazine illustrators. Parsons had followed the development of Homer's style year by year, seeing it change throughout the 1860s and '70s in response not only to new subjects but also to Homer's steadily evolving skills of expression. He recognized Homer's distinctive merits and gave them free rein.

Much later, in 1893, Parsons' perceptiveness regarding Homer received its own critical recognition. Writing in *Century* about Homer's oil painting *The Fox Hunt* (Pennsylvania Academy of Fine Art), W. Lewis Fraser observed in a note: "Some years ago—in the days of the conventional art of the wood engraver—Homer made his bow to the public in *Harper's Weekly*. His drawings were naïve and unconventional, and we owe a debt to Mr. Parsons, then art director of that paper, for his discernment in allowing them to appear." [9] Fraser's point is well taken, though he errs in claiming that Homer's work first appeared in the *Weekly*—his earliest drawings in fact came forth in *Ballou's Pictorial Drawing-Room Companion*. The naïve qualities that Fraser ascribes to Homer's early graphic work to some extent reflected the artist's lack of academic training but they seem also to have been conscious choices on his part, as we will see.

Homer constantly took chances in his mature illustrations, and this is why they continue to surprise their viewers. In this way he differed from the other graphic artists in Parsons' operation. Abbey, Rinehart, and Parsons himself rarely risked failure. Each had established himself with a distinctive style and a narrow range of subject specialties, and then resisted departing from the manner that had brought success. Parsons drew ship portraits—his specialty—in the 1860s essentially as he had in the 1840s. But Homer continually took risks. From the beginning of his career as an illustrator he seemed compelled to set himself new problems and to find new solutions to them. As a painter he sometimes treated subjects repeatedly in modulations of style, composition, and medium, and then, satisfied with what he had done, or bored, or even defeated (rarely), he sought new challenges in new directions. This same impulse to move on to new things also shows in his magazine work. It resulted in a body of illustrations remarkable in their variety, yet clearly the product of a single hand.

The continuous development of Homer's visual intellect is one of the key markers of his greatness as an artist.

When Homer visited Harper's art department with his sketch of boys on a sandbank, neither Kelly nor Parsons, and perhaps not even Homer himself, had any way of knowing that this call would be one of his last. His final two magazine illustrations would appear the next year, in 1875, one in *Harper's Weekly* and one in another of the Harper firm's magazines, *Harper's Bazar*. By then the watercolors that Homer had begun to paint in 1873 for exhibition and sale—he had previously exhibited only oils—were earning enough to allow him to forgo work for magazine publishers.

His work for the weeklies had amounted to more than 220 published images. This count has varied from checklist to checklist primarily because a few illustrations consist of parts countable either as single or multiple works. The tally has also differed depending on the willingness of compilers to include works conjecturally attributed to Homer. Of the illustrations unquestionably Homer's, about 190 are original subjects. Most of the others are portraits that he adapted from photographs, at times adding original details.

Beyond their intrinsic value as graphic art and as documents of culture, his original subjects highlight the distinctions he made in addressing two rather different audiences, one for fine art (his paintings) and the other for popular art (his illustrations). The few instances in which he treated a single composition in oil, in watercolor, and in pencil-on-woodblock demonstrate his remarkable virtuosity—all three share a great unity and yet each is distinctly different. They show how sharply he understood not only the strengths and limitations of each medium, but also the need to address each of his audiences in a different voice. While he frequently included a greater quotient of narrative in his illustrations than in his paintings, and often a more specific sense of time, he rarely did so at the cost of pictorial integrity. Parsons and his staff must have admired Homer's command of these distinctions, not least because they themselves had not managed to master them quite so well.

His early original illustrations suggest what his earliest paintings might have been like if he had begun working on canvas in the late 1850s rather than waiting until 1862. In their subjects such paintings would have been very different indeed. The most interesting of his magazine images from those early years dealt with a wide range of elaborately active subjects, from teeming city streets to buoyant family festivities. Subjects of this sort had disappeared entirely from his magazine work by the time

he began to paint. But, content aside, when he became a painter the strong linear definition of his style on the woodblock provided an enduring foundation for his style on canvas.

In his ability to work successfully and simultaneously at a high level in two quite separate fields, painting and illustration, Homer had no peer in America. A few artists, Abbey among them, achieved some interesting things in both fields, but not at Homer's level. Most others failed in the attempt. Even Thomas Nast (1840–1902), an illustrator of unquestioned genius and a salaried employee of *Harper's Weekly,* aspired for recognition as a painter, but he proved to be as uninteresting on canvas as he was superbly engaging on the woodblock.[10] In almost every case, American artists of Homer's generation who sought to move from popular illustration to the more rarified world of the fine arts attempted to leave their distinctive strengths as illustrators behind them.

Homer never surrendered those strengths. Rather than abandoning his background in illustration, he carried it with him and integrated it into the largely naturalistic painting style of his day. In the work of no other major American artist of his time did the meshing of these two different realms of art bring forth such distinctive results in each realm. His thinking as an illustrator informed his work as a painter, and his sensibilities as a painter shine forth from many of his later illustrations. To understand how this meshing came about, we need to turn from New York in the 1870s to Boston in the 1850s and to locate Homer's origins as an original artist.

2

Homer and the Woodblock

*A*NYONE SEEKING to pinpoint the place where in 1857 Homer began his career as an illustrator needs to look to Winter Street in Boston. Winter Street leaves Tremont Street at the edge of the Boston Common and runs a single block. It ends at Washington Street, the nineteenth-century city's ever-busy main artery of business and commerce. Winter loses its name at this point, but its axis crosses the intersection to continue on as Summer Street. In one of his earliest published works (see fig. 6.1), Homer depicted a lively moment at this meeting of Winter, Summer, and Washington, a crossing that Bostonians of the era sometimes called "the four corners." [1] Homer knew the locale well, and not only because he was a native of the city. These streets crossed less than a hundred yards from his Winter Street studio.

That studio was in number 22, the most imposing structure on the street (fig. 2.1). Only a year old, and taller than its immediate neighbors, the building housed on its first two main floors the editorial and business offices of the publisher Maturin Murray Ballou. The basement held the twelve steam-powered presses that each week brought forth, among other publications, more than a hundred thousand copies of a sixteen-page, profusely illustrated journal, *Ballou's Pictorial Drawing-Room Companion*.[2] Engravers occupied the third floor, working at desks by the windows. Atop the building's four storeys rose an attic crowned with a large light-admitting lantern. This lantern illuminated the room that Ballou had provided for the graphic artists who contributed to his *Companion*.

Most of these artists—perhaps all—worked on a freelance basis, as did Homer. The building provided him with his first studio as a professional artist. When he began to use it, sharing it with the others who drew for the magazine, he was twenty-one. Because he was not a regular employee of Ballou's firm, by the spring of 1858 he had established his pro-

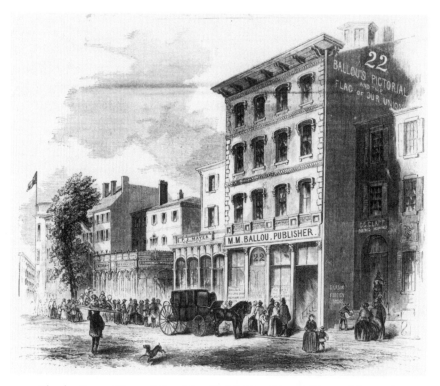

2.1. Charles Barry, *View of Our New Publishing House, No. 22 Winter Street, Boston*, 8 x 9¼ in. *BP*, December 6, 1856. Private collection.

fessional mailing address next door at no. 24½ Winter Street, at a shop—C. Clapp's—that sold paintings, engravings, and other works of art.[3] The Ballou studio remained the center of Homer's activity as an artist for more than two years, that is, until the autumn of 1859 when he left Boston to continue his career as a magazine illustrator in New York.

He had begun his association with the *Companion* in June 1857, little more than three months after reaching his twenty-first birthday. On that date, February 24, he had ended his term as an apprentice to the Boston job lithographer John Henry Bufford.[4] In his time with Bufford, which probably amounted to two and one-half years, Homer had become a highly skilled lithographic draftsman. Nevertheless, by the end of his apprenticeship he was determined to leave that field. Most of his work at Bufford's Washington Street shop had obliged him to copy or improve on routine and often banal source images without allowing oppor-

tunities to respond to the larger world of his experience. As soon as he was free from Bufford's, he became a freelance woodblock artist.[5]

In becoming a freelancer he left a profession in which journeymen draftsmen on stone were not especially well paid for their essentially reproductive work. He joined a field that, with the arrival of the *Companion* in Boston six years earlier, promised greater income to freelance artists who could with some regularity sell the magazine original drawings of general interest. Time was a factor as well. Drawing on lithographic stone was a slower process than making an equivalent drawing on a woodblock. Late in his life Homer claimed that while at Bufford's it had taken him a full day to draw a small-scale face in tone for the large print *Massachusetts Senate*.[6] Drawing a portrait of the same size in line on a woodblock for the *Companion* would have occupied an hour or so. Beyond that, an artist in a lithographic job shop became a relatively anonymous operative in a long-established service profession. Drawing for the pictorial press was quite another matter, for here an artist was able to develop a distinctive identity within a relatively new, high-profile publishing industry.

Homer's first drawing for the magazine was a small portrait in the issue for June 6, 1857, of J. W. Watkins, a sea captain resident of California who had many Boston connections. Homer copied the likeness from a photograph. The assignment probably came from the head of the magazine's art room to test Homer's skills. His second illustration, the larger, highly original *Corner of Winter, Washington, and Summer Streets, Boston* (see fig. 6.1), reached print a week later. Homer himself may have proposed the subject, though it might have been a suggestion from the magazine's art editor. That editor, or someone of editorial authority at the *Companion*, undoubtedly specified the subjects of all the portraits Homer drew for the *Companion* and probably also proposed at least some topics of general interest. But there can be little doubt that Homer followed his own instincts in treating whatever original subjects he drew. The consistency of style, mood, and attitude in his early depictions of life in Boston and its environs shows how effectively he made the subjects his own in every important respect.

Once the *Companion*'s art editor had accepted a drawing, Homer's sole task was to draw the final version of the image on the prepared surface of a block of boxwood.[7] Line by line, he drew precisely what he wanted the printed image to show. Since wood engravings are strictly linear, every bit of the block's surface that the engraver left standing printed the same intensity of black ink on white paper. Though the medium was

incapable of true tonal reproduction, hatching and cross-hatching were often an effective substitute.

Because the image he drew would be printed in reverse, Homer drew backwards such things as the lettering on shop windows, views of sites familiar to his audience, and, of course, his signature. He drew on a block that was in fact not a single piece of boxwood but consisted of several smaller blocks tightly bolted together. They created a smooth, composite surface much larger than any single piece of end-grain boxwood could possibly be. The trunk of this small, slow-growing tree was never large enough to produce blocks of the size needed for full-page illustrations in small-folio magazines. Some composite woodblocks needed to be large enough to contain a double-spread illustration, about fourteen by twenty-two inches. This size required the bolting together of forty or more small blocks, each about 2¹/₄ inches square.[8]

After Homer completed his drawing, the head engraver cut the margins of the block's many joins and then disassembled it to parcel out the component pieces to his team of assistants. Working on different parts of the drawing at the same time, they sped the project to completion. Speed in this case was a relative matter. What a team accomplished in a few days might take a single engraver a few weeks.

Reassembling the block was a difficult task. A telltale grid of white lines remains on some of Homer's wood-engraved illustrations as evidence of less than complete success in fitting the parts back together with perfect tightness. His *"Winter"—A Skating Scene* (see fig. 10.5) of 1868 shows this grid, as do several other illustrations that he drew for the Harper firm's publications. Some weeklies, including the *Companion*, managed to avoid the problem, but the imperfection was common enough to be taken as a normal state of affairs within the pictorial press, a price to be paid for timeliness in making illustrations available to a mass audience at a cheap price. That price in the 1850s and early 1860s in America was ten or fifteen cents a copy for most pictorial weeklies, with subscription rates of two to three dollars a year.

When he had made his drawing on the block, Homer's part in the production of the illustration was finished. He had no need to be in contact with the engravers who cut the block's surface, though he knew some of them. He probably had no association with the electrotypists who made metal replicas of the reassembled block's engraved surface, or the pressmen who oversaw the multiple power presses that printed the electrotypes. Homer's printed images have always been called wood engravings, and they did indeed begin as such, but in every case they were printed from steel-faced electrotypes. Made of metal, and incorporating

a page's letterpress as well as its pictorial matter, electrotypes were stronger and more durable than any woodblock could ever be. The electrotype (of which more in chapter 3) had made the age of the great pictorial weeklies possible.

Little material evidence remains from the process of production in the case of Homer's images. Only a few of his preliminary sketches—his "roughs"—have survived. He presumably discarded the others once they had served their purpose. Meanwhile, the engravers destroyed each drawing that he made on a block as they cut through it. After the block had been electrotyped, its engraved surface was planed down to prepare it for another drawing. Accordingly, no block bearing an engraving made from an original drawing by Homer is known to exist. Those electrotypes that were not kept for possible reuse in another publication were sooner or later melted down or dumped as refuse. The normal state of affairs in industrial-based printmaking throughout Homer's career as an illustrator paid little heed to history.

Removed from the magazines in which they were published, Homer's illustrations have often been called prints. Matted, framed, and exhibited, they have assumed an important place in private and public collections of American graphic art. They are not "fine" or "original" prints, for Homer neither prepared their printing matrixes nor oversaw their printing. He drew them for a general audience rather than a discriminatingly specialized one. The impressions came from an industrial power press, not from a printmaker's hand press.

Nonetheless, the illustrations reproduce drawings that Homer made specifically for reproduction by this process. It is inaccurate to describe them, as some museums and publications have done, as works "after" Homer, for this description implies that an engraver adapted an image by Homer and in the process contributed something original to it. The role of the engraver in the case of Homer's magazine illustrations was of much narrower scope. Far from having the freedom to adapt his images, Homer's engravers were required to cut blocks strictly in accordance with his drawn lines. There is no reason to suppose that any of his engravers contributed anything of positive substance to any image he drew on the block. The same is true in the cases of such other artists of distinctive style as Augustus Hoppin and Thomas Nast. This is not to say that all engravers produced the same results. Approaches varied, especially in the hatching and crosshatching of shadows. But these were minor variations in the execution of a drawing, and not interpretive or collaborative efforts.

There were, however, a few occasions when someone other than

Homer drew his illustration on the block. These instances occurred in 1862 when he sent drawings from the Civil War battlefront in Virginia to his publisher in New York. The variable qualities of these illustrations suggest that more than one draftsman copied the drawings. The results in these cases were very much "after" Homer and, as we shall see in chapter 9, he did not much care for them.

Once he had established himself as a painter, magazines from time to time reproduced one or another of his paintings as electrotyped wood engravings. *Harper's Weekly* did this in 1880 with his 1876 oil *Sunday Morning in Virginia*.[9] There is no reason to think that Homer, who had ended his association with magazine illustration five years earlier, drew the image on the block. Whoever did so performed the task as faithfully as the medium allowed and contributed nothing to alter the image. Homer might well have avoided this care in replication, for he often altered an image when adapting a painting for use as an illustration. The wood-engraved *Sunday Morning* in *Harper's Weekly* is a reproduction of Homer's work rather than an original work "after" Homer.

In the 1880s, several years after he had stopped drawing for weeklies, Homer made eight prints of a different kind. These were studio-based copper plate etchings in which he produced the printing matrix and then arranged for its hand-printing in a small edition on a fine-art etching press. His audience here was a small one of collectors of etchings. Earlier, during his years as an illustrator when he addressed his work to a hugely larger audience of magazine readers, interest in printmaking as a fine art had barely stirred in America. It came vigorously to life only in the 1870s, inspired by the taste for etchings that had arisen in no small part from excited responses to fine prints made by the American expatriate James Abbott McNeill Whistler.

The etching craze that swept the United States in the late 1870s and 1880s was a reaction within the cultivated class against industrial printmaking as a popular art. Popular prints had flourished in America since the 1830s, but they were products of a system whose graphic artists had become little more than operatives in factory mass production. A few lithographers, such as Homer's friend Louis Prang in Boston, gave some latitude in subject and style to freelance artists and took pride in the relatively high quality of his products. Some magazine art editors encouraged original work from able artists, as Parsons did for many years at Harper & Brothers. A few artists, such as Abbey, managed to use this kind of start as a stepping-stone to a career in painting. But compared to the best of what came from England and France, the general run of American popular illustration and industrial printmaking during Homer's years

with the weeklies was undistinguished at best. Standards in the field of American painting were higher. In Homer's generation anyone who aspired to be a "true" artist hoped to be a painter, even if it meant abandoning a successful career as a printmaker or illustrator.

Major differences separated woodblock artists from painters. Their audiences differed (much greater in numbers for the illustrator) as did their levels of professional prestige (more for the painter). There were also disparities in income. Rinehart, who was a regularly employed woodblock artist, had a modestly substantial annual salary that probably exceeded that of a good many painters. Then, too, a freelance illustrator such as Homer received payment immediately on acceptance of a drawing.[10] This was a distinctly different state of affairs from that faced by most painters. They needed to wait for a painting to be bought from an exhibition or a dealer or, better still, for a collector to appear at a studio. As a woodblock artist Homer quickly became accustomed to a pattern of rapid remuneration for work performed. Immediate payment was rarely the case with his paintings.

But a career in painting was his goal. He had asserted this while still an apprentice lithographer.[11] Nevertheless, after his release from Bufford's shop he bided his time. He apparently painted nothing of substance while freelancing as an illustrator in Boston. Then, after making a start in oils in 1862, he exhibited nothing until 1863. The reasonably steady income he earned from his illustrations in the late 1850s and early 1860s enabled him to defer his debut until he believed he was ready.

Just how much he earned in his early years as an illustrator is open to conjecture, for no evidence on this point seems to have survived. His first original subjects for the *Companion* probably brought him ten to fifteen dollars apiece, depending on size.[12] By early in the next decade, however, payment for a full-page drawing executed on the block for *Harper's Weekly* probably brought him at least thirty dollars. By 1863 it had risen to sixty.[13] For a freelancer whose work appeared in the pages of a pictorial magazine once or twice a month, payment at this rate added up to a modestly good annual income. As Homer would learn soon enough, in the course of a year as a critically praised painter he might not realize that much from his work on canvas.

He had reasons to defer his debut as a painter until after his move to New York. Boston had no adequate academy of fine art in which to study painting. Then, too, time spent in painting classes would have diminished his income at a time when part of what he earned from the weeklies was very likely needed at home. Home was at first in Cambridge, where he had resided with his parents since childhood, and then in the nearby leafy

suburb of Belmont when the family moved to that town in 1858.[14] He might have allied himself with a Boston painter, but his apprentice years with Bufford had predisposed him against putting himself in an equivalent relationship with another master. Having taught himself how to succeed as a woodblock artist, he most likely assumed that when the time came he would for all practical purposes teach himself how to succeed as a painter. In the event, this is what he did. Temperamentally disinclined to follow others, he all but bristled with independence.

Beyond a reasonably good income, Homer as a young man in the late 1850s must have gained a sense of well-being and even empowerment from his early affiliation with first the *Companion* and then *Harper's Weekly*. These magazines quickly established his reputation as an illustrator. In 1857, when he was the *Companion*'s youngest artist, each issue that featured his work came off the presses in more than a hundred thousand copies, almost always with his name prominently mentioned in the adjoining text. As these copies passed from hand to hand, perhaps as many as three or four hundred thousand adults saw his work. His name became steadily more familiar. In his first six months with the *Companion*, sixteen of his illustrations appeared in its pages—ten original subjects and six portraits. Another illustration, the first of many to come beginning the next year, had introduced him to the readers of *Harper's Weekly*. By any measure, except those of high art, Homer had become a successful professional artist before he had reached his twenty-second birthday. True, the aims of art on Winter Street differed from those in the painters' studios of Manhattan, but the original subjects he drew for the pictorial press in the early months of his career possessed their own validity as descriptive journalism of a high order.

It was to Homer's great good fortune that he set out to be an artist of this sort just as the still-new era of the pictorial weeklies began to reach early maturity in America. Worldwide, in little more than decade this new type of publication had altered the face of magazine journalism. The pictorial weekly magazine became the first mass delivery system for visual art. Compared to the periodicals that had preceded them, the weeklies were new in almost every respect. Their newness existed in frequency of appearance; in format; in methods of production; in means of distribution; in international circulation; in size and breadth of audience; and, above all, in their faith in the power of visual communication. Other influences would join in the shaping of Homer's long and distinguished career as an artist, but he was first of all a product of the woodblock and the electrotype when the innovative spirit of the pictorial press was still fresh.

3

The Rise of the Pictorial Press in England

On May 14, 1842, two hundred men paraded grandly through the busiest streets of London carrying large advertising placards above their heads. Their signboards read: "The Illustrated London News. Published Every Saturday. 30 Engravings. Price Sixpence."[1] This was the launch of the first of the great pictorial weekly magazines. Within a year, the *Illustrated London News* had become a staple of Victorian life. Within a decade, its success had inspired the founding of pictorial weeklies in other nations throughout the world.[2] In 1843 *L'Illustration* came forth in Paris and the city soon thereafter welcomed a second major journal, *Le Monde Illustré*. Stuttgart greeted *Uber Land und Meer,* Leipzig began its *Illustrirte Zeitung,* Boston saw the arrival of *Gleason's Pictorial Drawing-Room Companion,* and four pictorials appeared in New York, two of which met with lasting success: *Frank Leslie's Illustrated Newspaper* and *Harper's Weekly.* Between 1850 and 1880 pictorial magazines similar in format and organization to the *Illustrated London News* appeared in Amsterdam, Barcelona, Berlin, Christiana (now Oslo), Madrid, Melbourne, Mexico City, Milan, Montreal, Rio de Janeiro, St. Petersburg, Sydney, Warsaw, Washington, and other cities around the globe.

In London itself substantial rivals to the *Illustrated London News* came forth beginning in the 1840s with the *Pictorial Times* and followed by *Pen and Pencil,* the *Illustrated Times,* and others. Some lasted for years, though none gained the following or the eminence of the *Illustrated London News.* Its most substantial competitor, *The Graphic,* arrived in 1870 with a distinctive design and literary style.[3]

The pictorial weeklies were nearly all the same in size: small folio. Most had sixteen pages, though a few had only eight. Their distinctive

appearance made them an immediately recognizable class of publication, much as tabloid newspapers would be in the twentieth century. But while the weeklies stood apart from most pre-1842 magazines in their format, they differed even more in their profusion of elaborate illustrations. Half of the pages in each issue contained pictorial matter, often large in scale. Earlier magazines and books had sported full-page illustrations, but these were usually sewn-in plates that took much longer to produce than the pictorials' wood engravings and were, as a result, more expensive.

By the 1860s, international travelers could expect to find the *Illustrated London News*, *L'Illustration*, *Harper's Weekly*, and other pictorials at rail terminals near and far—this was the first class of magazine to enjoy such ubiquity. With its illustrations of faraway lands, often based on photographs or adapted from travelers' drawings, the pictorials helped to collapse their readers' sense of distance and remoteness. With illustrated reports on relatively recent events every seven days, they helped to tighten their readers' sense of time. Along with the camera, the telegraph, the Atlantic cable, the clipper ship, and the railroad, the pictorial weekly magazine instilled modern concepts of time and space in the nineteenth century.

The popularity of the pictorial press rested also on the improved levels of illumination that brightened increasing numbers of homes, places of business, and public buildings. Gas lighting had made it possible in urban settings to read at any hour, comfortably, cheaply, and safely. Where gas was not available, improved long-burning lamps made reading—and the close examination of illustrations—easier. All this improvement occurred within the lifetimes of people who had once read after dark only by candlelight. The tightly spaced text of the pictorials and the fine details of their illustrations testify to these brighter environments.

The sixteen-page limit persisted for decades because a pictorial weekly, unlike many other magazines of the day, was meant to be read from front to back in not much more than an hour or two—on a train journey, perhaps, or in the parlor following dinner. The page limitation also allowed the magazines to benefit from low newspaper postal rates. Most pictorials were published on Saturdays to have them freshly available for weekend reading. Each number was dated a week ahead so that, for example, the issue dated June 27 actually appeared on June 20. Publishers in any event wanted the reading to be finished before the appearance in seven days of the next number. Light of weight, the pictorials folded in half easily to fit into a bag or tuck under an arm. Their thinness allowed a quantity to be shipped cheaply and easily by train, carriage, or

boat. Without altering its size, the pictorial weekly remained a major presence in the publishing world into the last quarter of the nineteenth century. The *Illustrated London News, Harper's Weekly, Le Monde Illustré,* and a few others survived into the twentieth century recognizably similar in format to their early issues.

The extent to which the public valued the pictorials is best attested to not so much by the number of copies printed each week, year after year— these were vast quantities indeed—but by the number of issues preserved. Households around the world kept these magazines for years, moving them from parlor to attic as time passed, as later generations would do with the *National Geographic* magazine. Libraries and schools across the land subscribed to them. Individuals and institutions alike paid to have runs of the magazines bound, usually semiannually, and took pride in the rows of gilt-stamped leather spines that glistened across their shelves. Much of the prose miscellany that constituted a pictorial's text soon lost its currency, but the pictures held interest for years. Collectors still seek them out.

Homer is certain to have seen the *Illustrated London News* with some regularity. Many Americans subscribed to it. The art and editorial rooms of American magazine publishers kept runs of it on file.[4] Homer probably also knew of Herbert Ingram, who had created the *News* and guided it to international eminence.[5] One of Homer's associates, Frank Leslie, had worked closely with Ingram in London in the 1840s. The story of Ingram's creation of the *News* was often told.

Trained as a printer, he had observed as a young man in London the public's growing demand for reading matter. By the 1830s rising rates of literacy had created a booming market for books, magazines, and newspapers, and this market in turn had spurred advances in the technology of printing and papermaking. The public's fascination with printed illustrations also intrigued him. London's tumultuous life, already brought vividly to life in Cruikshank's etchings and Dickens' early novels, offered a rich supply of subjects for any observant writer or artist. Other subjects came from Britain's far-flung empire, whose exotic places and peoples required literary and pictorial description.

Ingram's entrepreneurial spirit blossomed when he bought the rights to a patent medicine. The highly successful advertising campaign he contrived for his "Parr's Pills" in the form of illustrated printed flyers, and the system of rapid product distribution he devised using the recently built railroads, brought him handsome profits. These sufficed to take him back to London early in 1842, where just off Fleet Street he set up as a

printer, book seller, distributor of newspapers, and publisher-to-be.[6] He had noted that when a newspaper carried a wood-engraved illustration of a timely topic on its front page, the demand for that issue rose sharply. The expense of producing such images discouraged their regular appearance, however, because the newspapers that used them had relatively small circulations.

But Ingram knew that the technology of relief pictorial printing was undergoing a quiet revolution that would allow the production of better and larger images at less cost. He also knew that the rail network, which had served his Parr's Pills so well, could be used to distribute newspapers and other publications speedily throughout the nation. It made no sense to send newspapers of local interest across the land, but a timely publication of national appeal would be a different matter. If it achieved a circulation many times that of a London newspaper, the cost per copy of an illustration would shrink markedly. If it catered to the public's growing interest in printed pictures by including them in quantity, it might attract a large audience.[7]

The *News* was neither a newspaper nor a magazine as those types then existed, but an amalgam of both, and something more. It appeared as regularly as some newspapers but more often than most of the era's substantial magazines. It was in fact a new kind of magazine. As would be true of its imitators, Ingram's *News* offered accounts of selected recent events throughout the world, and on occasion brief and subdued accounts of crimes and other sensational happenings. Most of the contents, however, consisted of fiction; feature articles on persons and places; popular accounts of travel; essays on historical topics; reviews of the theatre and exhibitions; notices of newly published books; a dollop of verse; squibs on curious and amusing topics; occasionally a piece of printed music; a page or so of advertisements; and more.

Its first number included a description of a glittering ball at Buckingham Palace, a report on a dreadful rail accident in France, an account of the new overland route to India, and a feature on ladies' fashions, all with illustrations. The front page included a distant view of the great fire in Hamburg, a conflagration that had begun nine days before the press run of this issue. By the production standards of the time, this small wood engraving stood as a remarkably quick job of international pictorial reportage. This was true even though the artist who drew it had done no more than copy an engraving of Hamburg from the collections of the British Museum and augment it with billows of smoke, crowds of onlookers, and other products of his imagination.[8] A potpourri of subjects

and occasional pictorial expedience became the standard among the weeklies worldwide. Most of the weeklies also emulated the *News*'s genteel tone.

Each issue contained eighteen or so wood-engraved pictures every week. Most were at least passably well-drawn. Some stood on their own as pictures independent of the magazine's letterpress. The editorial staff often supplied these images with brief commentaries written after the artists had submitted their drawings. No newspaper had ever contained so much pictorial matter. No magazine of serious purpose had ever featured illustrated articles as timely as newspaper accounts. The size of the illustrations, at first small, reached full-page size within nine months.

Until close to the end of the century, color printing remained a practical impossibility for the high-speed, high-volume presses that produced the weeklies. In an era when the discovery of aniline dyes made a range of bright color increasingly evident in such things as interior decoration, women's fashion, and poster advertising, the grayness of the weeklies might have seemed an impediment to their popularity. But this was also the era of photography, another gray medium, and one that shared with the pictorials a reputation for visual truthfulness. Color printing had grown increasingly common in lithography by the late 1850s, and color had also become part of other printmaking processes, but in each case it was prohibitively expensive for the cheap-to-buy weeklies.

The title piece that headed the front page of the *Illustrated London News* presented a panoramic view of St. Paul's Cathedral rising grandly above the City of London as seen from the south bank of the River Thames.[9] When another illustration appeared below this title piece on the front page in the journal's early years, it rarely occupied more than a quarter of the available space—this had been the case with the view of Hamburg in flames. By leaving room on the front page for letterpress, the *News* perpetuated the newspaper lineage in its ancestry. But the front-page fit of picture and text remained inherently problematic for all pictorial weekly magazines until much later in the century. While a timely news report received by telegraph or, after 1857, by the trans-Atlantic cable could be set in type with dispatch, the engraving of an illustration required at the very least a week's work. As a result, a degree of disjunction typically existed between the front page's text and image. The London *News* might report a great fire in letterpress two days after its occurrence, but no illustration accurately documenting that event could accompany the text.

A pictorial weekly's deadline-driven process of production required

many hands. To prepare eight pages of pictures each week, Ingram called on a staff of wood engravers larger than any serial publication had ever previously needed. And to ensure that these artisans had woodblock drawings to engrave, he secured the talents of several graphic artists, most of whom seem to have contributed regularly on a freelance basis. They ranged from the young and ever-serious John Gilbert to the older but brighter-spirited Kenny Meadows. All the illustrators drew images meant to attract and hold the attention of a general readership, but the magazine's policies required that they do so without resort to sensation or vulgarity. An occasional humorous drawing in the *News* by Meadows or John Leech added to its sense of miscellany and reflected the influence of such popular London comic weeklies as *Punch* and *Fun.* Aside from these, and the modestly imaginative drawings that illustrated pieces of fiction, most of the magazine's pictorial matter was earnestly bland journalism of a documentary kind. This, too, became the character of most pictorial weeklies worldwide.

The rise of the pictorial press had depended on a new development in the technology of printing: the electrotype. This metal printing matrix was produced by a galvanic process that had been developed in 1839 by inventors working independently in England, Russia, and the United States. The process was quickly adopted worldwide for many industrial tasks, but its most widespread application was in the world of printing.[10]

In the case of a pictorial weekly magazine, the pressroom's electrotypist prepared a page for printing by first making a wax mold of that page's component parts. The parts included the text set in type and, when the page was to contain pictorial matter, the engraved woodblock. After coating the interior of the page-size mold with powdered graphite, the electrotypist placed it in an electrolytic bath—a large basin containing a fluid with copper in solution. The application to the fluid of electric current from a battery precipitated copper onto the graphite-lined mold, creating a thin but exact metal replica of the surface of the type and the engraved woodblock. When backed with sturdier metal for strength and faced with steel for durability, the electrotype was ready to be fitted to a press where it could print tens of thousands of impressions of the entire page without significant wear. Since duplicate electrotypes could be made from a single mold, the same page could be printed concurrently on multiple presses. In practice, a press typically printed four pages on each sheet of paper that passed through it. The sheet was then machine folded, cut, and trimmed.[11]

The London comic weekly *Punch* had begun printing from electrotypes a year earlier than the *Illustrated London News,* though on much smaller pages. Most of its illustrations contained little detail and shading, and so required less engraving. In the *News,* however, Ingram exploited the potential of the process by calling for more finely and elaborately engraved illustrations on an increasingly larger scale. Further, he attracted to his magazine more highly skilled draftsmen than those who had drawn for earlier popular publications.

The electrotype dominated the world of mass-produced popular illustration for half a century. Other methods had been used earlier to obtain metal replicas of wood-engraved surfaces; the most common had been the stereotype, made manually from plaster-of-Paris molds. But the electrotype process was easier, faster, and more precise. It enabled the pictorial weeklies to have their distinctively large format. It allowed woodblock artists to work on a larger scale and to bring a new delicacy of expression to the realm of mass-produced popular illustration.

A second development of the early 1840s also influenced the nature of the illustrations in pictorial weeklies worldwide. This was photography. If the arrival of the electrotype had made the high-volume printing of large, finely engraved illustrations possible, the emergence of photography gave many of these images a distinctive character. Soon after the daguerreotype had swept the world in the early 1840s, woodblock artists began to use these early photographs as sources for their illustrations. The growing presence of wood-engraved portraits in the weeklies in the 1840s and 1850s arose directly from the ubiquity of portrait photographs, any of which could easily be mailed or shipped anywhere in the world. In 1857, when Homer in Boston copied onto the block from a daguerreotype a portrait of a sea captain who resided in California, it allowed the captain's likeness to reach publication in the *Companion* without the subject's having been within a few thousand miles of the artist who drew him.[12] Nothing quite like this had been possible so routinely or with such ease before the introduction of the daguerreotype in France in 1839 and its rapid spread elsewhere.

Beyond supplying them with subjects, photography also influenced what some illustrators drew and how they drew it. As daguerreotypes and, later, ambrotypes became increasingly common in the 1850s, illustrators began to emulate (as best they could in their linear medium) the distinctive tonality of early photographs. This emulation was easier to do in the tonal medium of lithography, but the effect is evident in the work of many wood engravers. Their efforts lent an aura of documentary realism to a pictorial's pages, at least in the case of that part of the public that

believed that a photograph captured more truth than could an artist. In a tour through the pages of European and American weeklies of the 1840s and 1850s, one encounters in many illustrations the angles of vision, optical perspective, and other pictorial qualities common in early products of the camera. The stillness of many drawn views echoed the static character of subjects photographed before lenses were fast enough to stop motion. It was surely to provide a welcome contrast to this stillness that some illustrators, such as Homer, drew scenes full of depicted movement.

The influence of photography can also be felt in a shift in the general character of popular illustration that occurred during the early years of the pictorial weeklies. The move was one from humor to staidness. Many of the leading book and magazine illustrators of the 1820s and 1830s had invested their work with an essentially comedic outlook—one thinks of Great Britain's George Cruikshank and America's D. C. Johnston. Even when they illustrated serious subjects, the artists of this generation trusted imagination at least as much as observation.. They worked with a lightness of touch that seemed to reflect the ebullient mood of Regency England and Jacksonian America. This spirit never entirely disappeared from the work of many of the most respected illustrators in the succeeding decades. But with the growth of a culture of Victorian propriety beginning in the 1840s, humor became dislodged from a central to a marginal position in the mainstream of popular book and magazine illustration. Satire and farce survived nicely in comic journals, but those publications were never entirely respectable.

Sobriety in text and illustrations was the expected tone of the pictorial weeklies, and it remained so for the rest of the century. Even as late as 1897 the critic Gleeson White felt it necessary to disparage the lighter mood of the generation of the 1820s and 1830s. In his study of Great Britain's "Sixties" illustrators, the woodblock artists who contributed to books and magazines between 1855 and 1870, he said of their predecessors:

> Granting all sorts of qualities to those pictures by Cruikshank, "Phiz" [Hablot K. Brown], and Thackeray, which illustrated the Dickens, Ainsworth, Lever, and Thackeray novels, you can hardly refer the source of their inspiration to nature, however remotely. Their purpose seems to have been caricature rather than character-drawing, sentimentality in place of sentiment, melodrama in lieu of mystery, broadfare instead of humor. These aims were accomplished in masterly fashion, perhaps; but is there a single illustration by Cruikshank, "Phiz," Thackeray, or even John Leech which tempts

us to linger and return again and again purely for its art? [Their] . . . drawing is often slipshod, and never infused by the perception of physical beauty that the Greeks embodied in their ideal.[13]

White's reproving comments set the stage for the high praise he then gave to such "Sixties" illustrators active in London as George DuMaurier, Birket Foster, John Gilbert, Arthur Boyd Houghton, Arthur Hughes, John Everett Millais, George Pinwell, Frederick Sandys, and Frederick Walker, among others. The work of these British illustrators was strongly felt in America, even by Homer. A generation following White's treatise, however, the tide turned. The critical fortunes of Cruikshank and his contemporaries rose in the 1920s as the *New Yorker* and other magazines of urbane wit flourished again in England and America. By then it was clear that the artifice of the illustrators of the 1820s and 1830s had rested in part on their makers' sense of theatre—a stage-like manner quite in harmony with much of the literature they illustrated, and very much to the taste of their times.

Further, in finding fault with the earlier illustrators' drawing skills, White had not taken sufficient note of the differences in mode of pictorial reproduction that separated the two generations. Cruikshank, Leech, "Phiz," and Johnston all worked primarily as etchers. Drawing rapidly with an etching needle through the ground on copper plates gave them little opportunity to correct or to have second thoughts. When they drew on woodblocks, they perpetuated the distinctive line of their etching styles. The woodblock artists who succeeded them worked in different circumstances. They not only sought what they saw as greater refinement in style and mood, but they also had ample time to work on their drawings and to worry them into final form before handing them over to engravers who, when the occasion warranted, gave further polish to a composition. Beyond that, the etching process of the early decades of the century was not well suited to making large images for popular publications. But even when these considerations are taken into account, it was a societal change of mood as much as anything that made the earnestly aesthetic work of the Sixties illustrators and their American colleagues seem right for the new pictorial weeklies.

The shift in Homer's magazine illustrations from a frequent lightness of spirit in the late 1850s to an altogether more serious tone a decade later surely reflected more than the sobering experience of the Civil War and his redefinition of himself as a fine artist rather than a popular illustrator. The less antic mood of much of his later work for the weeklies fol-

lowed a shift already complete in the outlook of most publishers of pictorial magazines.

It took a large staff of artists, engravers, writers, and printers to produce an issue of a pictorial magazine each week. Ingram attracted superior talent in all these fields. Perhaps the most celebrated of his early employees was Henry Vizetelly. Trained as a wood engraver, he became a skillful original artist, an able writer, and in time a successful publisher. Another of Ingram's engravers of wide-ranging talents was the redoubtable Frank Leslie. After a few years with Ingram's *News,* Leslie crossed the Atlantic hoping to establish a pictorial weekly of his own in New York. As we will see, before he accomplished that goal he played a vital role in moving Boston's *Companion* ahead. He was an irrepressible figure: "short, opinionated, and demanding." [14] Immediately after the Civil War, Homer contributed illustrations to two of Leslie's publications.

The pictorial press was the creation of young men. When Ingram founded the *Illustrated London News,* he was thirty-two. His aides Vizetelly and Leslie excelled in major responsibilities at age twenty-one and twenty-two, respectively. A decade and a half later, when Homer entered the profession in Boston at age twenty-one, he was not much younger than many of his illustrator colleagues. In creating the modern mass-circulation pictorial magazine, Ingram's generation of young men shaped one of the great international success stories of the nineteenth century.

For four decades the pictorial press flourished worldwide with pictures produced by specialist woodblock artists and teams of wood engravers. Then, in the 1880s, new means of pictorial reproduction began to arrive to supplant the old. The most influential of these was the halftone screen, which utilized photography to make a tonal printing matrix. It spelled an end to the hatching and cross-hatching of wood engravings. Indeed, within two decades it effectively put an end to wood engraving as an important profession within the publishing world. Illustrators now no longer needed to draw on woodblocks, nor did they need to draw to scale, since their work could be enlarged or reduced photographically. They drew more freely, knowing that the camera would pick up the autographic and tonal nuances of their styles. They had no need to worry about the intermediary—the wood engraver—who for better or worse had long stood between a drawing and its realization on the printed page. By the 1890s a new generation of illustrators had begun to

exploit the halftone's much enlarged possibilities for expression. New illustrated magazines came into being, different in concept, format, and design, and often cheaper than the old pictorial weeklies.

The world of magazine publishing soon changed rapidly and in more ways than anyone could have predicted even at the start of the 1880s.[15] By early in the twentieth century shelf after shelf of bound runs of the great magazine innovators of the 1840s and 1850s—the *Illustrated London News,* the *Pictorial Drawing-Room Companion, Harper's Weekly, Frank Leslie's Illustrated Newspaper,* and many others—began to collect dust in homes and libraries. They represented the residue of a remarkable generation in the history of visual communication. Their pages contained a prodigious quantity of undistinguished illustration that is now of little other than documentary interest, but they had made it possible for a few artists of exceptional sensibilities to rise above that level and reach audiences numbering hundreds of thousands with graphic works of lasting merit. This was the opportunity seized by Homer in Boston.

4

The Pictorial Press Begins
in America

THE HANDSOME profits that the *Illustrated London News* earned for Ingram led more than one American entrepreneur to weigh the prospects of establishing a similar magazine in the United States. This was a daunting proposition. To bring a pictorial weekly into being required a large capital investment in high-speed presses and the other equipment necessary to electrotype, print, fold, cut, and trim tens of thousands of copies. The proprietor needed to assemble and pay not only an editorial staff attuned to a broad range of journalistic and literary forms but also a sizeable group of wage-earning skilled engravers. He needed to attract competent freelance artists capable of interesting work. Space had to be found for business and editorial offices. America's largest and wealthiest city, New York, seemed the likeliest place to launch such a magazine. As things turned out, the honor went to Boston.

When Frederick Gleason (1819–1896) and Maturin Ballou (1820–1895) established *Gleason's Pictorial Drawing-Room Companion* in May 1851, they not only modeled it closely on the *Illustrated London News* but asserted that they meant to surpass their model.[1] In two respects, those of quality of printing and a polished "familiar essay" literary tone, they could in time claim to have achieved their goal. They initially met with less success in the realm of illustration, primarily because Boston had fewer graphic artists of real talent than did London. Still, compared to the other pictorial weeklies established in the United States during the decade of the 1850s, the general level of illustration in the early years of the *Companion* strikes the eye as more interesting than that of its rivals.

As was true of all such magazines, the pictorial images in any given issue amounted to a grab bag of subjects and styles. By 1855, however,

the *Companion* had begun to impose a little coherence on this olio chiefly by instituting running series of subjects. This meant, for example, that readers might expect every few weeks to see one in an engaging sequence of front-page illustrations by Hammatt Billings (1816–1874) devoted to the States of the Union. In each he set the state's seal over a view that included an idealized prospect of agricultural, industrial, marine, or other activity characteristic of the state. In another running series, Billings every few weeks presented double-spread depictions of dramatic moments in American history such as the Battle of Cowpens and Pocahontas's rescue of Captain John Smith. In concept and execution, Billings' series are an impressively ambitious achievement in mid-nineteenth-century American illustration.[2]

Gleason was a printer and the *Companion*'s founding proprietor. He oversaw production. Ballou was the weekly's editor, but he was also a financial partner, and apparently the dominant one. By the end of 1854 he had edged Gleason out of the business. In January 1855 he renamed the *Companion* after himself.

Ballou's New England forebears included several distinguished preachers, but none more prolific with words than his father, Hosea, a Unitarian minister who was the author of some two hundred books on sacred topics. Maturin was similarly prolific, but his interests as a writer were venal rather than theological. At age thirty-one, he was already a best-selling author of popular fiction. A decade earlier, when he was scarcely in his twenties, he and Gleason had formed a publishing house; Gleason printed what Ballou wrote. That writing consisted largely of pamphlet-length sensation novels—predecessors of the twentieth century's pulp fiction. He wrote not only under his own name but under pseudonyms as well. The partners reaped heady profits. In 1846 they used some of their earnings to establish a literary weekly magazine in double elephant-folio format, *The Flag of Our Union*. To this somewhat higher-toned serial, Ballou enticed contributions from such writers as Edgar Allen Poe, Lydia Sigourney, and the young Horatio Alger.[3] The *Flag,* too, enjoyed robust sales. It demonstrated that Gleason's presses were capable of rapid, large-format, high-volume printing.[4]

The financial success of their publications enabled the two men to venture into the world of the pictorial press. They did so in the expectation that, like the *Illustrated London News,* their weekly would make them a tidy profit, but they undoubtedly also hoped that this new enterprise would carry them to a higher level of professional respectability. Yet, while Gleason had first-rate printing facilities and Ballou possessed

well-honed editorial skills, neither could claim expertise in the crucial and complex area of the production of pictures for a pictorial weekly. Boston was home to a number of skilled illustrators and wood engravers, and they would be essential to the new publication's success, but few if any of them could offer experience in the production of large illustrations on a demanding and inflexible schedule. Gleason and Ballou looked to New York for this background. Soon after the *Companion*'s launch, they found it in a person who with no false modesty and ample self-confidence believed himself to be the most experienced and resourceful person in that field in America: Frank Leslie.

Leslie itched to run a pictorial magazine of his own, but since his arrival from London in 1848 he had failed to find investors prepared to back his project.[5] He supported himself as a wood engraver. In 1850 his prospects for founding a weekly had worsened when Thomas W. Strong (act. 1840s–50s), well known as a comic illustrator and wood engraver, managed to find financial support for a pictorial of his own. Unwilling to join Strong, or to continue working only as a journeyman engraver, Leslie in 1851 accepted Gleason and Ballou's proposal that he move to Boston to oversee the production of wood-engraved illustrations for the *Companion*. Meanwhile, Gleason and Ballou moved quickly to get the Boston weekly underway before its New York competitor hit the streets.

They succeeded. Priced at ten cents a copy, the first number of the *Companion* reached publication on April 26, 1851, dated May 3. It preceded Strong's *Illustrated New York News* by a month. Though Strong had been a publisher of comic journals, he meant his pictorial weekly, which was limited to eight pages, to be a journal of current events that also included fiction and humor. He imitated both the title of the *Illustrated London News* and the panoramic manner of its title piece by devising one that offered a bird's-eye view of lower Manhattan. But he flanked this view with four vignettes, and one of these depicted firemen rushing to a burning building. This scene, small as it was, suggested that the journal would be reporting local news—that it would be, as its title claimed, an illustrated newspaper at least as much as a pictorial magazine of miscellany.

This goal proved to be beyond Strong's resources. On June 7, the first number of his *Illustrated New York News* devoted its front page to a subject that was of current interest but hardly up-to-the-minute news. The subject was the "New Costume," that controversial fashion for women in which "Turkish" or "Semi-Oriental" pantaloons were worn under a calf-length skirt to allow a more active lifestyle. This fashion, introduced in the early months of 1851 and then rapidly popularized by Amelia

Bloomer and others, quickly became a symbol of the women's rights movement. It had already made a stir in the American press by February.[6]

Strong devoted the second page to "Gleanings and Gossip," extracts from other publications. The initial installment of a serialized piece of fiction, illustrated by the already well-established Frank Bellew (1828–1888), occupied the third page. The news in Strong's *News* was unillustrated. Not until the number for June 28 did his weekly publish anything that remotely resembled news illustration. This consisted of two half-page depictions of a fire that had consumed part of San Francisco seven weeks earlier, on May 4. Undoubtedly adapted from other sources, these were not pictures of news so much as of recent history.

In Boston, the *Pictorial Drawing-Room Companion* implied through its title that it would pay little attention to news and current events. The title suggested that the contents would center instead about benign topics of general cultural interest. The front page of the first number supported this expectation. Beneath a panoramic title piece in the manner of the London *News* showing Boston from above its harbor, with Bulfinch's State House on Beacon Hill surmounting all, the *Companion*'s first page featured a sentimental illustration by Asa Coolidge Warren (1819–1904) of May Day celebrations in an English village. This subject was timely only in the sense that the illustration and its text appeared in the month of May, but it had no news value. In choosing an English setting, Gleason and Ballou perhaps meant to reinforce their magazine's ties to its London model.

But Ballou did indeed have news to report in this initial number of the magazine, though he placed it well into the issue on pages 4 and 5. Following two pages of letterpress devoted to Clinton Barrington's novelette *The Young Fisherman, or the Cruiser of the English Channel* came illustrations and text relating to the recent trial in Boston of Thomas Sims, an escaped slave. Sims had been arrested in the city on April 4. The Fugitive Slave Law required his return to his owner in Georgia. The trial took place a few days following the arrest, and on April 11, found guilty of unlawful escape, he was taken from the courthouse, marched under heavy guard to a ship waiting in the harbor, and sent in custody to Savannah. When the *Companion*'s first number reached the streets on April 26, it contained depictions of Sims, the abolitionist Wendell Phillips who had argued against his return, an antislavery meeting on the Boston Common, the courthouse in which the hearing was held, and a group of policemen. Supporting the rule of law, the *Companion*'s text revealed no sympathy for Sims's plight. The illustrations are more even-handed. They invest Sims with dignity and emphasize his powerless status by depicting

him as he was marched to the harbor surrounded by the phalanx of policemen needed to prevent his rescue by abolitionists. This slight disparity in meaning between text and picture was not rare in the early years in the pictorial press.

The Sims illustrations had reached print within two or three weeks of the sequence of the local events they depicted. Leslie would emphasize and improve upon such celerity when, three and one-half years later, he finally brought his own pictorial weekly into being. Other illustrations in this first issue of the *Companion* include a picture by William Wade (act. 1840s–50s) of the river steamer *Isaac Newton*; Warren's view of a female seminary in neighboring Charlestown; and a portrait of Daniel Webster with a depiction of his carriage by the French émigré artist Emile Masson (act. 1850s). A touch of Orientalism came in an unsigned depiction of a scene from the play *Children of Cyprus,* then in production at the Boston Museum. The most skillfully drawn illustration in this first issue was a depiction by the magazine's eldest artist, William Croome (1790–1860), of the recent burning of the Assembly Building in his native Philadelphia. Other pages contained verse commissioned by Gleason and Ballou for their magazine's inaugural number, brief extracts from the works of well-known authors, and squibs borrowed from and credited to other magazines. Although most of the illustrations were little more than workmanlike, their vivid depictions of newsworthy events and persons made Strong's efforts in New York the next month seem weak.

Succeeding issues of the *Companion* presented in a tone of refined popular taste illustrated accounts of travel in America and abroad, biographical sketches with portraits of noted figures, seasonal essays, and much else, always including some newsworthy content. In its pictures, letterpress, literary content, and general polish, the *Companion* lived up to its claim to be a superior publication of its kind. Ballou had promised as much in the editorial matter of the first number when he had also suggested that illustrators who drew for the pictorial press were artists still taking the measure of a new kind of audience.

> Let those who feel a pride in American art, and the excellence of native workmanship, compare our paper with a copy of the *London Illustrated News* [sic], a journal which has heretofore taken the lead in illuminated publications throughout the world. . . . We ask our readers to compare the two publications minutely, and then judge for themselves which is the most beautiful and valuable paper. . . . And we assure the reader that the number before him will still be im-

proved upon as our various artists get more and more to understand exactly what is desired in the illustrated department.[7]

Even though the *Companion* maintained a Boston orientation, especially in its illustrations, it rapidly gained subscribers from around the nation. In Manhattan, to achieve the same end, Strong changed the name of his *Illustrated New York News* after a few weeks of publication to the more widely embracing *Illustrated American News*. He devised a new allegorical title piece to replace his weekly's original view of Manhattan. Despite these efforts, his magazine never captured a large following. It ceased publication after six months, leaving the *Companion* as the only pictorial weekly magazine in the United States. Throughout the early and mid-1850s it prospered steadily.

Beyond supplying Gleason and Ballou with some of the technical skills needed for the production of the *Companion*'s large-scale illustrations, Leslie had also brought with him from London a talent for organizing people and tasks. He almost certainly played a role for a year or so in assembling a staff of wood engravers and electrotypists. Capable engravers were already available, for Boston had long been a center of wood-engraved illustration for book publishers. But the *Companion* required larger-scale work on composite blocks executed by teams of engravers according to an inflexible schedule, and this requirement was new. Already at hand was the able engraver John Andrew (1815–1875). Then thirty-six, like Leslie he had learned his trade in England. He would be the magazine's head engraver throughout its existence, and he may possibly have served as its art editor. The younger John Manning (act. 1840s and 1850s) and John Chapin (1823-c.1908) were among the magazine's other early engravers. The *Companion* advertised widely for more. Leslie and Andrew undoubtedly trained neophytes as rapidly as they could.

Even this local talent would not have sufficed to sustain the *Companion*'s output of illustrations without help from the 48-ers. These were artists and pictorial artisans who had emigrated to the United States chiefly from France, Germany, and England between 1848 and 1851. Some came for political reasons, fleeing from their homelands in the aftermath of the revolutions of 1848. Others, like Leslie himself, crossed the ocean attracted to opportunities for advancement available only in the United States. Among other 48-ers from England were two draftsman brothers, Alfred Waud (1828–1891) and William Waud (c. 1827–1878). Masson, who had drawn Webster's carriage for the *Companion*'s first number, may earlier have drawn for pictorial weeklies in France. Boston

had attracted several European-trained graphic artists. Homer's friend Louis Prang (1824–1909), the lithographer, was a 48-er.

So, too, was the wood engraver Charles Damoreau (act. 1850s–1870s), who cut several of Homer's drawings. According to Homer family tradition half a century later, Damoreau gave the young illustrator early instruction from an engraver's point of view in how best to draw on the block.[8] He was the only person remembered from the group of artists and artisans with whom Homer associated during his first years of drawing for the *Companion* and the *Weekly,* and this memory suggests that Homer found his instruction to be of lasting value. Some of the compositional strengths of Homer's earliest illustrations may owe more than a little to Damoreau's coaching. Like most expert wood engravers, he was also an able draftsman. Later, in Canada, he would list himself as an artist as well as a wood engraver.[9] It behooved engravers to be proficient draftsmen, for they were occasionally pressed into service to make original drawings from scratch when a magazine's inventory of work from freelancers was spent.

The arrival of the *Companion* in Boston and the *News* in New York in 1851, followed later in the decade by *Frank Leslie's Illustrated Newspaper* and *Harper's Weekly,* restructured the world of illustration for skilled draftsmen in America. The weeklies' demand for drawings in the 1850s offered older artists such as Croome a new lease on artistic life. It presented novice artists such as Homer with previously unknown opportunities to reach publication and even national prominence. It enabled many 48-ers to gain a foothold in a new land.

The woodblock artists who drew for the *Companion* were always aware of the existence of a parallel universe of popular picture-making in Boston during these years. This was the world of lithography. While the magazine's illustrators drew images meant to hold the attention of readers for a week or so, Boston's lithographic artists drew images whose engagement with viewers they hoped would be of much longer duration. From the lithographic shops of the 1850s (they would become factories in the late 1860s) came framing prints that graced the walls of homes, schools, businesses, hotels, taverns, and countless other places for years on end. The prints were hand-crafted to the extent that an artist created the printing matrix as he or she drew on the prepared stone; no engraver intervened. Beginning in the 1840s many lithographs were printed in colors.[10] Since the 1820s, lithographs had been produced and sold very

largely on a regional basis, but in the mid-1850s the New York firm of Currier & Ives moved ahead of its rivals throughout the nation. It did so on the basis of innovative national marketing and steady reliance on hand coloring, a less costly process than printing in colors.[11]

The lithographs produced throughout America in the 1850s and for a generation afterwards differed in so many ways from the printed images that proliferated in the pages of the weeklies that there was never any real competition or even conversation between the two. The pictures in the weeklies were not only more or less ephemeral, but they also moved about as they were carried from chair to chair, from veranda to kitchen, and from newsstand to first-class carriage. They usually received little real attention a week or two after their publication (though they were frequently saved for perusal on rainy days). Conversely, framing lithographs were prints worth keeping, if only because they were much more expensive than pictorial weekly magazines. Framed or merely tacked up, they substituted for paintings on America's walls for years on end.

There was little movement of artists back and forth between the two media. Homer was unusual in having worked in both. Two different sets of skills were involved, one (lithography's) far more time-consuming than the other. Most woodblock artists could churn out one or more original drawings a week. Lithographic artists of necessity worked at a snail's pace. The differences between the two enterprises were so great that one doubts that Parsons and Currier & Ives viewed each other as competitors.

In 1851 the most proficient Boston graphic artist available to the *Companion* was Billings.[12] He was then thirty-five and prodigiously productive as a book illustrator even while working also as an architect, painter, and designer of many things from furniture to monuments. Blessed with powers of invention that were singularly absent among the *Companion*'s other artists in its early years, he brought a remarkable array of allegorical, emblematic, historical, and fictional subjects to life in the pages of a magazine otherwise devoted largely to depictions of a more documentary kind. Gleason and Ballou seem quite properly to have regarded Billings' work as one of their magazine's great strengths. He was indeed a wonder in his time, but viewers one and one-half centuries later tend to find more clichés than surprises in what he drew. This finding is hardly surprising in view of the volume of his work. If he lacked a distinct artistic personality, he was nonetheless more ambitious in his aims and more versatile in his

imagination than most American illustrators of his time. Homer, in his first year of drawing for the *Companion*, probably found Billings a useful model of virtuosity and industriousness. They must have been acquainted, but whether they conversed about their work is a question for which no evidence seems to survive.[13]

In gathering together a group of freelance woodblock artists, or "designers" as they had come to be called in the trade, Gleason and Ballou attracted a varied lot. These freelancers included Samuel Worcester Rowse (1822–1901), whose work on the block rarely rose above the mundane. He is better remembered for his paintings. George Devereux (c. 1814-aft. 1860), from Philadelphia, both drew and engraved for the weekly. Among the *Companion*'s younger artists in the early 1850s was Charles A. Barry (1830–1892), twenty-one when the magazine began. He soon became a regionally prominent painter and later a leading art educator in Boston.[14] That he was selected in 1856 to draw for the *Companion* a view of the new Ballou building on Winter Street (see fig. 2.1) was a measure of his stature within the stable of designers, but he was not greatly more able than most of his colleagues, and not as proficient or wide-ranging in his subjects as Billings.[15] Wade and Warren drew much, but rarely with notable distinction, as was true of most other contributors.

W. L. Champney (1834–1880), twenty-one in 1855 when his work began to appear in the weekly, turned out only workmanlike drawings until Homer, two years his junior, began to contribute to the magazine. In the *Companion* for January 31, 1857, Champney's *Corner of Washington and Boylston Streets* was a static, ill-designed view of a busy Boston intersection with a jumble of uninteresting figures. Nine months later, his *Boston Street Showmen and Musicians* had a fluidity of movement, subtlety of lighting, and richness of characterization that had been found in the magazine's pages only in Homer's early illustrations. It is easy to suppose that Champney's remarkable progress came at least in part from studying what Homer drew.[16] Indeed, Homer may have coached him. After 1859, recently married, Champney apparently abandoned his career as an illustrator.[17]

After training in England, the brothers Waud (pronounced *Wode*) came to America in 1851. Leslie may have recruited them. They set up in Boston as freelance graphic artists and soon became contributors to the *Companion*. In 1853, when Leslie had returned to New York to make his first attempt at establishing a pictorial weekly of his own, the brothers followed him there. While in New York, Alfred became romantically involved with a married woman, fled with her to Boston, and resumed

making woodblock drawings for the *Companion,* now signing them with the pseudonym "A. Hill." When he had resolved his domestic arrangements—the woman divorced and became his wife—he again signed his own name to his drawings.[18]

Homer was undoubtedly well acquainted with the Wauds—in 1858 and 1859 he and William shared the 24½ Winter Street mailing address next to the Ballou's building. Like Homer, each of the Wauds became a "Special Artist" for *Harper's Weekly* during the Civil War. Homer's depiction in 1862 of an artist drawing in a military camp in his *News from the War* (see fig. 9.5) has long been believed to be a portrait of Alfred. It suggests a cordial relationship between the two men.

Homer must have been acquainted with most if not all of his fellow freelancers at the *Companion,* and he must also have known Ballou and the magazine's literary editor, Frank Durivage. Indeed, a tradition holds that Emily R. Page, a female cousin of Homer's mother, was an editorial assistant at the weekly.[19] Whether she might have brought her young relative to Ballou's attention is purely a matter for speculation. But as a woodblock artist Homer would have had most of his dealings with the head of the *Companion*'s art room. No evidence indicates who might have served in this role. Billings at first seems an obvious candidate, but he was far too overextended in his commitments outside the *Companion* to have had sufficient time to attend to the day-to-day management of this crucial operation. John Andrew as head engraver may well have also headed the art department. Ballou doubtless reviewed and approved the illustrations for each issue, and may have suggested subjects. But it would be interesting to know precisely who supervised the art room at the *Companion* in May and June 1857, for that person recognized Homer's talents and sensed that in him the Boston weekly stood to gain an artist more original and more varied than anyone who had previously appeared in its pages.

With the disappearance of Strong's *Illustrated American News* late in 1851, Gleason and Ballou's weekly had no competitor in the United States for a year. Then, late in 1852, Leslie returned to New York where the showman Phineas T. Barnum was prepared to bankroll a pictorial magazine and wanted Leslie to bring it into existence. When Barnum's *Illustrated News* came off its presses in January 1853, it sported a pictorial title piece drawn by Leslie's former Boston colleague Billings. He had drawn a view of the U.S. Capitol on its hill above Washington City. In

this way the New York magazine left no doubt that it aspired to be a national journal. The *Illustrated News* was a more interesting publication than Strong's earlier attempt, and it gained a greater following, but it, too, failed to turn a profit. When the magazine ceased publication after six months, it cut its losses by selling its subscription list to the *Companion*. Once again, Gleason and Ballou had no viable rival.[20]

Leslie was undaunted. Remaining in New York, he laid plans for another attempt. In January 1854, he brought forth a smaller-format illustrated monthly for women, *Frank Leslie's Ladies' Gazette of Fashion and Fancy Needlework*. This magazine was a success. Its earnings enabled him within two years to finance his own pictorial weekly. He brought out the first number of *Frank Leslie's Illustrated Newspaper* in December 1855. Despite financial ups and downs, it made him a wealthy man. It survived competition from *Harper's Weekly* after that journal made its debut in January 1857. Leslie's emphasis on sensational topics appealed to a rather different audience than did the sedate propriety of the Harper brothers' publication. By mid-1857 the success of the New York pictorials had begun to take business away from the *Companion*. The financial panic that arrived in August of that year worsened the Boston weekly's situation.

Late in 1859, Ballou chose to cease publication. His engravers scattered, Damoreau to Toronto and others to New York. In a remarkable "valedictory" in his weekly's last number—December 24—Ballou summarized the expenses of his publication's nine-year history, exclusive of the cost of facilities. Paper headed the list at $423,000. Next came "drawings and engravings" at $161,000. Third on the list was presswork at $54.000. Payment to authors for manuscripts was only $28,000. In view of the heavy cost of producing pictorial matter, it is no wonder that Ballou continued his publishing career with a fiction monthly that had little need for illustrations.

Homer may have sensed by the summer of 1859 that the *Companion* was not likely to survive very long in a field now dominated by the two New York pictorials. He had already become a fairly regular contributor to *Harper's Weekly*. His move to Manhattan that autumn took him not only to the new center of the pictorial press in America but also to the long-established center of the fine arts. He took with him two years of experience in the creation of original woodblock drawings on a broad range of subjects, all relating to the life of his times as he had observed it. He was no longer a fledgling illustrator. Indeed, by age twenty-three he had become one of the nation's leading woodblock artists. He planned, however, to be a painter.

5

The Corpus

A CENTURY FOLLOWING the end of Homer's association with the pictorial press, his illustrations unexpectedly received widespread attention. In the winter and spring of 1975–76, one or more thieves removed thousands of pages containing Homer's printed work from runs of pictorial weeklies housed in public, college, and university libraries nationwide. Each thief took bound volumes of *Harper's Weekly* and other periodicals from open stacks and surreptitiously and systematically removed from them the pages with Homer's illustrations. The operation followed the Foster checklist, probably in its Gelman adaptation. In most cases the thieves used a razor blade to slice out pages, but they seem also to have occasionally used a wet thread to remove the leaf, much as a wire is used to cut a wheel of cheese.

After spiriting the pages from the libraries, the thieves peddled them to unsuspecting dealers who in turn sold them in good faith to private collectors and public collections. Many librarians remained unaware that their serials had been plundered until weeks or months later when reports of the discovery of the loss at other libraries received national newspaper coverage.[1]

The vandalizing of the magazines represented an unhappy episode in the growth of interest in Homer's magazine illustrations. The touring exhibition of 1968–70 had made this aspect of the artist's career better known to a fast-growing population of collectors of Americana. By the mid-1970s the illustrations had became a steadily active commodity at the low end of the art and antiques market. With few exceptions, such as Homer's single illustration for *Hearth and Home,* these were hardly rare items, but the demand for them was quietly persistent. Depending on size, subject, and condition, they sold in the early 1970s for prices ranging from twenty to two hundred dollars.[2] The publicity aroused by the

thefts in 1976 edged the prices higher. A shrinking supply and the general economic inflation of the 1970s moved the prices higher still by the end of the decade.

While the thefts were lamentable, the publicity they aroused sharpened the public's understanding of Homer's activity as a graphic artist. Museums that had long considered the magazine illustrations too minor a component of the artist's *oeuvre* to warrant special exhibition became willing to show generous selections of them. The interpretive materials used in most of these exhibitions offered little, however, concerning the world of the pictorial press in which Homer had worked.

Despite the attention brought to the illustrations by the thefts and exhibitions, certain questions concerning the corpus as a whole remained largely unexamined, at least in the scholarly literature. Among them was a matter that had bothered collectors and dealers since early in the twentieth century. This was the question of Homer's signatures. A signature in the form of "Homer" drawn on the block and engraved as part of the image left no doubt of authorship. But throughout his years as an illustrator Homer sometimes signed with only one or both of his initials. The first generation of collectors, eager to enlarge the count of Homer's works, were tempted to claim for him nearly any work that appeared to contain an *H,* a *WH,* or even an *HW.* But Homer was not the only artist drawing for the pictorials who possessed these initials. In December 1857, *Harper's Weekly* published an impressive double-page spread signed "WH" showing Congress in session, but the drawing style is not in the least like Homer's and there is no reason to believe that he visited Washington at any point in 1857.[3] In some illustrations ligatures made of initials could be read in more than one way, though it sometimes required a little imagination to do so. Even William Thwaite's initials in the early numbers of *Harper's Weekly* have been seen as Homer's.[4]

The chief temptation, however, was to claim for Homer, on the basis of an initialed signature in the block, a work that had in fact been drawn by William J. Hennessy (1839–1917). Homer and Hennessy were acquainted. Both were able illustrators, though their styles differed in important respects. Unlike Homer, Hennessy was at home in imaginative work. In style, he was much less inclined to simplify and eliminate inessential detail. Other differences become apparent as one gains familiarity with Hennessy's work. Appearing occasionally in the same publications (until 1870 when Hennessy emigrated to England), the two men made an effort to use distinctive signatures to avoid confusion. Hennessy often gave special prominence to the *J* of his middle name when he configured his initialed signature.

Having only two initials, Homer sometimes signed with one or both of them when he could count on a printed caption that credited the work to him. Early in his career he sometimes added to his name on the block "del.", short for the Latin *delineavit*—"he drew it." This abbreviation distinguished him from the illustration's engraver, who often added his own signature to the image, sometimes followed with "sc." for *sculpsit*— "he cut it." While working in Boston, Homer usually signed the portraits he adapted from photographs and prints with simple, small-scale initials, a modest signature for a modest task. Later, in the early 1860s, he began to use a bolder elongated *H* when he signed more complex portrait drawings in which he freely adapted a photo rather than copying it. Such a signature is visible, for example, in the likeness of Abraham Lincoln that Homer took from a Mathew Brady photograph in the autumn of 1860 (see figs. 8.6 and 8.7). When he added a quantity of important original elements to a portrait, as he did in the case of the elaborate surround encompassing his visage of Giuseppe Garibaldi (1860, see fig. 8.8), he joined a smaller *W* to the *H*. He did this presumably to claim even more clearly his authorship of part of the image. He signed in the same manner in the case of *The Expulsion of Abolitionists and Negroes from the Tremont Temple* (see fig. 8.10), a work that he seems to have synthesized from sketches made by another person.[5]

There is at least one instance in which Homer appears to have drawn part but not all of an illustration and for that reason omitted a signature. *The Inauguration of Abraham Lincoln as President of the United States* in 1861 (see fig. 8.12) contains figures in the foreground that are in Homer's style but in all probability someone else drew the view of the Capitol in the background. After 1862, Homer's name often appeared in an illustration's caption, but in the pictorial press's constant rush to meet deadlines, captions could be incorrect. This was probably the case with the *Watch Tower* of 1874, a work whose style contains nothing warranting an attribution to Homer, though the *Weekly*'s caption claims it for him.

Some early collectors wondered whether all unsigned Civil War subjects in *Harper's Weekly* credited to a "special artist" might be by Homer. He had indeed served in this capacity for a while, but he was by no means the only illustrator that the magazine designated as "special" during the war. It is difficult to make a persuasive attribution to Homer for any unsigned Civil War illustration that lacks his distinctive drawing style.

Despite the variety and permutations of his signatures, Homer used them logically and consistently. Now and again he also used them whimsically. He did this, for example, in *The Beach at Long Branch* (see fig.

11.7), where a girl uses the tip of her parasol to mark his initials boldly in the sand. A touch of whimsy comes as well from his occasional inclusion in illustrations of what seems to be a self-portrait, as in *Thanksgiving Day—The Dinner* (see fig. 7.10), *A Parisian Ball—Dancing at the Casino* (see fig. 10.2), and *The Picnic Excursion* (see fig. 11.6). It seems idle to assign deep significance to details that appear to suggest little more than an artist involved in good-natured play with friends and family.

As the portraits he drew for the weeklies attest, he was highly competent in face drawing. But until his very last works, few of the faces he drew in his original subjects displayed much expression. Some are crudely rendered. In this regard he was always dependent on his engravers' ability to capture whatever expressive nuances he might draw on a face on the block. Until the 1870s, even the best of those engravers were hard-pressed in conditions of team cutting and inflexible deadlines to achieve much more than a quick but serviceable approximation of facial features. Engravers dealt in outline, bold detail, and coarse shading. For Homer to have drawn faces with greater subtlety in expectation of a finer elucidation of facial expression by engravers would have been wasted effort. Only late in his career did he receive the quality of engraving needed for crucially important facial details.

These two concerns—Homer's signatures, or lack thereof, and his treatment of faces—come together in the case of an illustration of uncommon interest published in *Harper's Weekly* for February 13, 1858: *The First Valentine* (fig. 5.1).[6] It is a work of great charm, unsigned but from

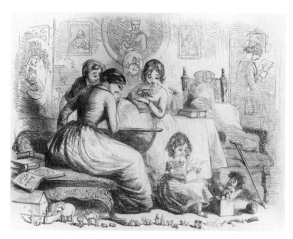

5.1. Unknown artist, *The First Valentine*. *HW,*
February 13, 1858. American Antiquarian Society.

the hand of an unusually able illustrator. There are reasons to claim it for Homer and reasons to deny it to him; it is omitted from the present study's checklist. The illustration is one of seven in a two-page feature concerning the history and present-day observances of Valentine's Day. The other six illustrations are the work of Frank Bellew, signed with his hallmark squat triangle. Routine in concept and detailing, these six are far from Bellew's best. *The First Valentine* is slightly larger in scale than Bellew's signed pieces and considerably larger in concept. It is better drawn. Its figures are more characterful, its bountiful details full of interest.

The image depicts a mother and two older children—a boy and girl—who watch a younger girl who is fascinated by a just-opened valentine greeting. Across the front of the scene a line of paired toy animals approaches a miniature Noah's Ark. A popped-open Jack-in-the-Box eyes the girl's valentine. Books are piled about. The globe around which the mother and her two older children gather offers an explanation for the absence of the father—he is away on business in distant lands. A cane rests against a vacant, heavily cushioned chair to suggest the nearness of a grandparent. In the next room a woman standing with a broom—the maid?—smiles at her own valentine. Among the rich array of furnishings in this well-to-do middle-class interior a vase of flowers on the table and the affectionate subjects in the pictures on the wall and screen reinforce the happy mood.

Much of the drawing seems to be in Homer's distinctive style—the woman's head, the older girl, the woman in the next room, the furnishings. The figures are better modeled than Bellew's. The play of light and dark is more effective and the illusion of space more convincing. The subtle humor of the animals and especially the popped-up Jack seem distinctly Homer-ish. The illustration's largeness of concept, its naturalism, its vitality of execution, all have counterparts in other of his illustrations, but not to this extent as early as February 1858. The level of artistic maturity evident in *The First Valentine* arrived later for Homer, not much before late 1859 and his *Fall Games—The Apple-Bee* (see fig. 7.21). The illustration is engraved with much greater aplomb than Bellew's work and that of most other artists in the *Weekly*. The art editor as well as the engraver clearly enough saw special merit in this woodblock drawing.

The question arises as to why the artist, whoever it was, did not sign the work. A possible answer lies in the fact that the printed image is narrower than the expected four-column width. Centered at the bottom of the page, it fills only about 90 percent of its allotted space. The right edge of the image ends relatively abruptly. It is within the realm of possibility that a vertical strip of the drawn image needed to be deleted, perhaps

owing to a mishap at a late stage in the engraving of the block's surface. A signature on that strip would have been lost. Such an explanation deserves at least brief consideration when a graphic work of such appeal as this is involved.

If Homer did not draw the illustration, who did? In early 1858, the *Weekly*'s small stable of freelance artists included only three or four capable of interesting original work. Bellew's forte was low humor—he had little feeling for subjects of this sort. Augustus Hoppin (1828–1896) often depicted moments of domestic and social pleasure, and did so with great charm.[7] A better draftsman than Bellew, he might be a stronger candidate for the authorship of *The First Valentine* were it not for the masterful handling of figures in space and the solidity of all the objects shown in the image. Hoppin's style was one of more delicate line and lightness of tone in both graphic execution and characterization. Like Bellew, the sensibilities of John McLenan (1827–1866) did not run to this kind of domestic subject, nor did he draw quite this well. McLenan, Hoppin, and Bellew were less able draftsmen than the adept Felix O. C. Darley (1822–1888). Darley had a superior talent for managing the kind of complexities of space, emotion, and allusion that are so evident in this illustration, but at every level the style seems not to be his. It is possible, of course, that an artist outside the *Weekly*'s regular contributors drew *The First Valentine* and that he appeared in the magazine's pages only with this work. In any event, despite intimations of Homer's style in the drawing, the arguments for his authorship seem insufficient to attribute this impressive illustration to him with confidence.

Homer's style was distinctive. He worked to develop an original voice, attained it early, and enriched it—even transformed it—as his career progressed. His strong instinct for independence kept him from emulating others. While he looked at the work of able illustrators here and abroad, his response to it was chiefly to avoid emulating it. The artistic persona created in his woodblock drawings of the late 1850s grew in the 1860s and 1870s in unplanned directions and it did so richly, organically, and always interestingly.

Homer achieved this distinctive style in an arena of art that must at times have been dispiriting. His woodblock drawings appeared in magazines whose general level of illustration was one of deadening sameness. He resisted sinking to that level. In any perusal of the *Companion*, Homer's early illustrations stand out from their neighbors. Their energy lifts them from the dross of the norm. As Lloyd Goodrich noted in 1944 about Homer's work in relation to that of other American woodblock

artists, his "observation was fresher . . . [his] draughtsmanship abler. Crudities there might be, but never softness or vagueness; everything was precise. . . . From the first there was a sense of movement, an energy that made other illustrators seem tame."[8] In 1986 the literary critic Hugh Kenner observed that "Homer liked the look of something impending or doing. . . . His early illustrator's discipline did underlie his greatness: always the moment of action."[9]

There was an intellectual difference as well, evident especially in the inventiveness of Homer's variations on themes, and in the overarching conceptualizations that unify his sequences on the life of the streets and on play, and later on children in the natural world. Subtle allusions abound. But his intellect was visual and not literary. Much of what makes Homer's illustrations work is close to ineffable.

Still, Homer's mental energy was inconsistent from work to work. There are too many underdeveloped or insubstantial illustrations to claim greatness for the entire body of work, too many moments in which admirable freshness of concept is undermined by carelessness of execution. The exceptional promise of many of his early works requires a tolerance of a certain immaturity in drawing. The rather banal concept of *Bathing at Long Branch—"Oh, Ain't It Cold"* and the awkward imposition of figures into the foreground of *Making Hay* (to mention but two of the less than fully successful illustrations of Homer's maturity) require a tolerance of a different kind. They reflect the conditions of commercial expediency under which the works were created. But the strengths within this body of work far outweigh the occasional weaknesses, and they are strengths that occur steadily throughout the corpus. The chapters that follow focus on these strengths in their considerable variety while considering also the circumstances that kept Homer from attaining them consistently.

PART TWO: *The Illustrations*

6

City and Country

1857

IN JUNE through December 1857, his first half-year of drawing for the *Companion,* Homer produced a sequence of five views of the life of Boston's streets. Toward the end of this period, he also drew a contrasting set of four subjects concerning children and adults at play that included a particularly robust scene of country life. Scarcely anything published earlier in the American pictorial press had quite approached the originality of concept or flair of execution that Homer displayed in these contrasting illustrations of urban and rustic life. During the same period he drew half a dozen portraits for the magazine and made his first appearance in *Harper's Weekly,* but his depictions of Boston's streets and of rural revels in the city's exurbia take pride of place among his earliest works.

These illustrations show in a formative stage qualities of design that later distinguished him as a painter: linear energy, a command of structural form, a play of rhythms, and an unerring sense of what was essential in a subject. The illustrations also display a cheerful verve emanating from a youthful vision of the world, a kind of innocence that had all but vanished by the time he began to exhibit paintings.

As these illustrations attest, from the start he was an unusually observant artist-reporter. Even his earliest illustrations carry the authority of an eyewitness account, though he synthesized most of them from things seen at various times and in different places. He possessed a precocious sophistication in matters of composition. His uses of light and shade served with great effectiveness to model figures, create mood, and direct the eye.

There is no certain explanation of how and when he had learned to

do these things so well. His time at Bufford's had surely played a part, as had, in all likelihood, his mother's tutelage, the study of art instruction manuals, the example of illustrations in English and Continental pictorial weeklies, and advice from Damoreau and perhaps others. Beyond these influences, and of utmost importance, his intuition was razor-sharp. He seems always to have trusted it over instruction. The flashes of wit that brighten many of his early subjects seem wholly natural—instinctive rather than learned. While these works also contain a few uninteresting figures and passages of awkward drawing—fewer as the months passed—on balance his work of June through December 1857 constituted an auspicious beginning. His confidence was unmistakable: the five street scenes differ in so many ways—composition, mood, activity—as to leave no doubt that he meant them as variations on a theme and as a display of virtuosity.

Nothing quite like them had appeared in the *Illustrated London News*. That journal paid little attention to life in London other than ceremonial processions, the opening of stately new buildings, or other events with scarcely any connection to ordinary life. Led by the *Companion,* the pictorial press in the United States differed from its British cousin in its emphasis on typical experience within American democratic culture. Homer seems naturally to have chosen to illustrate the life that he knew, and rarely anything else. This choice was true of his paintings as well as his illustrations.

He was in a sense the first artist of note in America to take a serious interest in the wholesome life of the streets. Painters of American life had very largely avoided urban subjects of this kind. Although they maintained their studios in cities, chiefly New York, their sensibilities as well as their knowledge of the tastes of American collectors took them to the countryside and sometimes into the wilderness in search of essences of national culture. Even portrait painters rarely found reason to set their subjects in outdoor urban spaces. A prevailing view in the fine arts held that American cities lacked aesthetic interest. No visitor to Paris, Rome, or Venice in the 1850s would have argued the point. When Homer became a painter he, too, ignored the city as a subject, even as he continued to make use of it in woodblock drawings for the pictorial press.

But while the life of city streets had held no interest for American painters, it had attracted a few American printmakers and book illustrators. Some drew finely rendered lithographic views of a city's places of business or architecturally most notable streets, as Philip Harry had in Boston in 1843.[1] But other graphic artists tended to depict people rather

than settings, and they often did so humorously. D. C. Johnston, for instance, did this in the etched vignettes that made up his *Scraps,* self-published in Boston between the late 1820s and late 1840s.[2] In this series he treated Boston's street life comically and even farcically, but with scant attention to the built environment. Now and then he included a distant view of the Massachusetts State House or some other well-known edifice to provide a sense of locality.

Because the broadness of Jacksonian humor had fallen out of favor in polite society by the 1850s, woodblock artists directed amusing vignettes of this sort to comic weeklies such as *Vanity Fair, Yankee Notions,* and the *Carpet-Bag.*[3] In the late 1850s when comic drawings occasionally found their way into the sober-toned pages of the *Companion* and *Harper's Weekly,* their humor was of the tamest sort.

The pictorial press sought more objective, less theatrical city subjects. To achieve this end, their woodblock artists reversed the approach of the comic artists by depicting the urban environment with meticulous care while treating the life of the streets prosaically, if at all. They presented views of civic buildings, public squares, places of business, churches, fine homes, major thoroughfares, and parks, but they rarely attempted anything more than to document the appearances of such places. They placed nondescript figures in the middle ground to establish scale, but barely suggested the flux of people and events that vitalize urban life. Champney's *Corner of Washington and Boylston Streets, the Old Boylston Market,* published early in 1857, is peopled with inert, badly drawn figures scattered about an ill-composed setting.[4]

Barry, Rowse, Warren, Alfred and William Waud, and others also drew subjects of this sort for the *Companion,* sometimes with greater skill than Champney owned at the start of his career. The magazine accompanied their views with descriptive commentaries meant to add interest to the stolid images. It was a challenging task, for their artists typically failed to individualize figures, establish associations among them, relate them to their setting, or provide the scene with any effective indication of the passage of time and events. The figures stand as mannequins marooned in front of one or another of Boston's well-known buildings or well-traveled streets.

Two things impeded most of these woodblock artists in any aspirations they may have had to enlarge the role of human activity in their urban subjects. One was their limited proficiency in figure drawing. Billings in Boston and Darley, Hoppin, McLenan, and a few others in New York were competent figure artists, but most of their colleagues

were not. By the end of the first year of his career as a woodblock artist, Homer's not yet mature ability to vivify figures outshone that of most of his colleagues. The other impediment was a lack of feeling for the dramatic moment. All but Billings, Darley, Hoppin, and a very few others were unable to invent, organize, and depict events in any of the ways that could bring a scene to life and connect it vitally to a magazine's readers. Homer was able to do this effortlessly from the outset. The others tended to produce urban topography with *staffage,* views more about places than people.[5] Homer shifted the emphasis of such views to the people.

But he was also at least as skillful as the others in depicting the built environment. Indeed, the backgrounds of his Boston scenes nearly always offered more visual interest than did those of his fellow illustrators. In constructing a street view he typically included a corner of a building as a key background element. The corner provided a recession of space with contrasts of light and shade while it also suggested the continuity of activities in unseen places. He brought figures into the foreground, varied their types, and involved them in bits of anecdote, while keeping the background similarly varied and interesting to the eye. He drew figures that were either very much like the *Companion*'s middle-class readership or very much unlike it, as when he depicted the arrival of a group of immigrants from Ireland. In composition as well as anecdote, he related his figures to their settings naturalistically. His early street scenes transformed the *Companion*'s practice of publishing still views of familiar places—*vedute*—into one of presenting animated scenes of everyday life—*genre.*

The first of Homer's early urban subjects, *The Corner of Winter, Washington and Summer Streets, Boston* (*BP,* June 13, 1857, fig. 6.1), published in the *Companion* for June 13, brims with activity.[6] A coach races through the intersection, headed toward Winter Street and the Ballou building—and toward the viewer as well. A policeman with a badge of authority shining on his coat lunges out to slow the wild-eyed team of horses. An alarmed young woman rushes from its path. Because she is the only unaccompanied female in the picture—the other women walk in pairs or with men—her narrow escape may be taken as a cautionary tale. It underscores her era's reproving attitude toward the venturing out alone of any respectable female. Three figures at right represent varieties of response to the oncoming coach. A boy protectively holds his mother back from the street; she reaches down to keep him safe; an older woman close behind her, perhaps the boy's grandmother, raises her hands in astonishment.

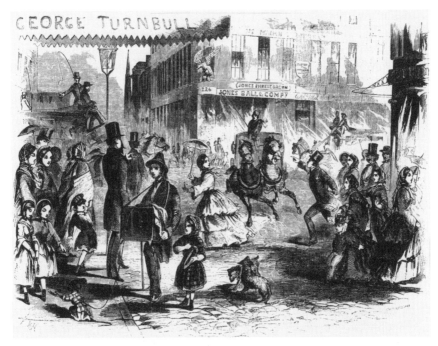

6.1. *Corner of Winter, Washington and Summer Streets, Boston,* 7 x 9³/₈ in.
BP, June 13, 1857. Private collection

The two dogs on the pavement at lower center are in harm's way and
will scoot to safety, but at present they serve Homer's design by anchor-
ing the two main diagonals that open the center of the composition to the
onrushing horses. One axis of that inverted triangle runs from the coach-
men at upper left through the heads of three key dark-toned figures to the
back of the dog closest to the foreground. The other axis runs from the
coachmen at upper right through the policeman's hat to the dogs. Homer
needed a strong structure to impose order on the quantity of competing
details that he loaded into this composition. There are too many centers
of interest, but much of the detail, ranging from the organ grinder with
his little girl and monkey to the lettering on the awnings and storefronts,
rewards inspection. In the street scenes that followed, Homer gradually
reduced the number of salient elements.

Even in this earliest of his original works Homer structured his com-
position with rebatements. He would use this elementary means of or-
ganizing a design often for the rest of his career, and he would do so in
watercolors and oils as well as in graphic works. It amounted to placing
a strong vertical component at a point along the work's horizontal di-

mension that corresponded to the work's height. In *Corner of Winter, Washington and Summer,* Homer located the policeman at a distance from the left margin equivalent to the illustration's height. The rebatement from the right margin falls directly between the organ grinder and the tall, well-dressed man to his right, an important point separating the men by social class and activity. Homer gave emphasis to these rebated figures through size, tone, and activity. Once these components were in place, he moved to more complex matters of composition. Unconsciously, most viewers find that the rebated design eases and strengthens their comprehension of the design. It seems "right."

The four street scenes that appeared in September, October, and November differed from his first not only in structure but also in location, mood, and content. They leave little doubt that Homer meant them as a display of his skill in devising variations on a subject. *A Boston Watering Cart* (*BP,* September 12, fig. 6.2) replaces the momentary melodrama of a recklessly speeding coach with the slow progress of a novel piece of street-cleaning apparatus designed to keep down the granite dust worn from paving stones by horseshoes and iron-rimmed wagon wheels. In placing the cart's cylindrical tank in front of the tall, triple-arched facade

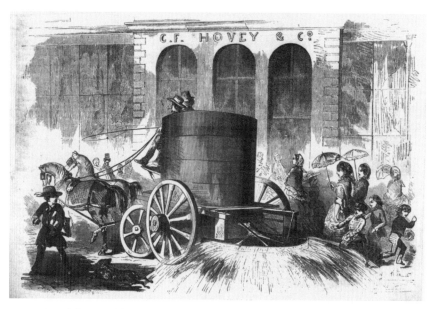

6.2. *A Boston Watering-Cart,* 6³/₈ x 9¹/₂ in. *BP,* September 12, 1857.
Private collection.

of C. T. Hovey's Summer Street store, Homer contrasts round against flat and dark against light. A running dog, lively children, and splashing water relieve the solidity of the architecture and the ponderous cart. The woman walking just beyond one of the cart's rear wheels is at a point of rebatement.

Having used the Hovey building to confine pictorial space in his *Watering Cart,* Homer opened up that space in his *View in South Market Street, Boston (BP,* October 3, fig. 6.3). The location shifts to the more spacious roadway next to the Quincy Market building and offers a vista westward past Washington Street toward Brattle Square. Market men sell the autumn's bounty from carts outside their storage cellars. Shoppers crowd into this space, much as they have ever since. Just beyond appears Faneuil Hall, the older market building whose second level housed Boston's already historic civic meeting room. Homer contrasts children and adults as before, but now, for the first time, he also divides figures by class and ethnicity. Among an extensive array of baskets and produce, a well-dressed middle-class couple buys from a vendor in country clothes. Like his colleague at center, he wears a ribbon-bedecked straw hat. At

6.3. *View in South Market Street, Boston,* 6⁷/₁₆ x 9¹/₂ in. *BP,* October 3, 1857. Syracuse University Art Collection.

right a pipe-smoking Irishman (so identified by his cloth hat) wears coarser clothing. The casual array of those around him, probably members of his family, contrasts benignly with the arm-in-arm closeness of the couple at left.

A few weeks later, Homer returned to the Irish in his *Emigrant Arrival at Constitution Wharf, Boston* (*BP*, October 31, fig. 6.4). Set on a dockside just off Commercial Street in Boston's North End, the space in this work has a background of marine architecture rather than buildings. The setting is home to a bounty of human warmth of a kind unseen in Homer's earlier public spaces. Figures embrace; emotion runs high in the central group. The calmer figures at left and right function in the composition to gently contain this outburst of joy. The *Companion*'s accompanying commentary observes that "a married woman who has long since left 'ould Ireland' and become Americanized, as her costume shows, rushes forward to greet her old mother." Almost certainly written after Homer had turned in his preliminary sketch, the comment may have emerged from a conversation between writer and artist, or, more probably, it was simply the writer's gloss on what he or she saw in the drawing. The figures are stereotypical but respectfully so. They have little in common with the disparaging caricatures of the post-famine Irish that had already begun to appear in other publications and that would within a few

6.4. *Emigrant Arrival at Constitution Wharf, Boston*, 5³/₈ x 9⁵/₁₆ in. *BP*, October 31, 1857. Syracuse University Art Collection.

years be prominent in Thomas Nast's malignantly anti-Irish, anti-Catholic illustrations for *Harper's Weekly.*[7]

In *Boston Evening Street Scene, at the Corner of Court and Brattle Streets* (*BP,* November 7, fig. 6.5), Homer shifts to the early darkness of an autumn evening. A man with his wife and daughter passes a woman who at first glance seems to be unaccompanied, but a closer look shows her to be catching up with her husband. He stands by the scene's central attraction, a great telescope. The *Companion* noted that "a group is collected round one of Alvan Clark's fine telescopes . . . gazing at [the] moon." It added concerning the background figure to the right of this group that "on the sidewalk of Brattle Street is one of those pulling machines which measures a man's strength to a fraction." A newsboy hawks an evening newspaper. In the distance on Tremont Row a building housing J. A. Cutting's photographic studio sports a sunburst sign at the edge of its roof, a much-used emblem of a daguerreotypist or, in Cutting's case, an ambrotypist. A colossal effigy of a camera hangs on the building's front amid grand-scale painted copies of portrait photographs. These images lean out from the facade at angles for ease in viewing from

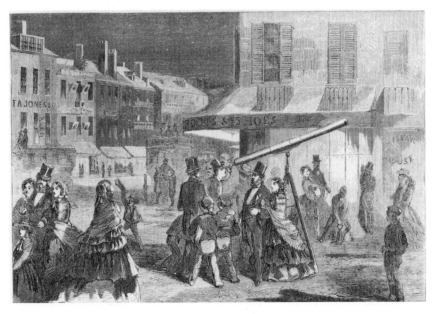

6.5. *Boston Evening Street Scene, at the Corner of Court and Brattle Streets,*
6³/₈ x 9³/₈ in. *BP,* November 7, 1857. Syracuse University Art Collection.

below. In such details, as well as in the recession of space, the arrange-
ments of light and shade throughout the design, and the interestingly var-
ied figures (all much more restrained than those depicted on Constitution
Wharf a week earlier), this was Homer's richest illustration yet.

Four of these five street scenes concern places within a few minutes'
walk of each other in the business center of Boston. None was far from
the Ballou building. The more distant Constitution Wharf was a fifteen-
minute stroll from Winter Street. Four of the scenes give such prominence
to merchants' signs on storefronts and awnings that it is easy to wonder
whether the *Companion* encouraged Homer to render trade signs legibly
for merchants and tradesmen who patronized the magazine. The signs
are sometimes so prominent that they amount to advertisements. They
echo a long-established practice among Boston job lithographers, as can
be seen, for example, in *Adams House,* a lithograph of buildings on
Washington produced by Sharp, Peirce and Company about 1847.[8]

Such details aside, the five illustrations leave no doubt that Homer
was keenly interested in the formal qualities of pictorial construction.
They show too his disinclination, even at this early point, to spell out
fully the meanings and significances of what he drew. Rather than telling
easily comprehended pictorial stories, he offered genre subjects touched
with quiet ambiguities that encouraged viewers to look actively into
what he had drawn to find their own resonances.

The *Companion* confirmed Homer's rapid rise as an illustrator by pub-
lishing in a single issue in late November a set of four illustrations with
accompanying text on two facing pages. The general subject concerned
the physical sensations of play, though the author of the text did not de-
scribe it these terms. The text claimed that the subject was Thanksgiving.

Of Homer's four images, the two smallest in scale depict rambunc-
tious moments of physical sensation in childhood. In *Blind Man's Buff*
(*BP*, November 28, 1857), boys and girls tumble over each other as they
scramble away from their blindfolded friend. In *Coasting Out of Doors*
(*BP*, November 28, 1857), boys on sleds race down a snow-covered
slope, most of them spilling. In the larger *Family Party Playing at Fox
and Geese* (*BP*, November 28, 1857, fig. 6.6), a group of momentarily
paired-off young men and women—some only adolescents—engage in a
popular parlor game. Their glances and touches (or lack thereof), all del-
icately rendered by Homer, make it clear that this play is more complex
and less innocent than children's games, that the sensations of the mo-

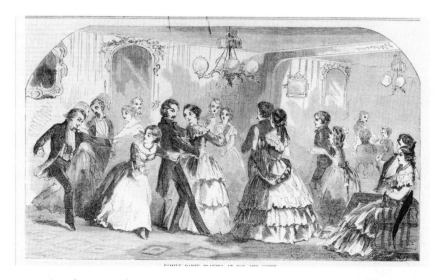

6.6. *Family Party Playing at Fox and Geese,* 5³⁄₈ x 9³⁄₈ in. *BP,* November 28, 1857. Mary and Mavis P. Kelsey Collection, Cushing Memorial Library and Archives, Texas A&M University.

ment are more subtle and refined. Chaperones seated at a card table offer a contrast of age to this otherwise youthful assembly. The attire and manners on display in the elegantly appointed room suggest an event in a good house on Beacon Hill, or perhaps in Homer's own Cambridge.

The fourth and largest image in the set, *Husking Party Finding the Red Ears* (*BP,* November 28, 1857, fig. 6.7), jettisons the subtleties of urban middle-class propriety for an earthier level of rustic play. The *Companion*'s commentary points out that a husking bee is "purely an American institution" and then explains that "the privilege attached to finding a 'red ear' is a kiss from the nearest damsel, and though the right is always contested, it is never abandoned. In the group before us several fortunate gentlemen are insisting on their rights and a merry struggle is going on between them and their partners." This distanced account hardly suffices to prepare the viewer for what Homer has drawn.

In the thrusting diagonals of the main figures, with no two axes in quite the same direction, and in the vivid contrasts of light and shade, Homer sets in motion a scene of barely restrained amorous play. At lower left a group of young men and women shuck corn. A smile brightens the face of the fellow who, having just found a red ear, is now entitled to a kiss. He directs his phallus-like find toward the young woman across

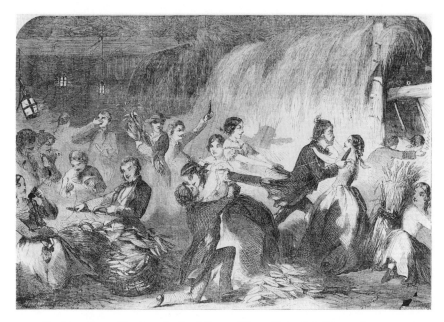

6.7. *Husking Party Finding the Red Ears*, 6³/₈ x 9³/₈ in. *BP,* November 28, 1857. Mary and Mavis P. Kelsey Collection, Cushing Memorial Library and Archives, Texas A&M University.

from him. Behind them, a woman smacks the face of a man, not because she is unwilling to be kissed but rather because the ear in his hand is not red. Standing next to them, and serving as a Ceres-like allegory of the harvest, a woman holds a shock of corn in her arms. To her left a mustachioed figure raises his red ear on high while looking intently at a nearby woman, though her attention is elsewhere.

In the foreground, a kneeling young man gets his kiss, but the girl whom he embraces has other things in mind. She reaches behind herself to hold onto one of the coattails of an ardent chap who, brilliantly silhouetted and with red ear in hand, embraces a beamingly willing young woman. He is a popular fellow; his other coattail is in the hands of yet another woman. A figure at far right races after a kiss as his choice flees into a distant corner of the great barn. At lower right a younger girl crouches by a sheaf of grain. She half turns away from these lusty eruptions but, transfixed by what she sees, hesitates to leave. It is as though she has been transported from the innocent world of Blind Man's Buff to the erotically charged realm of adult experience, and finds the change beyond her comprehension.

There had been no real precedence in American painting for Homer's street scenes, but rural frolics had appeared on canvas as early as the 1830s when, for example, William Sidney Mount painted *Rustic Dance After a Sleigh Ride* (Museum of Fine Arts, Boston). Yet nothing in Mount's work, or in that of the few other painters who undertook such subjects, approached the unbridled energy and libidinous currents of Homer's scene. Distant forebears of all these works can be found in Netherlandish paintings of peasants and boors in festive settings, but in both Mount's paintings and Homer's illustrations of country life, the figures are certainly not peasants. As their dress shows, Homer's country folk are the prospering cousins of his city dwellers, the exurbanite edge of the American middle class. Shedding their smocks, overalls, and housedresses, they have donned their Sunday best for this occasion. Homer had undoubtedly observed social gatherings of this kind in one or more rural communities outside Boston, perhaps near his relatives in Belmont.

Having titled this set of illustrations "Thanksgiving in New England" even though none of the four deals directly with that holiday, the *Companion* felt obliged to justify so much attention to play in what Homer had drawn. It observed that "with all the gravity of New England character there mingles much of humor and an undercurrent of mirthfulness. . . . There are times and seasons when it becomes suddenly demonstrative."[9] But this not quite what Homer illustrated. He had in fact devised four contrasting images that differentiate sensual play in three stages of life: childhood, adolescence, and young adulthood. Then in two subjects he further distinguished between the pleasures of urban propriety and those of rustic ribaldry. He drew sensual behavior contained in one case and unbuttoned in the other. He was a product of the urban middle-class society, but his treatment of the husking scene suggests that even at this early stage he had an affinity for rusticity.

Nothing so openly erotic as his *Husking Party* had ever before appeared in the pages of the *Companion*. It is easy to wonder whether the magazine's editors might not have harbored reservations about printing an illustration whose recurrent phallic imagery and displays of bawdy behavior, by women as well as men, must have raised at least a few eyebrows among readers. But the next year Homer returned to this subject in the *Companion* with undiminished vigor (see fig. 7.8), and then in 1859 he treated a similar subject—an apple bee—with somewhat greater reserve in *Harper's Weekly* (see fig.7.21).

It is easy to find an inventive mind and masterful skills of design in these early illustrations of town and country, but it is less easy to find satisfactory figure drawing. Homer's foreshortening was approximate

rather than exact, and his modeling of rounded shapes was suggestive rather than wholly persuasive. He conveyed the exterior appearances of a clothed figure without giving a convincing sense of the kinetic properties of the body within. He was at this point a highly gifted, largely self-taught graphic artist who was still learning, and learning rapidly. Even at this beginning stage he had few peers in the American pictorial press. The verve and inventiveness of his sharply observed subjects easily outbalanced the rough edges of their rendering. When the *Companion* referred to him as a "promising young artist," it undoubtedly hoped that its readers would appreciate his already evident strengths and not fret about his relatively minor shortcomings.[10]

7

Boston to New York

1858–1859

DURING THE first half of 1858, the *Companion* bought fewer of Homer's drawings. It had began to cut corners as it lost subscribers to *Harper's Weekly*. It trimmed further when the Panic of 1857 lingered and left businesses and families alike short of cash for the next two years. Nothing by Homer appeared in the magazine in January, February, or most of March 1858. Then, in the number for March 27 came another of his street scenes, *The "Cold Term," Boston—Scene, Corner of Milk and Washington Streets* (*BP*, March 27, 1858, fig. 7.1). This work's dry humor comes from graphic means; to suggest the severe cold Homer withheld the passages of crosshatching that imply warmth, leaving chilly expanses of white. Not until July did another original subject appear, *Class Day, at Harvard University, Cambridge, Mass.* (*BP*, July 3, 1858), in which graduating seniors race hand-in-hand around trees in Harvard Yard.

In August the *Companion* made up for its lack of patronage by publishing on facing pages a set of four closely related illustrations, all of the same size. The set carried the general title *Camp Meeting Sketches* and consisted of scenes from a week-long religious revival held earlier in the month at Millennial Grove near Eastham on Cape Cod. The first of the four, *Landing at the Cape* (*BP*, August 21, 1858, fig. 7.2), is the richest in design and realization of detail. A party of travelers who have come to the site by boat transfer to the covered, horse-drawn wagons that will carry them through the shallow water to shore. In the last of the four, *The Tent* (*BP*, August 21, 1858, fig. 7.3, Homer includes himself at left drawing a scene described in the accompanying commentary as one in which "under the lead of a distinguished preacher . . . men and women become

7.1. *The "Cold Term," Boston—Scene, Corner of Milk and Washington Streets,*
6⁷/₈ x 9³/₈ in. *BP*, March 27, 1858. Syracuse University Art Collection.

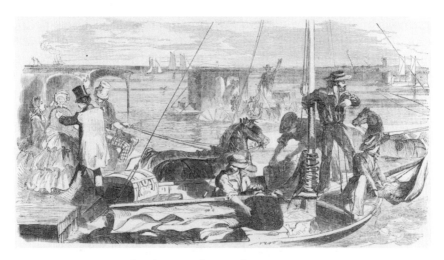

7.2. *Camp Meeting Sketches: Landing at the Cape,* 5 x 9³/₈ in. *BP*, August 21,
1858. Syracuse University Art Collection.

7.3. *Camp Meeting Sketches: The Tent,* 5 x 9³/₈ in. *BP,* August 21, 1858.
American Antiquarian Society.

powerfully agitated and convulsed. . .") The circumstances that took
Homer to the meeting are unknown. In later life he remained aloof from
organized religion. Even in this self-portrayal he stands as an outsider
who objectively records the outward appearances of passionately ex-
pressed spiritual revelation.

During the time when the *Companion* had bought few of his
sketches, *Harper's Weekly* had begun to publish his work with some reg-
ularity. He had made a first appearance in the *Weekly* eight months ear-
lier, but this had been a false start of sorts. A more regular association
with the New York magazine began in April 1858 and continued off and
on until 1875.

Harper's Weekly, A Journal of Civilization, first appeared on January
3, 1857. It was the creation of Fletcher Harper, one of the four siblings
whose publishing firm, Harper & Brothers, stood among the largest and
most successful in the world. In 1850 the firm had established a literary
journal, *Harper's Monthly Magazine,* that prospered greatly. In his new
Weekly, Harper was initially reluctant to exploit the art of illustration
fully. He may have wanted to differentiate his publication from the *Com-
panion* and *Frank Leslie's Illustrated Newspaper* with their wealth of
pictures, but it is just as likely that at this point he simply followed what
he knew best—securing and promoting a broad range of literary genres.
He was, in any event, in his early fifties when he established his *Weekly,*
and less attracted to adventurous innovation than had been the case with

the young men who had brought forth the first pictorials. Indeed, for the next two decades the pictorial press in America would be in the hands of large, well-established publishing houses, and would be rather more conservative as a result.

Over the years Harper & Brothers had published thousands of relatively small-scale wood-engraved illustrations, but the firm had concentrated so thoroughly on its literary publications that it had come to treat the art of illustration almost routinely—its *Illuminated Bible* of 1843–46 had been a grand exception.[1] In its early numbers the *Weekly* was more a journal of news, literature, and current events than one that emphasized pictorial communication. The first number had no pictorial matter on its front page other than a title piece emblematic of the arts and sciences. The few illustrations on the inside pages were small in size, octavo or often less, as though they had been designed for use in smallish books.

Only in April 1857, after three months of publication, did the magazine's pictorial matter begin to increase in size and quantity. Even so, it remained for the most part undistinguished in execution and uninteresting in subject compared to its rivals. Not until May 30 did the front page carry an original illustration, one of modest size. After six months of publication, on June 20, an illustration came for the first time to occupy the entire front page beneath the pictorial banner. This was a portrait of Prince Frederick William of Prussia and Victoria, Princess Royal of England, who had married in January. By July the *Weekly* at last began to contain illustrations that in kind, number, and size finally brought it into the mainstream of the pictorial press.

A notice published on the first page of the *Weekly* for May 2, 1857, documents the impetus for this change of course regarding illustration. It read: "*Harper's Weekly* has already reached a regular issue of more than sixty thousand copies. . . . The proprietors beg for to say that they will be happy to receive sketches or photographic pictures of striking scenes, important events, and leading men from artists in every part of the world, and to pay liberally for such as they may use." This call ran in every number of the magazine for the next several weeks. By July the *Weekly*'s pages had begun to include original work by able artists including Hoppin, Bellew, and Thwaites. Having at first seen no need for original illustration by notable woodblock artists, Harper was now determined to take those artists away from Ballou and Leslie and to make his publication the exemplar of American pictorial weeklies. In this attempt he largely succeeded.

Probably in response to the *Weekly*'s notice, Homer at some point between late spring and early summer 1857 had submitted a set of

sketches concerning student life at Harvard University. The magazine accepted five images. They reached publication on facing pages in August (*HW,* August 1, 1857). The largest, titled *The Match Between Sophs and Freshmen—The Opening,* boldly signed "W. Homer" (fig. 7.4), depicts the start of a game of football (that is, soccer). It spans the upper third of the two-page opening. Below it are four vignettes of indoor student life: *Freshmen; Sophs; Juniors;* and *Seniors.* These vignettes are emblematic of the not very original notion that a student passes from industry to idleness in the course of four years at college. Homer may have known the treatment of this subject in lithography by the Harvard student John Noyes Mead, published in Boston in 1849.[2]

A slender strip of commentary, "College Life in New England," spreads across Homer's two pages and continues overleaf, but makes only passing mention of the illustrations. In its commentaries the *Weekly* rarely followed the *Companion*'s practice of identifying an artist and chatting about some aspect of what he had drawn. Nevertheless, this grand display of Homer's work in a pictorial weekly that only a few weeks earlier had announced that it would pay serious attention to the art of illustration was a momentous occasion for an artist still little known outside Boston.

It is curious, then, that nothing else by Homer appeared in the pages of the *Weekly* for eight months. He may, of course, have submitted his Harvard sketches to the *Weekly* as early as May 1857, when the magazine first issued its call for pictorial matter and before he had made his debut in the *Companion.* After that appearance, the Boston journal may have discouraged him from sending further work to its New York competitor. In these years Homer would, in any event, have found it more convenient to draw on blocks near home in Boston than in distant New York. Because the drawing style in the college life set is unmistakably Homer's, there is

7.4. *The Match Between Sophs and Freshmen—The Opening,* 5 1/2 x 20 1/4 1/4 in. *HW,* August 1, 1857. Private collection.

no question that he put these illustrations on the block himself. That required a trip to New York or, less likely, the shipment of blocks to Boston.

An elaborated pencil and wash drawing of another college football subject, dated 1858, exists (private collection), this time with the game in progress in front of a large and responsive group of onlookers.[3] Homer may have meant this richly composed work for the pages of either the *Companion* or the *Weekly* as a seasonal follow-up to his 1857 football subject. But if he offered it, neither magazine found room for the subject. Homer could easily have depicted other aspects of student life at Harvard, for since childhood he had resided near the university. His brother Charles, older by two years, had attended the university's Lawrence Scientific School from 1850 to 1853 and again from 1854 to 1857, receiving a Bachelor of Science degree *summa cum laude* in 1855 and then engaging in graduate studies.[4]

After April 1858, Homer sold drawings to both the *Weekly* and the *Companion* until the latter closed at the end of 1859. His work rarely reached publication on any regular schedule. The drawings he sold to the *Weekly* in 1858 and 1859 while he still resided in Belmont often appeared in groups. This pattern suggests that now and again he took the train from Boston to New York with a portfolio of sketches and stayed long enough to make final drawings on the block for subjects the magazine bought. His work for the *Weekly* in these years was essentially that of a Boston correspondent.

His *Spring in the City,* (HW, April 17, 1858, fig. 7.5), set in Boston according to the *Weekly*'s accompanying text, extended his sequence of street scenes. He arrayed figures across the foreground's relatively shallow space, somewhat in the manner of a fashion plate. This display of slow-moving sartorial elegance contains, however, things foreign to such plates, including a shabbily attired flower girl, a newsboy who runs with copies of *Harper's Weekly* under his arm, and two dogs engaged in a chase. More than other illustrators, Homer added canine details of this sort to several of his early illustrations, gaining homey interest while balancing his composition.

A month later, *The Boston Common* (HW, May 22, 1858, fig. 7.6) documented the advances he had made in nine months. Compared to a relatively lifeless depiction of a similar subject he had drawn for the *Companion* the previous summer—*The Fountain on Boston Common* (BP, August 15, 1857)—there was now more to interest the eye. In single-point perspective, the Mall's walkway with its flanking trees and groups of figures plays against the great ovoid form that encompasses the figures.

7.5. *Spring in the City*, 9³/₁₆ x 13³/₄ in. *HW*, April 17, 1858. Syracuse University Art Collection.

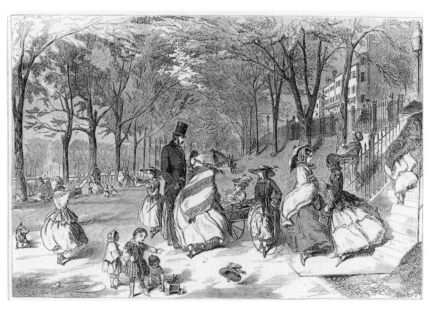

7.6. *The Boston Common*, 9¹/₄ x 13¹⁵/₁₆ in. *HW*, May 22, 1858. Syracuse University Art Collection.

Movement vitalizes the scene. Girls toss hoops; the breeze moves skirts; a gust carries away a small boy's plumed hat. A well-dressed man joins a pair of finely attired women to engage in the pleasant rituals of admiring a child in its carriage. Sunlight reflects from the facades of the houses along Beacon Street.

In its unity and variety, its play of space and mood, and its greater naturalism, Homer's *Boston Common* marked a new level of achievement. The two illustrations that followed in the *Weekly* in September were lesser works. In *The Bathe at Newport* (*HW*, September 4, 1858) crowded details compete for attention, but no center of interest is strong enough to bind them together. The angle of vision, a foot or two above the water, is subverted by inconsistent perspective among the foreground figures. The humor is commonplace. One and one-half centuries later, the onshore bathing machines offer an element of historical interest.

In the same issue, *Picknicking in the Woods* (*HW*, September 4, 1858, fig. 7.7) is also overcrowded with detail, but its central couple presents a strong organizing element. The large triangular form around them, echoed at a lesser scale in several similarly formed groups and details, anchors the composition while it also moves the eye upward to the figures

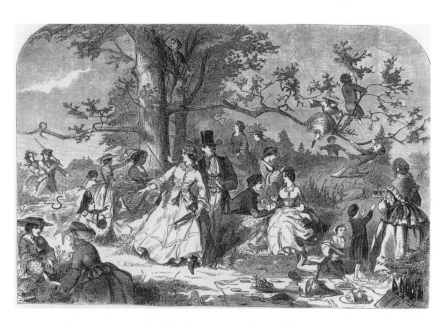

7.7. *Picknicking in the Woods*, 9¹/₈ x 13³/₄ in. *HW*, September 4, 1858.
Syracuse University Art Collection.

on the limbs of the oak tree. The drawing is more polished than in the Newport scene, but the subject is curiously unresolved. The central couple reacts in alarm to a girl who flees from a snake, but nothing ties their emotional charge to anything else. The other figures, singly, paired, or grouped, seem disconnected from each other and oblivious to what occurs near them. Homer probably assembled this odd picnic from sketches drawn in several locations at various times, but spent too little time unifying them. His earlier *Boston Common* had depicted a well-known location and accordingly had required greater accuracy in its treatment. His picnic and swimming subjects possessed less specific senses of place. Even at this early point it was clear that real places aroused Homer's creative impulses more readily than did those he imagined or generalized.

Both of the illustrations in the September 4 issue would have profited from further development and synthesis of parts, but each contains effective details and much richness of observation. As was true of most of Homer's genre subjects, what he drew did not lend itself very well to the construction of narrative. The *Weekly*'s staff wordsmith made no attempt, remarking of these two in a brief commentary that "such pictures need no text—they tell their own stories." [5] In these works and most others, Homer thought not as a scriptwriter but as a reporter attracted to the chance, sometimes chaotic, events that occur in everyday life. He gave them order without imposing narrative sequences. His genre subjects must have surprised his viewers more than they reminded them of what they already knew.

Late autumn found Homer's strengths once again at high pitch. In *Harper's Weekly* with his *Husking the Corn in New England* (HW, November 13, 1858, fig. 7.8), he revisited the subject that he had treated so provocatively for the *Companion* a year earlier. Now his figures were better drawn and more richly varied. At left a young man wearing a goatee pulls back the husk to expose his red ear and shows it to a dreamy-faced girl by his side. Next to them a smaller girl smilingly tips a boy out of a basket of corn while beside them a young couple involved in a more serious level of play tumble over another basket. Beyond them, against the great wall of hay, a bespectacled husker runs after the fleeing object of his attention. Nearby a couple embrace and kiss with evident affection. In the background, a fiddler smiles as he makes music for a group of dancers by the barn doors. At a rebated point right of center a husker with a red ear in hand attempts to force himself on a young woman who, in resisting, falls to her knees. Her female friend pulls at the man's hair to restrain him and a boy tries to tug him away, but to no avail. One profiled

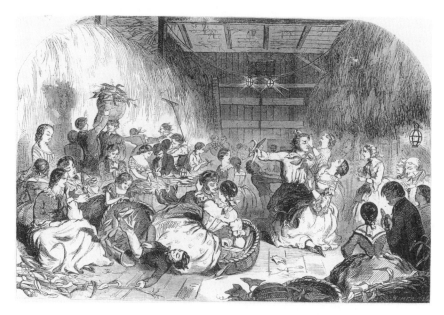

7.8. *Husking the Corn in New England,* 9³/₁₆ x 13¹³/₁₆ in. *HW,* November 13, 1858. Syracuse University Art Collection.

member of a trio of elderly chaperones rises to object to this unseemly display; Homer balances her in the composition with a single figure also in profile placed precisely at the work's center. Unlike the chaperone, she watches this tussle without expression. The young couple at lower right acts as a balance to their counterparts at left. Heads, lanterns, baskets, a large squash, and other round objects intensify the composition's circular organization and movement.

This was the most powerful of a set of three illustrations concerning the corn harvest that *Harper's Weekly* included in a single issue. Its near-turbulent energy makes its partners, the well-composed *Driving Home the Corn* (*HW,* November 13, 1858) and the mild-mannered *Dance After the Husking* (*HW,* November 13, 1858), seem to be afterthoughts. In the *Dance,* a copy of *Harper's Weekly* rests on a table. Near it stand an older couple; they were present as chaperones in the barn scene. They reappear later in the month in a set of Homer's illustrations concerning Thanksgiving. John Chapin, late of the *Companion* and now head of the *Weekly's* art room, may have suggested that Homer treat this festive occasion.

Thanksgiving Day-Ways and Means (*HW,* November 27, 1858, fig. 7.9) is intricately composed of parallel planes and rounded forms. A boy

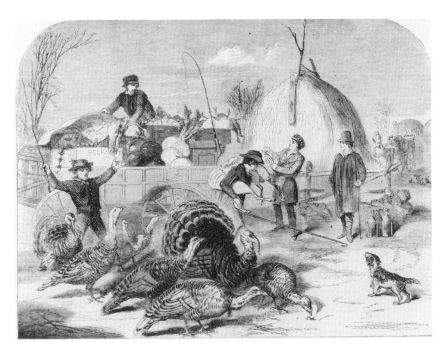

7.9. *Thanksgiving Day—Ways and Means,* 6¹³/₁₆ x 9¹/₈ in. *HW,* November 27, 1858. Mary and Mavis P. Kelsey Collection, Cushing Memorial Library and Archives, Texas A&M University.

drives a flock of turkeys past a wagon. The wagon, fully loaded with the fruits of the harvest, has been topped off with recently slaughtered poultry. Jugs of cider and sides of mutton await loading. A crate in the wagon marked "Belmont" suggests that at least part of this abundance will soon be unloaded at the grocers, butchers, and poulterers of the town in which Homer now lived with his parents, with a number of relatives nearby.

Thanksgiving Day—Arrival at the Old Home (*HW,* November 27, 1858) may recall Homer family holiday gatherings at the country home of a relative more prosperous than Winslow's immediate family. A well-to-do couple and their children alight from a coach to meet their elders at the door of a substantial house. *Thanksgiving Day—The Dinner* (*HW,* November 27, 1858, fig. 7.10) gathers the family at the table. Some individuals are probably loosely based on Homer's relations, though the cast of characters is not consistent from illustration to illustration. The mustachioed young man who holds a napkin in his hands, and who appears only in this illustration, may be a self-portrait. An African American household servant pours wine. In the fourth illustration, *Thanksgiving*

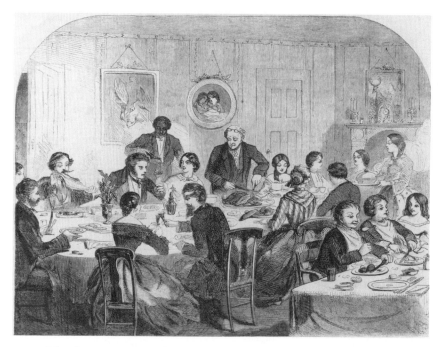

7.10. *Thanksgiving Day—The Dinner,* 6⁷/₈ x 9¹/₄ in. *HW,* November 27, 1858. Mary and Mavis P. Kelsey Collection, Cushing Memorial Library and Archives, Texas A&M University.

Day—The Dance (HW, November 27, 1858, fig. 7.11), the elderly gentleman performs some lively steps with a young relative.

Other than *Ways and Means,* this set has few graphic strengths. Most of the figure drawing is routine, perhaps reflecting a rush to meet a publication deadline. But two of the illustrations in their details offer a brief compendium of American middle-class taste in painting. In the dinner scene, a still life of hanging game (perhaps alluding to the festive menu), a roundel portrait of two girls, and a stag in an alpine setting grace the walls. In the dance scene, a landscape, perhaps in the Barbizon style, a portrait of a man, and a less distinct subject hang in the rooms. These may summarize the holdings of one or more of Homer's well-to-do relatives, but they probably also reflect what he had seen in visits to galleries in Boston and New York.

In his Thanksgiving set of 1858, Homer came as close as he ever would to the manner and spirit of Currier & Ives's colored lithographs of harvests, rural life, and holidays.⁶ His scenes are more individualized than the popular prints, more sharply pointed in their details, and alto-

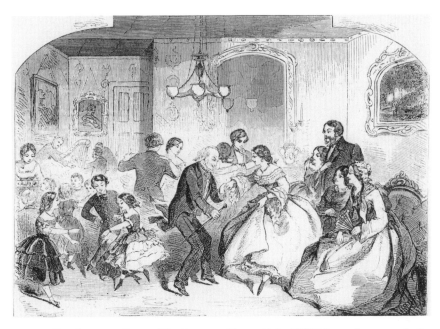

7.11. *Thanksgiving Day—The Dance,* 6⁷/₁₆ x 9¹/₈ in.*HW,* November 27, 1858.
Syracuse University Art Collection.

gether more dynamic, energized not only by the activities depicted but
also by the rhythmic march of light and shade across the compositions.
They nonetheless perpetuate the New York print publishers' highly pop-
ular notion that the American farm was a thing of beauty set in a benefi-
cent natural world and offered enriching experiences to the city folk who
visited it. The very idealization of country life makes it remote from its
viewers. In Homer's scenes, the immediacy of the setting, the intimacy of
family feeling, and the particularized documentary flavor carry the
viewer into the scene as virtual participant.

The *Weekly* for December 25 included an impressive set of four
Christmas subjects. The holiday itself had only recently gained official
recognition in Massachusetts after the gradual waning of generations of
Puritan-founded dismissals of Christmas as a day to be left to the Church
of Rome and the Church of England. Decorated balsams, pines, and other
evergreens such as the one in *The Christmas-Tree* (*HW,* December 25,
1858) had gradually since the 1840s become part of the holiday tradition
in American homes. Some of the figures from the Thanksgiving set reap-
pear in this scene. The landscape painting on the wall, decorated with

boughs, continues the survey of household fine art that Homer had begun in the earlier set. The boughs connect the illustration to another of the set's subjects, *Christmas—Gathering Evergreens* (*HW*, December 25, 1858).

The most innovative of the illustrations in the two holiday sets—indeed, in all of Homer's work from 1858—is *Santa Claus and His Presents* (*HW*, December 25, 1858, fig. 7.12). In the other holiday subjects he placed the important components of the compositions back from the picture plane, leaving a little air between the viewer and the depicted objects and actions. In *Santa Claus*, however, a sturdy bedpost heavily laden with Christmas presents directly abuts the viewer's space and occupies much of the picture plane. Between the two bedposts—both are rebated verticals—hangs a further bounty of gifts. The large central mass of bedstead with its busy panoply of presents divides the scene right and left into quiet realms of sleeping and watching. The placement of the heavy bedstead brings the viewer virtually within touching distance of the room while it simultaneously blocks access to that space. It allows an almost voyeuristic sharing of intimate familial feeling but forestalls intrusion. Homer depicted no action but he enlivened his illustration with an abundance of well-rendered detail—holly, toys, effects of light, and more.

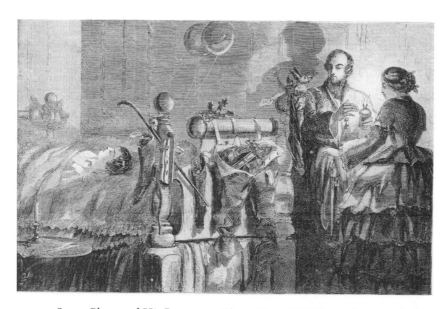

7.12. *Santa Claus and His Presents*, 5¹³/₁₆ x 9¹/₈ in. *HW*, December 25, 1858. Mary and Mavis P. Kelsey Collection, Cushing Memorial Library and Archives, Texas A&M University.

These details are among the most carefully studied of any in Homer's early works.

The set's concluding subject, *Christmas Out of Doors* (*HW*, December 25, 1858, fig. 7.13, returns Homer to Boston's streets, but now with less decorous figures.) Bundled up against the cold, and in some cases wearing expressions of concern, these figures act as foils for the silhouetted couple in the window, who are warm, secure, affectionate, and at home. Configured much as the parents in the set's preceding illustration, they have perhaps returned to their parlor after a last look at a sleeping son and his yet-to-be-discovered wealth of presents.

In January 1859, the *Companion* attempted to regain some of the readership it had lost to *Harper's Weekly* and *Frank Leslie's Illustrated Newspaper* by renewing its emphasis on original illustration. Having been absent from the *Companion*'s pages since his camp meeting set in August, Homer now returned in force. A single number in late January included three winter subjects: *Skating on Jamaica Pond, Near Boston*; *Sleighing in Haymarket Square, Boston*; and *Sleighing on the Road, Brighton* (*BP*,

7.13. *Christmas Out of Doors*, 5¹⁵/₁₆ x 9³/₁₆ in. *HW*, December 25, 1858. Mary and Mavis P. Kelsey Collection, Cushing Memorial Library and Archives, Texas A&M University.

all January 29, 1859). He later drew from life two child performers in costume, *La Petite Angelina and Miss C. Thompson* (*BP*, March 12, 1859). They brandish American flags while dancing a hornpipe on the stage of the Boston Museum, the city's leading theatre. Another skating subject appeared in the same issue: *Evening Skating Scene at the Skating Park, Boston* (*BP*, March 12, 1859). Next came a rather conventional panoramic view, *The New Town of Belmont, Massachusetts* (*BP*, April 23, 1859) showing more hills and fields than buildings. A train moves along the railroad line that spurred Belmont's growth as a suburb. Homer presumably traveled the line often.

More unusual than any of these purposefully benign subjects is *Scene on the Back Bay Lands, Boston* (*BP*, May 21, 1859, fig. 7.14). Here pickers sort through refuse that has been dumped as landfill in the great enterprise of enlarging the city through filling in the Back Bay. The project had begun a year earlier. Homer's illustration represents his first foray into the world of the lower classes. Women as well as men dig, sort, and carry off what they have salvaged. An imposing block of houses illustrates the accompanying text's prophecy that the filled land will be the site of "stately edifices . . . laid out in broad streets with rows of graceful shade trees." In the following weeks came an interior view of the latest project of the entrepreneurial ambrotypist J. A. Cutting, *The Aquarial Gardens, Bromfield Street* (*BP*, May 28, 1859). Homer returned to the site of earlier illustrations with two subjects set in the city's great open

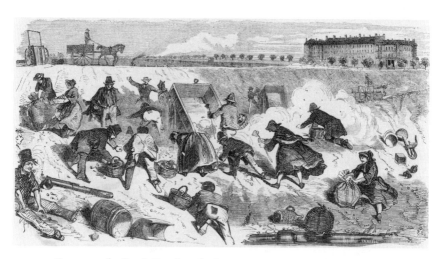

7.14. *Scene on the Back Bay Lands, Boston,* 5 x 9⁷/₁₆ in. *BP*, May 21, 1859.
Syracuse University Art Collection.

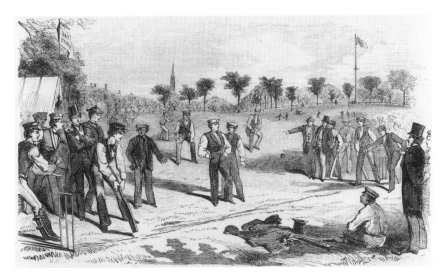

7.15. *Cricket Players on Boston Common*, 5³/₈ x 9⁷/₁₆ in. *BP*, June 4, 1859.
Syracuse University Art Collection.

space. In *Cricket Players on Boston Common* (*BP*, June 4, 1858, fig. 7.15), the ball is in mid-air between bowler and batsman. In *Fourth of July Scene on Boston Common* (*BP*, July 9, 1858), boys play, fireworks explode, and a policeman arrives to impose order on momentary pandemonium. The unusually elevated angle of vision in *Cambridge Cattle Market* (*BP*, July 2, 1859, fig. 7.16) allows the subject to explain itself; the scene is full of quiet good humor and fine drawing. Then, as his final and largest original illustration for the *Companion*, Homer drew the ambitious and engaging *Boston Street Characters* (*BP*, July 9, 1859, fig. 7.17).

In both its title and its format, *Boston Street Characters* followed a series begun a few years earlier by Barry.[7] But where Barry's vignettes tended to be generalized portraits of the poor and downtrodden in tattered clothing, Homer drew better-rendered full-length figures brighter in spirit and more varied in anecdote. He offered glimpses of ladies' fashion and an elegantly attired dandy—an "exquisite"—but most of his characters come from Boston's working classes and are treated respectfully. Perhaps he knew when he drew this work that he would be moving to New York in the autumn, for it conveys a hint of good-natured valediction to his hometown.

The *Companion* began its commentary by saying, "[T]he large and

7.16. *Cambridge Cattle Market*, 6 x 9½ in. *BP*, July 2, 1859. American Antiquarian Society.

costly engraving . . . is one of the best we have ever published, local in character, but possessing a general interest from its artistic merit. It was drawn expressly for us, by Homer, from sketches made in our streets." In the central vignette, Homer returns to the site of his first original subject, the "four corners" of Winter, Washington, and Summer. He again makes a policeman a key figure, but now brings him to the foreground. The surrounding vignettes show, clockwise from the bottom: firemen racing to a blaze with a view of the State House dome beyond; the "exquisite placidly and imperturbably gliding along the sidewalk"; the Razor-Strop Man singing the merits of his ware; three "dock loafers, smoking villainous cigars and enjoying a *lazzaroni*-like *otium sine dignitate*" [an inelegant loafer's leisure]; a scissors-grinder; a seller of roasted chestnuts with children standing by his brazier; a crippled young pencil-seller; a lamplighter; a teamster; men wearing fore-and-aft advertising placards. One placard promotes Oak Hall, a ready-to-wear clothing store, but the man in front advertises *Ballou's Dollar Monthly*. Ballou had begun this story magazine in 1855. Its rousing success eased the losses that the *Companion* had begun to incur in 1857.[8]

Like his view of Back Bay refuse pickers, Homer's *Boston Street Characters* looked beyond the superficialities of middle-class comfort

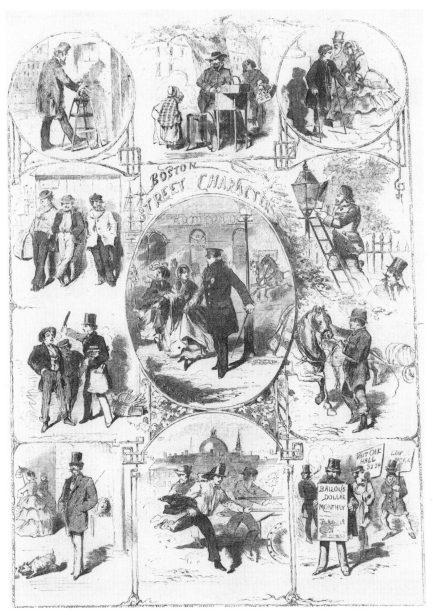

7.17. *Boston Street Characters*, 13⁷/₁₆ x 9¹/₂ in. *BP*, July 9, 1859. Bowdoin
College Museum of Art, Brunswick, Maine, Museum Purchase,
George Otis Hamlin Fund.

and decorum to touch on society's unfortunates, its laggards, and its honest laborers. But nowhere in his illustrations of Boston life in the late 1850s did he allow the intrusion of any of the decade's most troubling and divisive issues. In these years he offered nothing on the temperance movement, the women's rights movement, the Know-Nothings, the Panic of 1857, Free Soil, or abolition. The choice was not his, of course, for with a few notable exceptions both the *Companion* and the *Weekly* in the late 1850s skirted most controversial subjects in their illustrations. Still, there is little sign in Homer's early work that he would have editorialized on these issues even if he were free to do so. Nothing suggests that an undercurrent of suppressed feeling lurks below the surface of his drawings.

Though *Boston Street Characters* was the last of Homer's original subjects for the *Companion* (a single portrait followed late in the year), he had remained busy drawing for *Harper's Weekly*. In April 1859, after an absence of four months, his work had begun to appear again in that magazine. *March Winds* and *April Showers* (both *HW*, April 2, 1859, figs. 17.18 and 17.19) offer amusing depictions of seasonal weather. In the former the wind lifts some crinolines while in the latter puddles cause others to be hoisted, allowing in both cases discreet glimpses of bits of women's legs. The April subject includes as its central figure the dandy who appears also in *Boston Street Characters*. He may be Paunceloup, a

7.18. *March Winds*, 5^{15}/$_{16}$ x 9^{1}/$_{16}$ in. *HW*, April 2, 1859.
Syracuse University Art Collection.

7.19. *April Showers,* $5^{15}/_{16}$ x $9^1/_{16}$ in. *HW,* April 2, 1859.
Syracuse University Art Collection.

promenading Bostonian of French origins, "conceited and pompous," whom Homer sketched "with his chest thrown out, and his big waxed moustache, as he walked down the street." [9] *May-Day in the Country* (*HW,* April 30, 1859) and *August in the Country—The Sea-Shore* (*HW,* August 27, 1859, fig. 7.20), speak of middle-class leisure. The crowded beach scene is overloaded with detail, but a few of its figures have an appealing freshness, especially the young woman at upper left who, shaded by her umbrella, makes a watercolor drawing while her companion naps. In all but *May-Day* Homer revisited old subjects, without revitalizing them in significant ways.

At the end of the summer his *A Cadet Hop at West Point* (*HW,* September 3, 1859) probably resulted from his newly formed acquaintanceship with the artist John Ferguson Weir (1841–1926). Weir's father, the artist Robert Weir, taught at the U.S. Military Academy. [10] The sweeping crinolines of the young women on the dance floor set the design in motion. *The Grand Review at Camp Massachusetts Near Concord* (*HW,* September 24, 1859) is distinctly retrograde. It echoes the conventions of the lithographed militia prints produced in Boston in the 1830s, 1840s, and 1850s. In the cheering crowd that fills a corner, Homer repeated the kind of stock detail that he had drawn as an apprentice at Bufford's. [11]

And so it comes as something of a relief after this variable group of il-

7.20. *August in the Country—The Sea-Shore*, 9¹/₈ x 13⁷/₈ in. *HW*, August 27, 1859. Syracuse University Art Collection.

lustrations to find that Homer's last New England subject for the *Weekly* in 1859 was a work of distinctive strengths. In it he returned to the country harvest festivities that he had treated so memorably in his two corn husking subjects. *Fall Games—The Apple-Bee* (*HW*, November 26, 1859, fig. 7.21) revives something of the erotic energy that had vitalized his husking parties, but tempers it by giving prominence to new themes. Two couples in the middle ground kiss fervently. A young man and woman in the foreground seem not to have reached that stage of closeness, but his fixed attention on her and her faraway look suggest that they will grow closer. In tossing an apple peel over her shoulder, the young woman at center follows the happy superstition that it will land in the shape of an initial foretelling of the name of the person she will marry. But these details now compete for attention with non-amorous elements. The older man at left, busy with his apple corer, and his jolly counterpart by the cask of cider at the rear, may be taken as personifications of work and play, or less charitably, industry and idleness. Other figures divide the composition into contrasting halves with age on the left and youth on the right. The strings of drying apple slices that hang along the ceiling tie the sides together and cap the composition.

7.21. *Fall Games—The Apple-Bee,* 9¹/₈ x 13⁷/₈ in. *HW,* November 26, 1859.
Syracuse University Art Collection.

Homer's three scenes of country gaiety—his husking parties and apple bee—stand with his *Boston Common, Santa Claus and His Presents, Boston Street Characters,* and a very few others as the most ambitious and fully realized of his achievements as an illustrator during his Boston years. But unlike the others, his three rural subjects push against the urban social proprieties of their time. Nothing in his work as a painter remotely recalls the electric, hot-blooded relations among young men and women that he recorded with such evident relish in these country frolics. In hardly any other of his drawings for the pictorial press did he depict such free and unselfconscious displays of emotion between individuals. One and one-half centuries after he drew them, the genuineness of these observations of human feeling still carries force. But by the time the apple bee reached print, he was settled in New York and determined to remake himself into a different kind of artist.

8

New York and the Advent of War

1860–1861

In October 1859 Homer enrolled in life classes at the National Academy of Design. He attended these sessions of drawing from posed models as a part-time student. His studies soon resulted in a greater appearance of solidity in a few of the figures he drew for the *Weekly*. An early instance is the man with his hands in his pockets in *A Snow Slide in the City* (*HW*, January 14, 1860, fig. 8.1). More academically naturalistic than any figure Homer had previously drawn for publication, this figure's mass and weight attest to its maker's growing comprehension of anatomy in the service of art. But these very attributes made the figure a somewhat foreign presence among the spontaneously sketched and theatrically postured men, women, and children who had filled Homer's illustrations from the beginning. Now, however, he drew them with greater economy and increasing skill.

These improvements in his illustrations were a bonus of sorts for his art editor. Homer had, however, enrolled in life classes not so much to give an academic flavor to the work he offered to *Harper's Weekly* as to enlarge his skills in preparation for entry into the world of painting. To succeed in that world in the 1860s his figures needed to conform more closely to academic practice than had those he had drawn for the weeklies in Boston. And there can be little doubt that he hoped that his debut as a painter would rapidly end his association with the pictorial press. He began to paint in oils probably as early as 1861, but discarded his early efforts and exhibited nothing until the spring of 1863. During this period his illustrations began to reflect here and there a painter's approach to the making of art.

His time at the academy, which extended off and on over a period of three years, completed his basic art education. His earlier education had

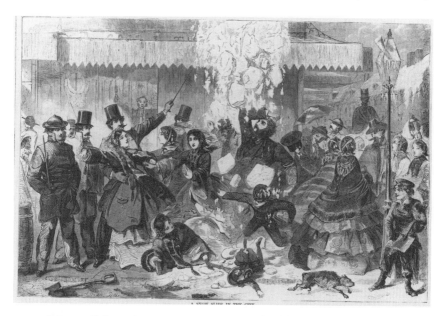

8.1. *A Snow Slide in the City,* 9¹/₈ x 13³/₄ in. *HW,* January 14, 1860. Bowdoin College Museum of Art, Brunswick, Maine. Museum and College Purchase, Hamlin, Quinby, and Special Funds.

been to a large extent autodidactic, but once he had established himself as a contributor of original drawings to the *Companion* he began to associate more closely with persons who possessed formal training in the fine arts. The young painter John La Farge was one of these. Homer had known La Farge in Boston and painted with him and Elihu Vedder in Newport in the late 1850s and 1860s. Coached by 48-ers, or even by La Farge, Homer had become a discerning connoisseur of painting by the late 1850s. During a visit to a gallery in Boston, he remarked to two colleagues from Bufford's: "I am going to paint," adding that his work would be "a damn side better" than a canvas in the gallery by the French genre painter Edouard Frère depicting a kitchen interior with figures.[1] But by the time Homer became a painter, his fundamental ways of seeing and recording—of composing, dealing in light and shade, selecting detail, and depending on linear definition—had already been formed by his work for the weeklies. His classes at the academy refined and augmented what he had already learned as an illustrator, but they did not supplant or transform it. Unwilling or unable to jettison his old ways entirely, he would remain an idiosyncratic figure artist, but one who nonetheless cre-

ated some of the more memorable figures in nineteenth-century American painting.

Homer had preceded his *Snow Slide in the City* with an elaborate holiday subject: *A Merry Christmas and a Happy New Year* (*HW*, December 24, 1859, fig. 8.2). In the upper part of the design two vignettes flank a Nativity scene. In one, a finely attired gentleman has just emerged from a carriage drawn by two well-groomed horses. He approaches a substantial brownstone on a newly developed block of Fifth Avenue. In the other vignette, a roughly dressed Irishman stands near a sledge pulled by a pair of goats. He beckons to a family outside a ramshackle cottage on the wastelands of Fifty-first Street. Homer had begun to make such stagy contrasts between the comfortably well-to-do and the less fortunate in his Boston work—that spirit had informed his *Christmas Out of Doors* and *Boston Street Characters*—but here he juxtaposed wealth and poverty more melodramatically. The bottom half of the design amounts to a potpourri of pleasant moments from holiday festivities. Among the more interesting details are two men looking at stereopticons, a duo performing at harp and piano, and an African American nursemaid holding a child.

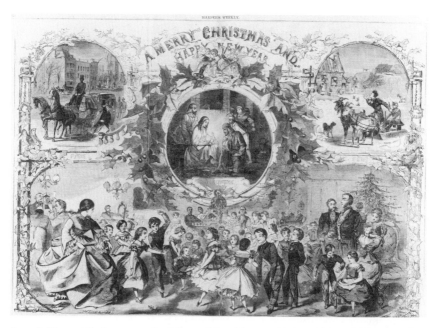

8.2. *A Merry Christmas and a Happy New Year*, 13³/₄ x 20¹/₄ in. *HW*, December 25, 1859. Private collection.

In Homer's first winter in New York he revisited for *Harper's Weekly* two seasonal subjects that he had drawn for the *Companion* during the previous year. These were the freshly rethought *The Sleighing Season— The Upset* (*HW,* January 14, 1860) and *Skating on the Ladies' Skating-Pond in the Central Park, New York* (*HW,* January 28, 1860, fig. 8.3). He included in each subject figures whose greater solidity owed something to his studies at the academy. Central Park was then a new presence in the city. Homer's distant view of the landscape with its guyed poles must have vied with his skating figures for the attention of the magazine's readers. The Ladies' Skating Pond, located on the park's west side between 76th and 79th streets, was an extension (later filled in) of The Lake. Homer may have adapted this illustration from a work, perhaps a wash drawing, that the academy included in its spring exhibition—his first inclusion in such a show.[2]

Published in the same month, but very different from these two seasonal illustrations and from all that Homer had drawn previously, was his *Union Meetings in the Open Air, Outside the Academy of Music, December 19, 1859* (*HW,* January 7, 1860, fig. 8.4). The crude engraving of

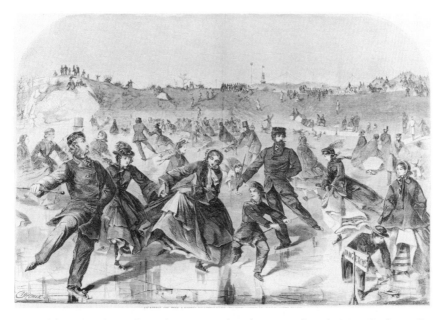

8.3. *Skating on the Ladies' Skating-Pond in the Central Park, New York,* 13¹³/₁₆ x 20⁵/₁₆ in. *HW,* January 28, 1860. Mary and Mavis P. Kelsey Collection, Cushing Memorial Library and Archives, Texas A&M University.

8.4. *Union Meetings in the Open Air, Outside the Academy of Music, December 19, 1859*, 10³/₄ x 9¹/₈ in. *HW*, January 7, 1860. Syracuse University Art Collection.

the figures at the left side has no counterpart in his earlier work, and it can have done little justice to what he had drawn on this part of the block. But the greater difference from his past work rested in the nature of the subject. The illustration was a news report rather than a genre subject. The invention, idealization, generalization, and personal vision that, in large or small dosages, underlay nearly all his earlier subjects gave way here to a more rigorous documentary realism.

The illustration presents a view of a grand-scale public meeting held in support of the preservation of the Union. It marked Homer's first direct involvement with the national crisis that in little more than a year would lead to war and his emergence as a war artist. In its commentary

the *Weekly* reported that "not less than five thousand were assembled within the [Academy of Music's] walls, and a number perhaps equally large congregated without and listened to addresses from the different stands erected there." Homer shows a speaker at one such stand. The Academy of Music looms beyond. A bonfire illuminates the scene as sky-rockets flash above. The event's newsworthiness put Homer's illustration on the *Weekly*'s front page. That it appeared nearly two weeks after the occasion it depicts points up the continuing inability of even the leading American pictorial weekly to bring a large illustration to publication quickly.

During 1860 Homer drew four other illustrations. Two were genre subjects: his *The Drive in the Central Park, New York, September 1860* (*HW*, September 15, 1860) and *Thanksgiving Day, 1860—The Two Great Classes* (*HW*, December 1, 1860). In the latter he drew another of his theatrical contrasts between wealth and poverty. Two other subjects were humorous. In *Scene in Union Square on a March Day* (*HW*, April 7, 1860), windblown men's hats are so similar as to defy identification by owners hoping to reclaim them. In the broadly farcical *Welcome to the Prince of Wales* (*HW*, October 20, 1860, fig. 8.5), inspired by the young prince's tour of Canada and the United States, the lower part of the composite image plays on the locally disappointing brevity of the royal visitor's stay in Boston. The crowd cries, "Here he comes!—There he goes!" Near the center of this throng Homer placed two smiling open-faced boys of the kind he had included in a few earlier light-spirited illustrations. As a caricature type, they make a final appearance here. The vignettes above depict the prince first playing at ten pins with President Buchanan's niece at the boarding school she conducted in Washington, and then slipping on the dance floor at a ball held in his honor in Quebec.

Throughout 1860 and 1861 Homer continued to accept portrait assignments from the *Weekly*. He presumably copied each likeness from a photograph or print. The subjects were mostly figures of political importance, including Chief Justice Roger Taney (*HW*, December 8, 1860) and, in well designed composites, the congressional delegations of three seceding southern states, South Carolina (*HW*, December 22, 1860), Georgia (*HW*, January 5, 1861), and Mississippi (*HW*, February 2, 1861). Not all of his portraits had to do with individuals of note, how-ever. The most unusual, adapted from a photograph, depicted some three dozen workers arrayed by a massive display of their handiwork in *Chime of Thirteen Bells for Christ Church, Cambridge, Massachusetts, Manu-*

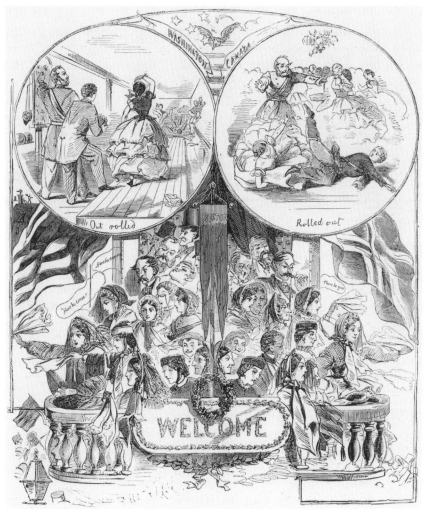

8.5. *Welcome to the Prince of Wales,* 10⁵/₈ x 9¹/₈ in. *HW*, October 20, 1860. Mary and Mavis P. Kelsey Collection, Cushing Memorial Library and Archives, Texas A&M University.

factured by Messrs. Henry N. Hooper & Co., of Boston. (HW, May 26, 1860).

Two of the portraits he drew in 1860 are of more than ordinary historical significance. The first of these is his *Hon. Abraham Lincoln, Born in Kentucky, February 12, 1809 (HW, November 10, 1860, fig. 8.6).* Lincoln had not yet been elected president when this number came off the press on November 3. The outcome of the contest would not be certain

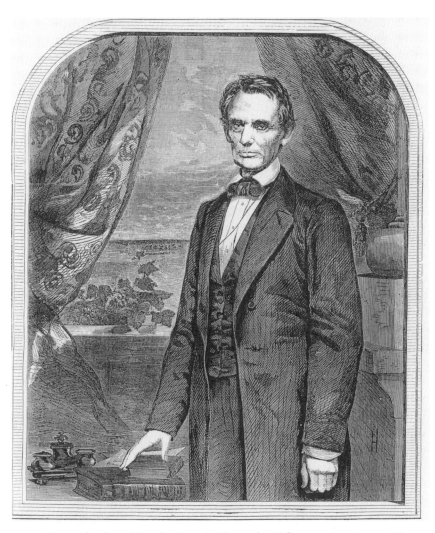

8.6. *Hon. Abraham Lincoln, Born in Kentucky, February 12, 1809*, 10¹³/₁₆ x
9¹/₈ in. *HW*, November 10, 1860. Syracuse University Art Collection.

for another week or two, but Fletcher Harper nonetheless ran this por-
trait on his journal's front page in the confident assumption that Lincoln
would be declared the winner. Homer drew his portrait of the beardless
president-elect at least two weeks prior to the election. He adapted a pho-
tograph taken by Mathew Brady in February 1860 (the *Cooper Institute
Portrait*) (fig. 8.7) The *Weekly* may have obtained it directly from Brady.
 Because Homer copied the likeness without reversing it, the printed

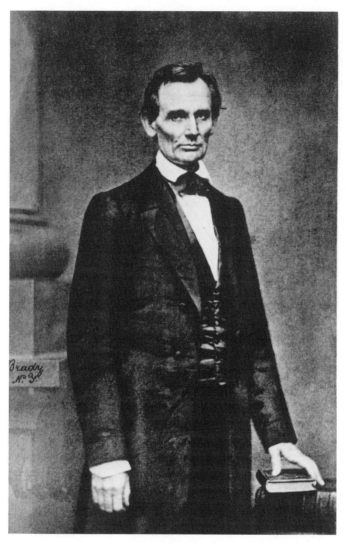

8.7. *Abraham Lincoln.* Cooper Union portrait photograph by
Mathew Brady, 1860. Library of Congress, Prints and
Photographs Division, LC USZ62–13459.

portrait is a mirror image of the photograph. It differs also in Homer's
several augmentations. In the photograph, Lincoln stands by a small col-
umn—a common prop in a photographer's studio—and rests his left hand
on two books. Homer kept the column's base, draped its shaft, added
more drapery for purposes of symmetry, and put an inkstand next to the

books, perhaps to suggest an active as well as a contemplative life. He placed a window behind Lincoln, opening to a view of bison grazing on the prairie. This placid scene and the bountiful grapevine on the sill together convey the magazine's stance that the new administration would peaceably resolve the worsening political crisis between North and South.

A week following his adaptation of Brady's photograph of Lincoln, the *Weekly* ran on its front page Homer's *General Guiseppe* [sic] *Garibaldi and Two Favorite Volunteers* (*HW*, November 17, 1860, fig. 8.8). The Italian patriot was not entirely a foreign subject; he had resided on Staten Island between 1850 and 1853. (Despite one of Homer's characteristic signatures, this portrait was long overlooked by compilers of checklists of his illustrations, perhaps owing to its non-American subject.)[3] In drawing Garibaldi, Homer adapted not a studio photograph but rather a photograph of an oil painting by the Milanese artist Eleuterio Pagliano (fig. 8.9). The *Weekly* explained in its commentary:

> The original was painted from life by Pagliano . . . in the spring of the present year for Lorenzo Valerio, the Governor of Como, and at present Commissioner Extraordinary of King Victor Emanuel for the Marches, an intimate friend and distinguished co-worker with Garibaldi in the cause of Italian freedom and unity. We are indebted to . . . [Valerio's] brother who, during the summer, commanded a volunteer force of four hundred from Genoa, for a photograph of the picture. The figure on the right, from a photograph furnished by the same gentleman, is the young Sicilian, Occhipuiti [that is, Ignazio Occhipinti]. . . . He had followed the fortunes of his leader in his triumphal march through Southern Italy, and is now attached to his staff. The dress is that of the heroic volunteers who landed at Marsala and have, in the incredibly short space of three months, liberated the Two Sicilies from the terrible tyranny of the Bourbon King of Naples.[4]

At a time when the dissolution of the Union seemed imminent, this praise of Garibaldi as a unifier of a divided country must have been taken by many of the *Weekly*'s readers as implicit criticism of the South's move toward secession.

The source painting is now in the collections of the Museo del Risorgimento in Milan. In his transcription of a photograph of it, Homer boldly imposed Pagliano's name and the year of his work onto the oval likeness. He signed his drawing with the elongated *H* that he used in 1860 when he made portrait drawings from photographs—his Lincoln

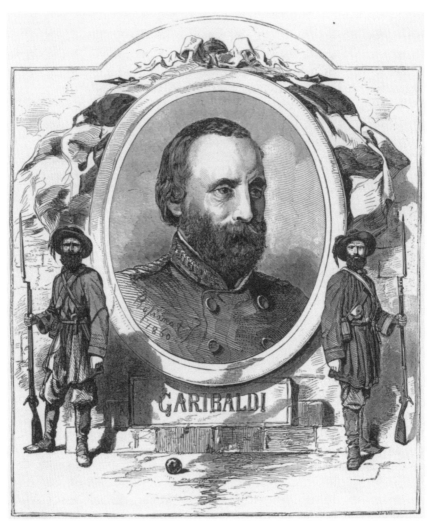

8.8. *General Guiseppi [sic] Garibaldi and Two Favorite Volunteers*, 9 x 10¹/₄ in.
HW, November 17, 1860. Private collection.

portrait has a similar tall *H*. But in signing the Garibaldi composition he
added a smaller-scale *W* to the *H*, perhaps to show that he had elabo-
rated more extensively than usual on his source and was especially
pleased with the outcome. His original contributions to the illustration
includes a well-drawn decorative surround of masonry and flags as well
as two standing figures. The similarity of the figures suggests that he

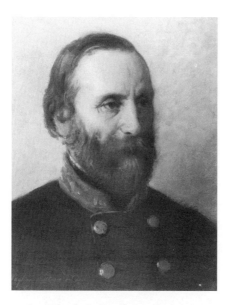

8.9. Eleuterio Pagliano. *Giuseppe Garibaldi,* 1860. Oil on canvas, 9¹/₂ x 7¹/₂ in. Museo del Risorgimento, Milan.

adapted both from the photograph of Occhipinti, varying details and stances slightly to attain a balanced but not identical pair for his symmetrical design. The able engraver (unidentified) and his assistants preserved the autographic qualities of Homer's drawing far better than most who served him in these years. The Lincoln portrait had been hobbled by less sensitive engraving.

A month following his portrait of Garibaldi, Homer produced the second of his illustrations of a public incident rife with political import. Like his depiction of the Union meetings outside the Academy of Music a year earlier, he presented his *Expulsion of Negroes and Abolitionists from the Tremont Temple, Boston, Massachusetts, on December 3, 1860* (*HW,* December 15, 1860, fig. 8.10) as an eyewitness report. This time the incident centered on the festering issue of slavery. The *Weekly* said in its commentary: "[W]e publish . . . from a sketch by a person who was present a picture of the riot that took place . . . on the occasion of the attempt by Garrison, Redpath, Sanborn, Douglass and other abolitionists to celebrate the anniversary of the execution of John Brown." This commemorative meeting, organized by Boston abolitionists, occurred just as

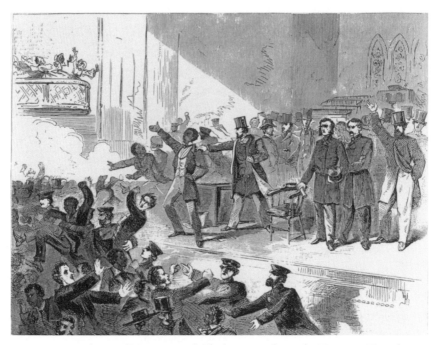

8.10. *Expulsion of Negroes and Abolitionists from the Tremont Temple, Boston, Massachusetts, on December 3, 1860, 6¹⁵/₁₆ x 9¹/₈ in. HW, December 15, 1860. Syracuse University Art Collection.

the previous month's election of Lincoln as president, and John Andrew as governor of Massachusetts, briefly destabilized Boston's civic life. The prospect of a break with the South caused many in the city's business community to panic. Northern merchants and bankers had loaned many millions of dollars to Southern planters and businesses and now, with secession in the air, the lenders faced prodigious losses. Massachusetts mill owners dismissed operatives and lowered wages as Southern orders for goods were cancelled. Visions of economic ruin drove usually staid Bostonians to mob action. The widely advertised John Brown memorial meeting at the Tremont Temple, a church hall on Tremont Street, became a target for disruption.

A large group of anti-Lincoln, anti-abolition rioters piled into the public meeting and attempted to take it over. They very largely succeeded in doing so, though the persistent resistance of the meeting's organizers kept the hall full of contentious action from mid-morning to early afternoon. The *Weekly* reported that after heated exchanges and impromptu

speeches by Douglass and other fervent anti-slavery leaders, "the meeting ended in the expulsion from the hall of the abolitionists and negroes by sheer force." A much fuller report appeared on December 7 in William Lloyd Garrison's abolitionist newspaper, the *Liberator,* under the head-line "Mobocratic Assault Upon an Anti-Slavery Meeting in Boston." When James Redpath, the young journalist and fiery abolitionist, at-tempted to call the meeting to order, the large number of "rioters" seated in the auditorium immediately set out to disrupt it with noise and to gain control of the proceedings by quasi-parliamentary means. Both Redpath and his fellow abolitionist, Franklin Sanborn of Concord, were shouted down as they attempted to speak. The hall manager summoned police who did little to quell the disturbance. The efforts of the African Ameri-can leader Frederick Douglass to speak met with jeers and other inter-ruptions. At one point a policeman bodily expelled him from the center of the stage.

Most women on the main floor and in the gallery held strong aboli-tionist views. The chief of police announced: "Will the ladies leave the hall? We give them five minutes. Then we will clear the hall by police force." But "the ladies on the main floor all took seats. Those in the gal-leries looked daggers [at the police]. All seemed as though they were de-termined to resist to the last. They did not appear greatly excited. . . . The police went into the galleries . . . the women resisted." They left of their own will when, after three and one-half hours of chaos, the mayor and the Temple's trustees closed the hall.[5]

Although it is possible that Homer attended this eruptive meeting on one of his trips to Boston, his signature strongly suggests that he adapted sketches made by, as the *Weekly* claimed, "a person who was present." He signed his woodblock drawing with the elongated *H* and smaller at-tached *W* that he had previously used only when adapting photographs, as in his portraits of Garibaldi and Chief Justice Taney.[6] But the adapta-tion in this case was a more thoroughgoing one, for the drawing style is distinctly Homer's, especially so in the energetic postures of several of the figures on stage and in the linear caricature of the women who, contrary to Garrison's report, flee in panic from the balcony. The two men without hats right of center are most likely Redpath and Sanborn. The African American whom a policeman grasps by the shoulder is surely Douglass. Homer must have composed and drawn the illustration quickly, for the *Weekly* rushed it through production to have it in print little more than a week after the tumultuous meeting.

Three weeks later Homer drew an original subject of a different, but,

for him, more conventional sort. In *Seeing the Old Year Out* (*HW*, January 5, 1861) he continued his attention to festive holidays by treating New Year's Eve. This illustration juxtaposes a family that lifts glasses of wine at midnight with a church congregation that lowers its heads in prayer at the same moment. The serious mood mirrors the national temper at the time.

It was probably Homer who in February sketched Abraham Lincoln from life during the newly elected president's brief appearance in New York on his journey to Washington: *Abraham Lincoln, the President Elect, Addressing the People from the Astor House Balcony, February 19, 1861* (*HW*, March 2, 1861, fig. 8.11). The *Weekly* claimed that a crowd of five thousand had assembled outside the hotel. The treatment of the throng is rudimentary and the hastily drawn figure of Lincoln has but little of Homer's style. The image captures not only the man's tall, lanky stature but also the beard he had begun to grow a few weeks earlier. The work is signed obscurely at upper left with an *H* wholly uncharacteristic of Homer. An attribution of this work to him can scarcely be made with unqualified confidence. Homer later drew Lincoln from life, close to the end of the war, standing with his son Tad and General Grant at City Point. That image remained unpublished, however, until 1887 when he adapted it for use in *Century Magazine*'s series "Battles and Leaders of the Civil War."[7]

Several checklists have attributed to Homer unsigned depictions of Lincoln in his inaugural procession and in the Capitol's Senate Chamber, but nothing in these works suggests that Homer had any role in their making.[8] He may have sketched at least part of the unsigned double-page spread *The Inauguration of Abraham Lincoln as President of the United States, at the Capitol, Washington, March 4, 1861* (*HW*, March 16, 1861, fig. 8.12). The foreground figures, especially those at right, are characteristic of his style. The publication of this large work on March 9, only five days after the event it depicts, suggests that the architectural part of the illustration—the East Front of the Capitol—was drawn by another hand and engraved well before the event. On March 4 or 5, an artist, presumably Homer, added the crowd to the partly engraved block, individualizing a few figures. It is of no little significance to the political import of the subject at a time of strong feeling on the national issue of slavery that an African American appears prominently on both sides of the foreground. This inclusion may well have been Homer's choice. Lincoln appears as a distant figure of no special presence.

Homer drew little that was original for the *Weekly* over the next three months. He produced a few portraits of no great distinction, in-

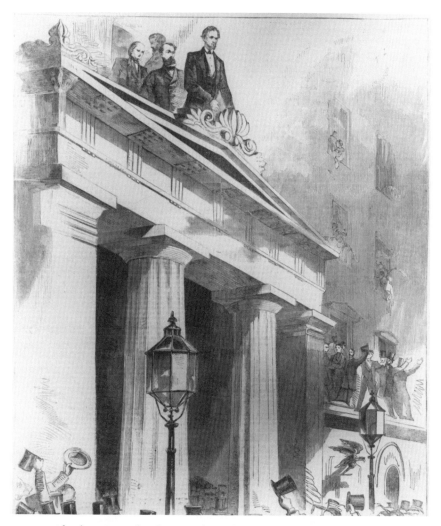

8.11. *Abraham Lincoln, the President Elect, Addressing the People from the Astor House Balcony, February 19, 1861,* 10⁷/₈ x 9¹/₈ in. *HW,* March 2, 1861. American Antiquarian Society.

cluding one (April 27, 1861) adapted from a photograph of the Confederate general P.T.G. Beauregard, whose bombardment of Fort Sumter two weeks earlier had begun military hostilities between North and South. The slowing of Homer's output as a woodblock artist of original subjects suggests that he was increasingly occupied by his work on canvas. He had begun to attend Thomas Seir Cummings's classes in painting

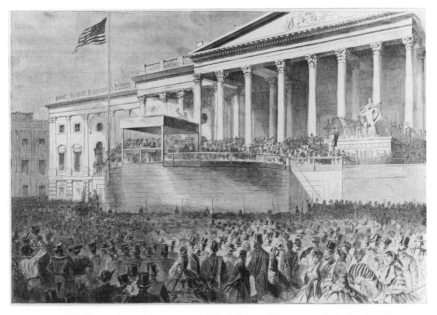

8.12. *The Inauguration of Abraham Lincoln as President of the United States, at the Capitol, Washington, March 4, 1861,* 13³/₄ x 20¹/₈ in. *HW*, March 16, 1861. Mary and Mavis P. Kelsey Collection, Cushing Memorial Library and Archives, Texas A&M University.

at the National Academy.[9] Scarcely any impact of the older artist's style, technique, or aesthetic thought registered in Homer's work, but the association very likely gave added impetus to the younger man's growing concept of himself as a fine artist rather than an illustrator. Still, his need to earn a living prevented a clean break from the *Weekly*. Further, the arrival of war made the weeklies eager to have pictorial documentation of the conflict. For this documentation they needed keen observers who knew how to draw for publication. In these circumstances the *Weekly* could scarcely afford to lose an illustrator as adept as Homer.

Homer's first wartime illustrations came from the home front in New York and Boston. In *The Seventy-Ninth Regiment (Highlanders) New York State Militia* (*HW*, May 25, 1861) kilted soldiers march down a Manhattan street. In *The War—Making Havelocks for the Volunteers* (*HW*, June 29, 1861, fig. 8.13), a group of stylishly attired young women industriously sew the cloth cap coverings that will protect the backs of soldiers' necks from the sun. A few of these havelocks are piled in the fore-

8.13. *The War—Making Havelocks for the Volunteers,* 10¹⁵/₁₆ x 9³/₁₆ in. *HW,*
June 29, 1861. Syracuse University Art Collection.

ground. Some of the women sew uniforms, one of which bears the word
Zouave. This word referred to Union volunteer military units that early in
the war went off to battle wearing French-inspired, colorfully Orientalist
uniforms. A large American flag or bunting hangs on a standard at right.
At left an oval portrait of a soldier looks down on the women. They con-
stitute a sewing bee, but one of a very different mood from Homer's apple

bee of two years earlier. The spirit of the occasion differs because it is wartime and only women are present, and, as their appearances proclaim, they are proper young ladies. One or two of his Belmont cousins may have modeled for all the women in *Making Havelocks*.[10]

The illustration's mood is also serious owing to the fact that Homer at this point was trying to put behind him the wit, humor, and effervescent energy that had been so much a part of his earlier graphic style. He had now begun to compose woodblock drawings with the solid planes and broader masses that would in time characterize his work on canvas. These new aspects of style were antithetical to the fluid movement of his earlier woodblock designs. *Making Havelocks* was an early announcement of this shift in style. The shift would not be permanent, however. The rush of subjects to press, especially during the war, would make such carefully composed works occasional rather than regular efforts by Homer.

His *Crew of the United States Steam-Sloop "Colorado," Shipped at Boston, June, 1861* (HW, July 13, 1861) and *Filling Cartridges at the United States Arsenal at Watertown, Massachusetts* (HW, July 20, 1861) document a summer spent partly at home in Belmont. All of his illustrations of spring and summer 1861 were wartime subjects, but well removed from the war's battlefronts. Their calmness reflected a widespread assumption in the North in the spring of 1861 that the war would be of short duration and would end with a Union victory. But in July the ignominious defeat of Union forces at the First Battle of Bull Run near Manassas in northern Virginia, some thirty miles from Washington, cast the national conflict in a different light. As readers in the North began to look to New York's pictorial weeklies for up-to-date visual reports on a war that had suddenly become more gravely complicated, the circulation of those magazines rose.

There were now three of them. *Harper's Weekly* and *Frank Leslie's Illustrated Newspaper* had been joined in 1859 by the *New York Illustrated News*, a weekly that never attained the popularity of the others, survived for a few years owing to its extensive pictorial coverage of the war, and ceased publication in 1864. Early in the war each of the three journals arranged to obtain eyewitness drawings of the conflict. In its number for July 6, 1861, *Harper's Weekly* announced that it "has now regular artist-correspondents at Fortress Monroe, Va., at Washington, D.C., at Martinsburgh, Va, [etc.]. . . . These gentlemen will accompany the march of the armies."[11]

The weeklies called these pictorial correspondents "special artists." This umbrella term covered three kinds of contributors. First were the

salaried artist-correspondents in the field who had contracted with their publishers to send drawings back to New York from one or another of the theatres of war. The publishers' staff artists then redrew the drawings on woodblocks, often freely. *Harper's Weekly* enjoyed the prolific output of two such special artists: Alfred Waud, who contributed at least 215 war subjects, and Theodore R. Davis (1840–1894), who outdid him with more than 250. But Waud also contributed more than 125 drawings to the *New York Illustrated News,* and this made him far and away the most prolific of the Civil War "specials." Homer was a special artist of this sort only briefly, as we shall see.[12]

The second type of special artist consisted of freelance professional graphic artists who occasionally sold to the weeklies drawings of subjects based on sketches they had made at war sites. Some mailed in their sketches; others developed and refined them, and then drew their finished designs on woodblocks. Most of Homer's Civil War illustrations fall into this category.

The third type of special artist was the amateur. The weeklies welcomed unsolicited drawings of places and events unrecorded by the professional reporting artists. Some of the amateurs were military officers who made use of their training in topographic drawing. The sketches of special artists of this kind were nearly always drawn on the block by a magazine's art room staff.[13]

About thirty special artists of the first two types covered the war for the three weeklies.[14] More than half of them, like Homer, visited the fronts for only relatively brief periods. In the course of the conflict *Leslie's* published more than 1,300 war subjects, the *Weekly* over 750, and the *Illustrated News,* 411. Homer drew fewer then 30, all for the *Weekly.*[15] His reputation as a major illustrator of the Civil War took shape in the early decades of the twentieth century and rests on the quality of his work rather than on its quantity.

The Confederate states had no pictorial magazines. Through an unexpected circumstance, however, they gained extensive coverage during the war from a single source: the *Illustrated London News.* Frank Vizetelly, brother of Henry who had aided Ingram in bringing that magazine to world prominence, had become a highly successful illustrator for the pictorial press in London and Paris. In 1859 and 1860 he had traveled much in Italy covering Garibaldi's campaigns in word and picture. By July 1861 he was in the United States as the *Illustrated London News*'s special artist for the Civil War. Unusual among "specials," Vizetelly wrote the commentaries that accompanied his illustrations.

He was remarkably candid in his observations. In reporting the First

Battle of Bull Run in July 1861, in which he described the Union forces in flight as a "disgraceful rout, for which there was no excuse," he so deeply offended the Union military command that he was refused further permission to visit the front.[16] As a consequence, he changed sides. He aligned himself with the Confederacy as a special artist and traveled with its troops and leaders throughout the war and even after Lee's surrender at Appomattox. Far more comprehensive than Homer's Civil War work, Vizetelly's 133 Civil War subjects, which ranged from Vicksburg in the west to Charleston in the east, and from Georgia in the south to Virginia in the north, remain an invaluable historical record of the South's military efforts. Because they were published in London, these illustrations had little circulation in the Confederacy during the war.[17]

Vizetelly, the Wauds, Forbes, Davis, and a few others were special artists on the move. They lived with troops, endured hardship, risked danger, and for four years sketched a constantly shifting world of war. They presumably had no aims as artists other than to document what they saw. Homer was an artist with different goals. His best war illustrations came from his studio rather than from the war front. They are syntheses of sketches, memory, and invention.

Having announced in July 1861 that it would have special artists in the field, the *Weekly* in October made Homer part of that loosely knit group. It assigned him to Washington in the expectation that he would visit and make drawings of the military camps that had sprung up near the city, and from which skirmishers would venture out to engage with such enemy as they could find. On October 8, Harper provided Homer with a letter of introduction identifying him as a "special artist attached to *Harper's Weekly* . . . [and] detailed for duty with the Army of the Potomac."[18] The letter requested commanding officers and others to allow Homer, insofar as "the interests of the service will permit," to move about and draw.

At about the same time. Homer wrote to his father in Belmont: "I am off next week as you know. I am instructed to go with the skirmishers in the next battle. . . . I get $30. per week, RR fare paid, but no other expenses. Any letters you can give me to parties in Washington I should like. I shall have some from Harper's to [General George] McClellan, etc, perhaps you can get one to Genl [Nathaniel] Banks [recent governor of Massachusetts and now commander of the Union forces in northern Virginia]. . . . P.S. I go on Wednesday afternoon."[19]

In Washington on October 15, Homer received a pass from an adjutant to General McClellan allowing him "within the line of main guards

one week. . ." [20] A week later, on the 22nd, he was back in Belmont to cel-
ebrate Thanksgiving with his family.[21] By the 28th he had returned to
Washington. His mother reports this in a letter of that date to her
youngest son, Arthur, saying that: "Win . . . scaled a parapet while out
sketching and was [nearly taken?] for a prisoner when they saw his book
[sketching pad?] and the only wonder was that he was not shot, his head
popping up on such high places. . . . He is very happy and collecting ma-
terial for future greatness." [22]

She was quite right in her appraisal. The drawings that he had begun
to make in the military camps in Virginia would within the next few years
form the foundation of his career as a painter.

9

The War and Its Aftermath

1861–1866

THE FIRST published evidence of Homer's initial trip to the Civil War battlefront in northern Virginia came with his *A Night Reconnaissance,* published in October (*HW,* October 26, 1861, fig. 9.1). In this subject soldiers crawl up a bank topped with corn stalks and pumpkins to gain a view of a Confederate encampment. The small illustration carries no signature and its maker is unmentioned in the text, but the kinetic distinctiveness of its figures leaves no doubt that Homer drew them. Indeed, the chief question relating to the making of the illustration concerns the location at which it was put on the block. He may have returned to New York by train for this task, perhaps on his way home for Thanksgiving. But he may instead have mailed his drawing to Franklin Square to be copied onto a block by a member of the *Weekly*'s art room staff. Because it was a product of the relatively brief time he spent as a salaried Harper & Brothers artist, Homer presumably received no separate fee for this illustration.

His much larger illustration the double spread *The Songs of the War* (*HW,* November 23, 1861, fig. 9.2) probably also fulfilled obligations remaining from his weeks on assignment in Virginia. No evidence survives on this matter, but Homer's inclusion of six subjects deriving from his time in the Union army camps must have had something to do with his publisher's expectations. In his earlier *Night Reconnaissance* he had offered little more than a straightforward record of things observed on an excursion with scouts to the edge of enemy territory. His *Songs* vignettes also derive from drawings made in the field, but he recomposed them in New York after his return from Virginia. The illustration's subject echoed the activity of music publishers in the North in bringing out for popular

9.1. *A Night Reconnaissance,* 6⁷/₈ x 9¹/₄ in. *HW,* October 26, 1861.
American Antiquarian Society.

9.2. *The Songs of the War,* 14 x 20 in.*HW,* November 23, 1861. Mary and
Mavis P. Kelsey Collection, Cushing Memorial Library and Archives,
Texas A&M University.

audiences songs, marches, and dances related to the war, many with lithographed pictorial title pages.

In his vignette titled "Hail to the Chief," Homer depicts General McClellan passing before his troops. This is the sole instance in which Homer made a high-ranking officer the center of attention in an illustration. He otherwise concerned himself with the life of the ordinary soldier. It was this life, of course, that especially interested the *Weekly*'s readers, many of whom had seen a friend, relative, or acquaintance go off to the war. Other artists, including Parsons, made something of a specialty of drawing likenesses of generals for the pictorial weeklies, nearly always adapting them from photographs.[1]

Only the "Dixie" vignette at lower right refers to the South. Homer's preliminary sketch for *Songs* (Prints and Photographs Division, Library of Congress) includes a different concept for this detail.[2] The rough shows black workers—slaves, perhaps—bent by heavy burdens as they pass before a covered wagon. They constitute an image of an oppressed people. The title of the bugle call "Reveille" appears on the side of the wagon. Its specific meaning in this context, once clear, is now ambiguous. In reworking the detail for publication Homer placed a restudied version of one of the burdened figures in the background but devoted the foreground to something new. This was his depiction of an African American seated atop a large cask marked "contraband." The term applied to both the goods in the barrel and the man himself.[3]

Homer took this figure from a watercolor wash drawing he had made at the front (Cooper-Hewitt National Museum of American Design, Smithsonian Institution). The *Weekly* may have suggested to Homer that he alter the vignette's original design in some way, but Homer himself surely reconceived this detail. His new version brings this detail closer in mood to the others.

As a group the vignettes offer a positive report on army life. Even the "Rogue's March" seems good-humored. In setting a scene of slavelike labor as a backdrop for the quietly thoughtful man who sits on the cask, Homer emphasized the apparent good fortune of those blacks freed by the army as "contraband." The moment was, in a sense, reveille time for freedom. Homer's figure remains one of his most affecting from the war years.[4] A window behind the figure reveals a sentinel atop a bastion, perhaps referring to the Union's stronghold at Fortress Monroe on the York Peninsula.

A month later the *Weekly* published another double-page spread by Homer. This was one of the most ambitious graphic works of his early ca-

9.3. *A Bivouac Fire on the Potomac*, 13¹³/₁₆ x 20³/₁₆ in. *HW*, December 21, 1861. Mary and Mavis P. Kelsey Collection, Cushing Memorial Library and Archives, Texas A&M University.

reer: *A Bivouac Fire on the Potomac* (*HW*, December 21, 1861, fig. 9.3). Based largely if not entirely on sketches made in the field, it depicts a large group of soldiers gathered around a campfire. There are more than three dozen of them, each individualized and all convincingly integrated into a scene of relaxed good feeling. A few play cards or are otherwise occupied, but most watch an African American who springs into the air while performing a dance by the fire.[5] Like the figure atop the cask in *Songs*, he is probably contraband. A black fiddler supplies the music for the dance. Firelight plays on the figures in the middle ground while it casts most of those in the foreground into silhouette. The richly varied faces give no hint of the emotions of war.

At left an officer stretches out in a field chair. The reclining figure next to him seems to have an overly large head—Homer may have traced this figure onto the block directly from a sketch without feeling a need to slightly reduce its scale. The caricatured grins of the fiddler and the soldier just left of the dancer intrude on an otherwise realistic scene. From figure to figure hands and faces are full of expression, as they rarely were in the work of other special artists. A moonlit sky and lantern-lit tent in-

teriors act as counterpoints to the campfire as sources of light. The complexity of design and the richness of detail suggest that at some point Homer envisioned this subject as a painting.[6]

Both *Bivouac Fire* and *Songs of the War* present life in Union army camps as orderly and at times pleasant. Neither gives evidence of the hardships endemic to the camps, though, as his surviving field sketches attest, Homer saw and recorded much that was unpleasant and even harrowing.[7] Both illustrations appeared in the *Weekly* at a time when the situation in Virginia remained relatively quiet as McClellan slowly readied his army for a planned drive to Richmond. Meanwhile, Homer returned to New York, where he chose a subject from the home front for his next illustration: *Great Fair Given at the Assembly Rooms, New York, December 1861, in Aid of the City Poor* (HW, December 28, 1861). Within this assembly of finely attired visitors to the fair he included a soldier at a foreground booth to serve as a reminder of the war and its role in enlarging the numbers of the needy. He almost certainly based his *Christmas Boxes in Camp—Christmas 1861* (HW, January 4, 1862) on earlier sketches, reports in the press, and his own invention.

February 1862 found him back in Washington and once again preparing to report the war. In mid-March McClellan at last began to move the Army of the Potomac by ship from Alexandria and its environs down the Potomac and along Chesapeake Bay to the James River and the York Peninsula. His army took up positions before the Confederate fortifications at Yorktown, the first impediment in his projected drive to Richmond. On April 1 Homer obtained for the second time a pass that allowed him to visit army camps at the front. He was again a special artist, but now on a freelance basis rather than salaried. With troops at last on the move, a greater sense of urgency motivated all the special artists in Virginia. On the day he obtained his pass, he sent to John Bonner, the editor of *Harper's Weekly*, a drawing of troops leaving Alexandria for Fortress Monroe. He wrote on its back a message indicating that he was about to follow them and would head for General Sumner's division.[8] The *Weekly* made no use of the drawing.

In General Edwin Sumner's Second Corps was Lieutenant Colonel (later Brigadier General) Francis Channing Barlow, Homer's friend from Cambridge days. Homer joined the headquarters camp of Barlow's 61st Regiment of New York Infantry. For most of April he was with Barlow, ranging out to witness skirmishes and other action. He sketched many individual soldiers, including the dead and wounded. Just after the war ended he used a profile rendering of Barlow's head to top the figure of the

Union officer in his warmly received painting *Prisoners From the Front* (Metropolitan Museum of Art).[9]

With no woodblocks readily available, Homer mailed his drawings to the *Weekly*. He did so in the expectation that once Chapin or Bonner or perhaps even Harper had selected a drawing for publication, a staff artist would copy it onto a woodblock in the magazine's art room and it would reach publication as an independent work. He expected further that each published drawing would net him twenty-five dollars. This was a sum less than his usual fee owing to the *Weekly*'s need to pay a staff artist to copy the drawing onto a block. But when *Our Army Before Yorktown, Virginia—from Sketches Mr. A. R. Waud and Mr. W. Homer* (*HW*, May 3, 1862, fig. 9.4) reached publication, Homer found to his dismay that four drawings he had assumed would be published individually had in fact been reduced to vignettes in a single composite work. The *Weekly* had used his four sketches along with three by Alfred Waud to make up this composite. Each artist received only twenty-five dollars for his contribution—in effect, payment for a single drawing rather than the number used. In Homer's case this meant twenty-five dollars instead of a

9.4. *Our Army Before Yorktown, Virginia—from Sketches by Mr. A. R. Waud and Mr. W. Homer*, 13³/₄ x 20³/₄ in. *HW*, May 3, 1862. Mary and Mavis P. Kelsey Collection, Cushing Memorial Library and Archives, Texas A&M University.

hundred. His resentment over what he saw as high-handed action lingered for years. Four decades later he was still indignant as he recalled the incident to his friend John Beatty.[10]

To make matters worse, nothing in or accompanying this composite illustration specified which artist had drawn which vignette. The legend stated only: "From Sketches by Mr. A. R. Waud and Mr. Winslow Homer." In his recounting of the event to Beatty, Homer specified that the *Weekly* had used four of his drawings. Homer's preliminary field sketches for two of the vignettes, "Rebel Works Seen from General Porter's Division" and "Reconnaissance in Force by General Gorman," survive (Prints and Drawings Department, Museum of Fine Arts, Boston).[11] On the basis of style, "Berdan's Sharpshooters Picking off the Enemy's Gunners" seems to be Homer's work; the tense figure at right is characteristic of Homer and not of Waud. "The Ocean Queen Carrying Troops to Yorktown" is probably not by Homer, for a drawing he had made of the ship on April 5 is quite different from the published view.[12] Waud might also have seen and drawn the ship. The fact that Barlow's unit is shown in "Religious Services in Camp of 61st New York Volunteers" offers a basis for claiming that vignette as Homer's fourth, though it possesses few of Homer's strengths of design. The remaining vignettes may be attributed to Waud: "The Enemy's Works at Yorktown" and the small "Assault on Rebel Battery at Lee's Mills."

Homer apparently complained to Bonner and Chapin not only about his payment but also about the inadequate crediting of his authorship. Thereafter, whenever the *Weekly* published his work it placed his name prominently in the caption or in the engraved illustration itself. Never again did he share space in an illustration with another artist.

He had found the procedure of sending drawings to the *Weekly* from Virginia unsatisfactory on another count as well. In addition to his unhappy experience with pay and credit, he found his role as a pictorial reporter in conflict with his emerging self-image as a fine artist. To be a feeder of drawings to an art room whose draftsmen then reworked them for publication was antithetical to his self-concept as an independent worker. Still, the time he spent in Virginia in 1861 and 1862—probably ten weeks or so—proved invaluable. The sketches he made there became the raw materials for most of the rest of his Civil War illustrations. They sustained his memory as he worked on his first Civil War paintings.

While *Our Army Before Yorktown* was a source of discontent, the illustrations that immediately followed it must have intensified his consternation. Other sketches he sent back from the front in April reached

print in May. His theatrically posed *Rebels Outside Their Works at Yorktown Reconnoitering with Dark Lanterns* (HW, May 17, 1862) may have come from distant observation, but it was also aided by his imagination. In its published form the foreground foliage, probably added by the engraver, is badly drawn. Two other illustrations in the same number, *The Union Cavalry and Artillery Starting in Pursuit of the Rebels Up the Yorktown Turnpike* (HW, May 17, 1862) and *Charge of the First Massachusetts Regiment on a Rebel Riflepit Near Yorktown* (HW, May 17, 1862), are more naturalistic. In the former a hot air observation balloon rises above the distant horizon. *The Army of the Potomac—Our Outlying Picket in the Woods* (HW, June 7, 1862) is routine in concept and ill-drawn.

The caption for each of these four illustrations includes the phrase "sketched by Mr. Winslow [or 'W.'] Homer." The use of "sketched" rather than "drawn" was the *Weekly*'s assurance to readers who knew Homer's distinctive style that his presence at the front had not allowed him to make the final woodblock drawings. In this way the magazine emphasized the authenticity of the images as reports from the field while explaining the inferior quality of the drawing in certain of the works. The ill-drawn foreground in *Rebels Outside Their Works,* and the lackluster definition in much of *Charge of the First Massachusetts* and *Our Outlying Picket* undoubtedly came from the art room's lesser staff, perhaps even apprentices. Only *The Union Cavalry and Artillery* preserved Homer's distinctive style, perhaps because his sketch was more fully developed or was drawn on the block by a more able copyist.[13]

By the time they reached print, these illustrations were anticlimactic. The Confederate forces that had held a reluctant McClellan and his army before Yorktown throughout April slipped away in early May to take new positions closer to Richmond. The long awaited major battle for Yorktown never occurred. As the warm season with its discomforts began, Homer returned to New York, probably by late May or early June. On June 7, 1862, his mother wrote to her youngest son, Arthur, that Winslow's time in Virginia had been difficult and that he came home "so changed that his best friends did not know him." She added that though he was back in New York, he was "not doing much, just paying his expenses."[14] Precisely what Henrietta Homer meant by "changed" is unclear, but the youthful zest for life of his Boston illustrations would not again be part of his style. His closeness to death, disease, and the suffering of the wounded left its mark.

When Homer's mother noted that he was not "doing much" in June 1862, she surely meant that he was not getting his painting career under-

way. He was busy otherwise, however. Immediately following his return to New York he sold the *Weekly* the first of a group of five illustrations that reached its pages between June and September. Following the not very satisfactory translation of the sketches he had sent from the front, these five demonstrated that his powers as an illustrator were again at full tide.

He began with a composite design, *News from the War* (*HW,* June 14, 1862, fig. 9.5), a work full of skillful drawing and fresh observation built around the war's modes of communication—letter, telegraph, rider, bugle, train—and events associated with them. In a vignette at lower left a special artist, long believed to be Waud, draws two unusually tall soldiers. At right, the "newspaper train" brings fresh news from the presses to the front. *Harper's Weekly* is prominent among the magazines.

This detail alludes to an incident that had occurred during his stay in Barlow's camp. That visit had been in some ways a happy one despite its rigorous circumstances. On April 18 Barlow had written to one of his brothers that he had been enjoying the presence of another brother and Homer "exceedingly." He said that "it seemed quite like home to have them here and I have not laughed so much since I left home. . . . [Barlow's brother] and Homer have done the cooking." [15] But on the 23rd, he wrote

9.5. *News from the War,* 13⁵/₁₆ x 20³/₈ in. *HW,* June 14, 1862.
Syracuse University Art Collection.

that "We have yesterday's [New York] *Herald*. . . . We were much amused to read that *Harper's* of last week had been suppressed. It had nothing of Homer's in it but we regard his occupation [as a special artist] as gone. He now does not dare to go to the front [lines] having been an object of suspicion even before. He says he will go home after the battle." [16]

The suppression of the *Weekly* mentioned by Barlow occurred at Fortress Monroe when the local military command confiscated copies of the April 26 number out of fear that its birds-eye view of Yorktown's fortifications might mislead Union troops and prove useful to the Confederate forces. The implication of this action was that pictorial weeklies and their special artists posed threats to the military effort. In its next two numbers the *Weekly* argued that good editorial judgment would prevent such compromises of security in the pictorial press, but its supposition that editors had expert knowledge of military matters was not persuasive. Yet, little further suppression occurred, soldiers still welcomed newspaper trains, and special artists remained within the Union camps for the rest of the war. [17]

Waud and most of his colleagues in the field continued to send the weeklies a steady stream of drawings from the theatres of war. But Homer for the most part ceased to be a special artist reporting from the front. In New York he composed striking images of the conflict from what must have been a bulging portfolio of field sketches. Some of these drawings have survived. Most are in the collections of the Smithsonian Institution's Cooper-Hewitt National Museum of Design, the gift of Homer's brother Charles to the present museum's predecessor institution, the Cooper Union Museum. (Other of Homer's Civil War sketches were probably among drawings destroyed by rodents when portfolios in his studio at Prout's Neck in Maine were left unattended during the winter following his death in 1910). [18] Homer returned to the theatre of war in Virginia probably in 1864 and certainly in 1865, but whatever sketches he made on these later visits informed his oils more than his woodblock drawings.

He followed *News of the War* with a pair of scenes unique among his Civil War illustrations: *The War for the Union, 1862—A Cavalry Charge* (*HW*, July 5, 1862) and *The War for the Union, 1862—A Bayonet Charge* (*HW*, July 12, 1862, fig. 9.6). These depictions of pitched battle purport to show combat as it might have been seen by an observer in the midst of the engagement. At a time of mounting reports of casualties, the *Weekly* may have asked for such subjects as a change from his more placid scenes of camp life. Homer had witnessed skirmishes from afar

9.6. *The War for the Union, 1862—A Bayonet Charge,* 13⁵/₈ x 20⁵/₈ in. *HW,*
July 12, 1862. Syracuse University Art Collection.

but it seems hardly possible that he or any other special artist experienced larger-scale battle at the close range depicted in these two illustrations. Both owe much to Homer's powers of imagination, but they also reflect his intimate knowledge of soldiers and battle sites. Within the subgenre of nineteenth-century battle art as it served the pictorial press, the two images are remarkable in their coalescence of realism and invention. As exciting reports on the war's most mortal moments, they possess a largeness of concept and an intensity of focus unequalled in the work of other special artists or in the lithographs of battle scenes issued by print publishers.[19]

The Surgeon at Work at the Rear During an Engagement (*HW,* July 12, 1862, fig. 9.7) is by contrast a convincingly documentary subject in which objectivity supplants bravura. This scene of a physician at work in an improvised field hospital amid gravely wounded men is among Homer's most quietly authoritative accounts of the war. An ambulance brings more wounded men from a battle visible in the distance. Two months later, in *Our Women and the War* (*HW,* September 6, 1862, fig. 9.8), he portrayed women who nurse the wounded, write letters for them, launder soldiers' clothes, and sew and knit for the war effort. This

9.7. *The Surgeon at Work at the Rear During an Engagement,* 9³/₁₆ x 13⁷/₈ 7/8 in. *HW,* July 12, 1862. Syracuse University Art Collection.

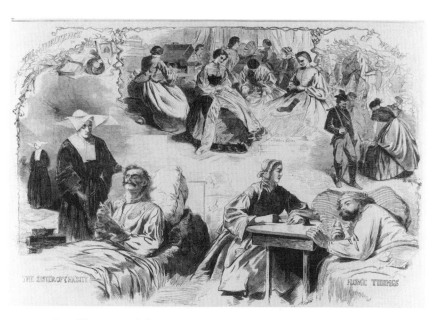

9.8. *Our Women and the War,* 13⁷/₁₆ x 20⁷/₁₆ in. *HW,* September 6, 1862. Syracuse University Art Collection.

work addressed the *Weekly*'s many female readers, but it must also have warmed more than a few hearts among the troops at the front.

The first significant public mention of Homer as a painter occurred in November 1862 with the publication of one of his illustrations. The caption of his *Army of the Potomac—A Sharpshooter on Picket Duty* (*HW*, November 15, 1862, fig. 9.9) announced that the artist had adapted the image from one of his paintings. The *Weekly* may have felt it prudent to mention this as a means of explaining to its readers why the illustration differed so much from Homer's previous contributions to the magazine. Its originality was not in its subject. Homer had, after all, depicted sharpshooters six months earlier in *Our Army Before Yorktown*. Other special artists had shown them as well, but not as Homer did here. His earlier sharpshooters fire from prone positions on the ground. He drew them from the viewpoint of a person standing a few yards away. Now he perched a solitary rifleman high in a tree, depicting him from the vantage point of a person on another branch (or, from all visible evidence, suspended in mid-air) and close enough to be within touching distance. The

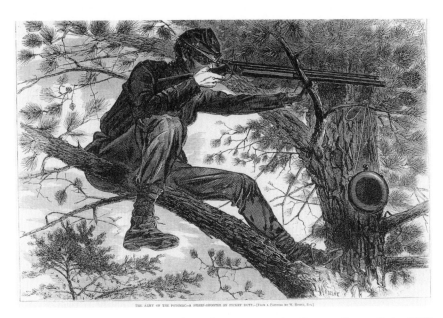

THE ARMY OF THE POTOMAC—A SHARP-SHOOTER ON PICKET DUTY.—[From a Painting by W. Homer, Esq.]

9.9. Army of the Potomac—A Sharpshooter on Picket Duty, 9$^{1}/_{8}$ x 13$^{3}/_{4}$ in. *HW,* November 15, 1862. Syracuse University Art Collection.

precariousness of the soldier's position, stabilized only by an extended arm grasping a branch and a heel propped against a limb, is intensified by the viewer's own levitated viewpoint. Then, too, the sharpshooter's presence virtually at the picture plane forces the viewer into a degree of intimacy with him that, considering his role as an agent of death, can be unsettling. Unlike Homer's earlier military subjects in which much is happening, this subject shows only a single thing: a rifleman taking aim. We see the still moment preceding the shot. Nothing else that Homer drew for the *Weekly* during the Civil War was so striking in its design or so powerful in its effect.

The credit line refers to the illustration's source painting, *Sharpshooter* (Portland Museum of Art, Portland, Maine; fig. 9.10), but that oil was unseen by the public for more than a year.[20] Indeed, Homer had not yet exhibited any oil paintings at the time his sharpshooter illustration reached print. He made his debut five months later, in April 1863, in the National Academy's annual exhibition, and not with *Sharpshooter*. He

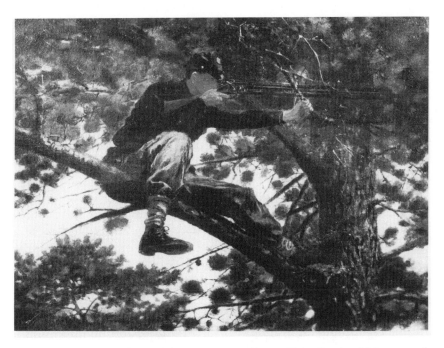

9.10. *Sharpshooter*, 1863. Oil on canvas, 12¼ x 16½ in. Portland Museum of Art, Portland, Maine. Gift of Barbro and Bernard Osher.
Photograph by Bernard C. Meyers.

exhibited two other Civil War subjects: *Home Sweet Home* (private collection) and *The Last Goose at Yorktown* (private collection). Although the *Sharpshooter* painting was sufficiently advanced in the fall of 1862 to allow him to adapt it for publication in the *Weekly*, he presumably worked on it further and dated it 1863. He exhibited it first at the Athenaeum Club in New York in January 1864 and then a month later at the Brooklyn and Long Island Fair in Aid of the United States Sanitary Commission.

In the Brooklyn exhibition the painting bore the title *Berdan Sharp Shooter*. This title referred to the Union's Colonel Hiram Berdan, who had selected and organized marksmen into elite sharpshooter regiments. He had already received much attention in the *Weekly*.[21] In the Army of the Potomac, sharpshooters used new, precision-tooled, long-range rifles fitted with recently developed telescopic sights. This was a new kind of weapon; in trained hands it could pick off an enemy at a distance of a few hundred yards. In the uneasy stalemate before Yorktown, Union sharpshooters in rifle pits exacted a substantial toll of pickets, gunners, and others. With greater fields of fire, sharpshooters stationed in trees were even more deadly. They were also at greater risk, for their elevated positions exposed them to enemy riflemen who scanned distant treetops for telltale puffs of smoke.

In his illustration for the *Weekly* Homer placed the sharpshooter closer to the picture plane than he had in his slightly larger painting. As a result, the figure gains in boldness. Homer drew less foliage in the illustration to make it possible to define the figure's dark form against open sky. In the painting foliage hides the figure while color defines it. A canteen hangs on the tree trunk only in the illustration, suggesting long stays in this uncongenial site and offering a prop for viewers eager to build some kind of narrative around the image. The canteen's concentric rings suggest a target, reinforcing a marksman's mindset.

From a comment Homer made a third of a century later it is possible to wonder whether he meant his *Sharpshooter on Picket Duty* to be a statement against snipers. He said in a letter to a friend in 1896 that the use of telescopic sights by sharpshooters had struck him "as being as near murder as anything I could think of in connection with the army, and I always had a horror of that branch of the service."[22] His thought was, of course, that in a killing battle of the kind he depicted in *A Bayonet Charge* combatants were on more equal terms, if only in their certain knowledge that a battle was underway. In contrast, sharpshooters picked off individuals who were sometimes unaware of the presence of danger. There was a certain unfairness to this situation—unless one believed the

maxim that all's fair in war—but it counted for little within the context of the wholesale slaughter by more conventional means that by late 1862 had come to characterize modern warfare. Newsworthy though they were, these solitary riflemen made little difference in the outcome of the war.

In his remarks to his friend about murderous telescopic sights, Homer made no complaint about the war itself. His "horror" of the army (as opposed, presumably, to the navy, in which his brother Arthur served) undoubtedly came at least in part from his experiences in Virginia in 1862. But it is difficult to find any openly editorializing comment in this image of a marksman in a treetop. The *Weekly*'s readers surely accepted it as an objective news report on an already somewhat familiar subject, a report made unusually vivid through Homer's presentation.

The Civil War illustrations that he drew for two years following his depiction of the sharpshooter are impressively varied in their subjects. Though he composed all of them in New York and based them to a large extent, if not entirely, on sketches made in 1861 and 1862, there is little sameness to them. Though he now directed much of his creative energy to painting, his illustrations continued with a few exceptions to be fresh in concept and execution. The slow sale of his paintings, even at low prices, kept him drawing on the *Weekly*'s blocks.

His *Thanksgiving in Camp* (HW, November 29, 1862) and *Winter Quarters in Camp—The Inside of a Hut* (HW, January 24, 1862) emphasize the rough edges of the common soldier's life. Sketches for figures in the former also served his painting of 1863, *The Sutler's Tent* (private collection).[23] The wild-eyed African Americans in *A Shell in the Rebel Trenches* (HW, January 17, 1863, fig. 9.11) are largely products of Homer's invention, but he probably took the fascine-built revetments behind them from his sketchbooks. In its accompanying text the *Weekly* observed that: "We continue in this number our illustrations . . . from sketches by our special artists in the field." Homer had not, of course, been in the field for several months, and he could not in any event have closely observed a scene within enemy fortifications. The *Weekly* further added that: "The secesh [secessionist] chivalry generally places their Negroes in the post of danger." Eight months earlier it had published an illustration sketched from telescopic observations by a "Mr. Mead" titled *A Rebel Captain Forcing Negroes to Load Canon Under the Fire of Berdan's Sharpshooters.* The commentary noted that these slaves, who were forced at pistol point to man exposed gun emplacements, were picked off by Union sharpshooters one by one.[24]

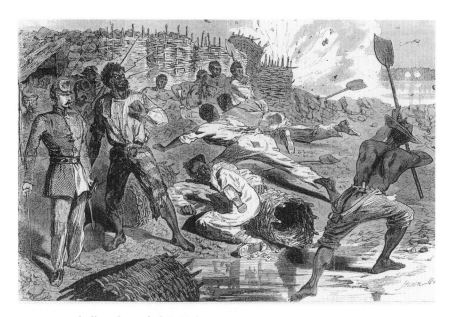

9.11. *A Shell in the Rebel Trenches*, 9¹/₈ x 13¹³/₁₆ in. *HW*, January 17, 1863.
Syracuse University Art Collection.

The issue of the *Weekly* in which Homer's *A Shell in Rebel Trenches*
appeared carried on its front page an illustration by Waud of a duel with
whips between two black mule drivers.[25] There is some irony in the fact
that these illustrations concerning blacks reached print in the number of
the *Weekly* that included that magazine's first printing of President
Lincoln's recently issued Proclamation of Emancipation. A week later the
magazine published an appropriately emblematic illustration on emanci-
pation by Thomas Nast.[26] Homer concluded this sequence of subjects
from Virginia with his *Pay-Day in the Army of the Potomac* (*HW*, Febru-
ary 28, 1863). Memory and invention as well as sketches informed the
composite illustration.

He now turned for a while to war-related subjects in other locations.
The *Great Sumter Meeting in Union Square, New York, April 11* (*HW*,
April 25, 1863) is unsigned, but the women on the parapet and the ener-
gized figures in the square below are drawn in Homer's distinctive man-
ner. *The Approach of the British Pirate "Alabama"* (*HW*, April 25,
1863), largely a product of his imagination, presents women on ship-
board alarmed by the appearance on the horizon of the heavily armed,
British-built Confederate cruiser that had terrorized the North Atlantic.
In the course of sinking Union merchantmen and warships, it had at-

tempted with some success, however, to minimize loss of life among crews and passengers. As the *Weekly* had reported rather blithely about the *Alabama* in its number for January 17, "[Captain Raphael] Semmes has not added murder to robbery. Indeed, the fascinated passengers of the Ariel report the marvelous politeness, which is traditional in the manner of pirates." In June, the *Alabama* was sunk by the Union's *Kearsarge* off Cherbourg in France. The crowd that watched the battle from shore and small boats included the painter Édouard Manet, who painted the subject.[27]

In the tossed-together *Home From the War* (HW, June 13, 1863), soldiers happily rejoin wives, mothers, and children. At the end of the year he drew two illustrations, *The Great Russian Ball at the Academy of Music, November 5, 1863* and *The Russian Ball—In the Supper Room* (both *HW*, November 21, 1863), but signed only the former. The latter suffers from hasty drawing as well as insensitive engraving.

Homer drew most of his illustrations of 1863 after Charles Parsons had succeeded John Chapin as head of the *Weekly*'s art room. Parsons' letter of acceptance, dated April 21, 1863, illuminates much about his position and the art room. He wrote:

> I agree to enter your Artists' Drawing Room as Superintendent of that department, and to work seven hours per day, and when required for your interest, will work any additional time that may be needed either during the day or evening, without extra charge, in the spirit of making your interest mine to the best of my ability. And that you give me the right of being absent a day or two now and again through the summer months, when it can be granted without detriment to the business. My salary . . . to be fifty dollars and my term of service one or more years, either party, when desirous of ending the contract, to give three months notice.[28]

He served for twenty-six years as head of the art room. His association with the *Weekly* had begun earlier when he had contributed woodblock drawings in the late 1850s. In the early 1860s he drew Civil War subjects, some allegorical and none giving evidence of familiarity with army camps.[29] From at least mid-1863 to 1875, he reviewed and accepted Homer's submissions. It is easy to wonder what may have passed between them when Homer in the mid-1860s and then again in the early 1870s broke his association with Harper & Brothers' publications to ally himself temporarily with other pictorial weekly magazines. But Parsons

seems always to have welcomed him back with, as Kelly remembered, "marked consideration."

In 1863 the painter Roswell Shurtleff asked Homer what price he meant to put on his sharpshooter painting. He responded that it would be not less than sixty dollars, for that was the fee he then received from *Harper's Weekly* for a large illustration, probably a double-page spread, drawn on the block.[30] This was more than Parsons' weekly salary, though of course Homer received such fees infrequently. Indeed, now that he was deeply involved in painting, he produced many fewer woodblock drawings. He drew only three illustrations for the *Weekly* in 1864. In the first of these, *Halt of a Wagon Train* (*HW*, February 6, 1864, fig. 9.12), a group in the foreground is loosely gathered around a campfire. Unlike the comradely closeness of the figures in his *Bivouac Fire* two years earlier, these tired soldiers and mule drivers are scattered and have no unifying central point of interest. Optimism has flown and with it the bright spirit of *Songs* and *Bivouac Fire*.

"Anything for Me, If You Please?" Post Office at the Brooklyn Fair in Aid of the Sanitary Commission (*HW*, March 5, 1864) took Homer's viewers away from army camps to the site of the elaborate exposition organized to collect funds for the care of the war's sick and wounded. This

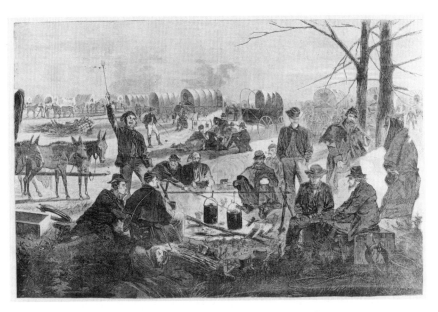

9.12. *Halt of a Wagon Train*, 13³/₈ x 20¹/₂ in. *HW*, February 6, 1864.
Syracuse University Art Collection

was the venue in which his sharpshooter painting received its first exposure to the general public. The illustration makes no reference to that work, or to any of the art on display, though the dandified figure at the post office window intimates an aesthetic presence within the great hall.

Nine months later, *Thanksgiving-Day in the Army—After Dinner* (*HW*, December 3, 1864) was one of Homer's sparest images. Its larger figures are in the manner of his Civil War paintings. An exception among those paintings was his *Skirmish in the Wilderness* of 1864, with its distant view of soldiers firing among great trees. Homer claimed to have observed some part of the Battle of the Wilderness in Virginia in early May 1864. If so, this may have been the first time he had observed combat since the spring of 1862. The last of his military camp illustrations, *Holiday in Camp—Soldiers Playing "Foot-Ball"* (*HW*, July 15, 1865, fig. 9.13) reached publication soon after the end of the war. He may have meant it as an emblem of peace—soldiers here battle for a ball rather than for their lives. The illustration's weakness in composition and drawing suggests that Homer rushed it to completion or, if the caption

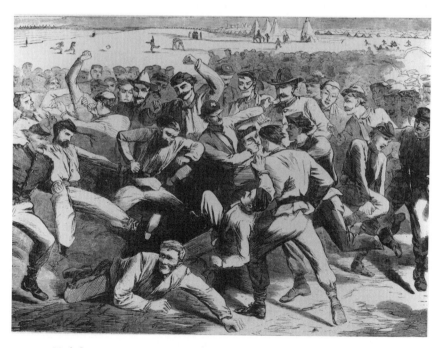

9.13. *Holiday in Camp—Soldiers Playing "Foot-Ball,"* 9¹/₄ x 13¹³/₁₆ in. *HW*, July 15, 1865. Private collection.

"sketched by Winslow Homer" is to be taken literally, then he let some-
one other than himself make the final drawing on the block.

In May 1865 the National Academy of Design elected Homer to its high-
est rank, that of Academician. This was the most prestigious honor to
which an American painter of his generation could aspire. It was no small
measure of the critical esteem for his paintings that the academy had con-
ferred this honor on him less than two years after he had been one of its
part-time students. Had his paintings enjoyed as much success in the
marketplace as they did among fellow painters and critics, Homer would
in all likelihood have informed Parsons that *Holiday in Camp* was the
last of his woodblock drawings.

His income from his paintings remained inadequate, however. Per-
haps in need of ready cash, during his summer travels he returned to New
York to draw on the block a pair of subjects from fashionable resorts he
had visited. Both works appeared in the *Weekly* for August 26, 1865. He
set *Our Watering-Places—Horse-Racing at Saratoga* (*HW*, August 26,
1865, fig. 9.14) in the upper tier of the racetrack's stands. The illustration

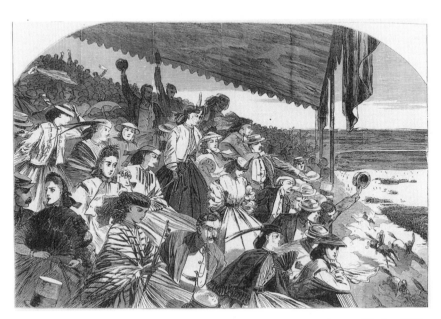

9.14. *Our Watering-Places—Horse-Racing at Saratoga*, $9^{1}/_{8}$ x $13^{13}/_{16}$ in. *HW*,
August 26, 1865. Syracuse University Art Collection.

has as much to do with women's fashion as with the sport of its title. The scale of the distant figures defies all explanation, for the racetrack at Saratoga Springs was never so vast. *Our Watering-Places—The Empty Sleeve at Newport* (*HW*, August 26, 1865, fig. 9.15) accompanies a highly contrived short story by an anonymous author titled, "The Empty Sleeve at Newport; or, Why Edna Aukland Learned to Drive." Homer's image presents a man who has lost his arm in battle and who still wears his army cap. He rides in a chaise driven by his wife.

The story ends with a short passage that attempts to explain what Homer had drawn. A comparison of text and image supports a conclusion that Homer's drawing came first and that the author developed the story around it. The author concludes: "His eye is on the road and his voice guides her; so that, in reality, she is only his left hand and he, the husband, drives." But in Homer's drawing it is the woman whose eyes are intently on the road while her husband's turn toward the sea. The author makes the woman "only" an extension of her husband, but Homer presents her as the person in charge. He makes her an example of the emerging postwar generation of New American Women—more independent, resourceful, and active in public life than the women who had preceded them.

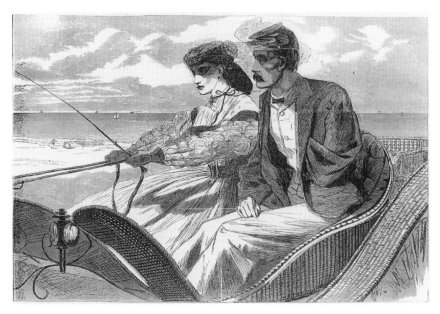

9.15. *Our Watering-Places—The Empty Sleeve at Newport*, $9^{3}/_{16}$ x $13^{13}/_{16}$ in. *HW*, August 26, 1865. Syracuse University Art Collection.

In its composition, *The Empty Sleeve* was the first illustration since his sharpshooter in which Homer pressed a figure so dramatically close to the picture plane. The results, however, are wholly different. The image of the sharpshooter explains itself—the viewer needs to know no more than what Homer shows. By contrast, the man and woman in the carriage seem to be part of a narrative, one implied by Homer and spelled out, tediously and presumably without his collaboration, by the story's author. Like *Horse-Racing at Saratoga*, Homer's Newport subject speaks of a nation returned after wartime struggles to the pleasures of peace. But unlike its companion, *The Empty Sleeve* carries a reminder of the cost of the struggles. Yet, judging from the preponderance of images in *Harper's Weekly* and *Leslie's* that paid no mind to the recently ended war, Homer's unsentimental Saratoga subject was more closely in tune with its times.

At this point Homer ended his first long association with the *Weekly*. He had already been busy on the woodblock for another publisher, however. In June and July 1865 he drew a sequence of ten literary illustrations for *Frank Leslie's Chimney Corner*. This was one of the several magazines that Leslie had underway in New York. Mostly small in scale, the drawings illustrated sensational stories by M. E. Braddon and other writers. Most of this work leaves little doubt that Homer tossed it off as a source of quick income. That he chose to sign none of the illustrations is hardly surprising for an artist recently elected to high rank in the National Academy and aiming to guard his reputation. Yet the series contains enough of his distinctive figure work to affirm his authorship. The largest of the group, "He Sees the Rigid Features, the Marble Arms, the Hands Crossed on the Cold Bosom," for Braddon's *The Cold Embrace*, is also the most fully developed.[31]

These illustrations were the first Homer had drawn for any magazine other than *Harper's Weekly* since his arrival in New York five and one-half years earlier. They led to a further, more important association late in the year with Leslie's publications. How Homer came to make three highly interesting drawings for the *Illustrated Newspaper* and one more for the *Chimney Corner* is not known, though it is fair to assume that Leslie paid him well.

All four are subjects of notable originality. They differ in mood and concept from any of his previous illustrations. With the exception of a single detail, they sustain a dignity befitting a National Academician. Their figures are more carefully studied and serve more serious ends than those of many of his earlier illustrations. There is no sign of the upbeat bustle of Homer's work of the 1850s and early 1860s. Instead, he distilled anecdote

into essence. Perhaps the experience of the war had diminished the naïvely simple view of the world that permeated his early work.

The first of the four, the sensitively drawn *Looking at the Eclipse,* came forth in the *Chimney Corner* (CC, December 16, 1865, fig. 9.16). Its title refers to the passage of the moon in front of the sun two months earlier on the morning of October 19. This had been the first eclipse of its kind visible in New York since 1854. Early in the morning heavy cloud

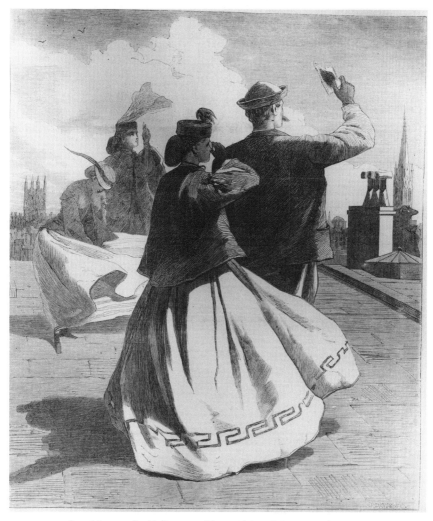

9.16. *Looking at the Eclipse,* 10³/₄ x 9¹/₄ in. CC, December 16, 1865.
American Antiquarian Society.

covered the city but by eleven, when the eclipse began, the sky had cleared enough to allow occasional views of the spectacle.[32] Homer's observers look at it through pieces of smoked glass. The gothic revival spire of James Renwick's Grace Church at right suggests that the rooftop is not far from Homer's Washington Square studio.

Virtually devoid of anecdote, the illustration makes its appeal through the quiet elegance of its figure drawing, its precisely tuned balance of parts, and its success in conveying sensations of moving air and darkening light. The breezes that clear the sky lift a hat-attached veil and move the women's skirts. The woman in the foreground wears a feather-decorated pillbox hat similar to those that appear in a few of Homer's paintings of the time.[33] In its composition and mood this illustration shares much with Homer's first group of paintings of women. He did not sign the illustration but the magazine added "by Homer" to its caption. While the remaining three subjects have no signature or credit line, their style leaves no question that Homer drew them. At this point he seems to have preferred to maintain a low profile in the popular arts while seeking to enhance his rising reputation as a painter.

His two Thanksgiving subjects in the *Illustrated Newspaper* in December differ greatly from his earlier festive treatments of that holiday. They do so in good part because the holiday itself had taken on special meaning in 1865. President Andrew Johnson had declared the first Thursday of December a day of national thanksgiving for the end of the war. Accordingly, Homer's *Thanksgiving Day—Hanging Up the Musket* (*FL*, December 23, 1865, fig. 9.17) and *Thanksgiving Day—the Church Porch* (*FL*, December 23, 1865, fig. 9.18) both refer to the aftermath of the great struggle. In the first of the two, a veteran, or perhaps his son, returns a musket to the wall above his fireplace. The musket's stock carries the year "1861." It will rest below an older, broken firelock whose powder horn is marked "1776." This linking of the War for Independence with the War Between the States implied that the latter was as "just" a war as the former, a view for which few of the *Weekly*'s southern readers would have held much sympathy.

Pictorial ceramic tiles on the fireplace portray biblical subjects ranging from Cain's killing of Abel through David's facing down of Goliath to Christ's carrying of the Cross, subjects that in this context allude to the ordeal of the war and the sacrifices endured by the nation. These tiles reappear in 1868 in *"Our Next President"—(U. S. Grant)*. The faces reflected in the mirror above the mantel are ambiguous. The enigmatic expression on the woman's face seems not to work in concert with the rest of the image, unless it is to be read as the face of a sorrowful widow or mother.[34]

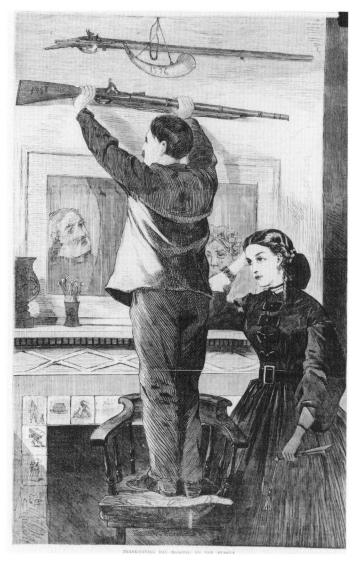

9.17. *Thanksgiving Day—Hanging Up the Musket,* 14³/₁₆ x 9³/₁₆
in. *FL,* December 23, 1865. Mary and Mavis P. Kelsey
Collection, Cushing Memorial Library and Archives, Texas
A&M University.

9.18. *Thanksgiving Day—the Church Porch,* 13¹⁵/₁₆ x 9¹/₈ in. *FL,*
December 23, 1865. Mary and Mavis P. Kelsey Collection,
Cushing Memorial Library and Archives,
Texas A&M University.

If the musket scene has unresolved problems of design and meaning, *The Church Porch* has none. Veterans in uniform, one of them an amputee, pass the younger members of this congregation as they emerge from a Thanksgiving service, setting the sobriety of the foreground figures against the distracted activity of those behind them. This work amounts to a more profound comment on the costs of war than the melodramatic *Empty Sleeve at Newport*.

In the double spread *Our National Winter Exercise—Skating* (FL, January 13, 1866, fig. 9.19), skirts fan out as a trio of women skate across the ice. A heels-up tumble at right exposes a crinoline cage. This bit of low humor seems out of place in a work otherwise serious in tone. Homer's close attention to the costumes leaves little doubt that he addressed this illustration primarily to style-conscious women, as he would increasingly do in the years ahead. The conical skirt, boxy tailored jacket, and pillbox hat then popular among young women offered Homer and other artists decorated three-dimensional forms of great visual interest. Homer depicted variations of this style in numerous works including *Horse-Racing at Saratoga, Looking at the Eclipse, The Church*

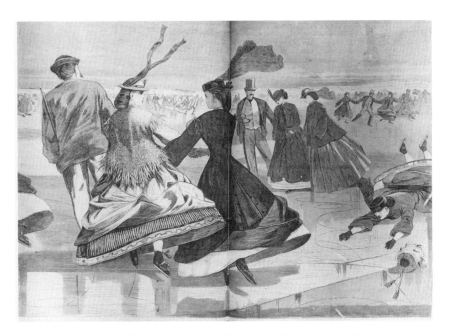

9.19. *Our National Winter Exercise—Skating*, 13⅞ x 20⅜ in. FL, January 13, 1866. American Antiquarian Society.

Porch, and this skating scene. He made effective use of the costume in several paintings in these years, among them his croquet scenes.[35]

For the time being, however, and with Leslie's cash in his pocket, he was at last ready to close the door firmly on his association with the pictorial press. He did so, and the door remained closed for nearly two years.

10

Paris and Its Influences

1867–1868

A s EARLY as the fall of 1861, Homer had hoped to visit Paris. The appeals of the city were multitudinous in the age of *la vie Parisienne*. In 1861 he would have wanted to gain a firsthand knowledge of the city's storied collections of art and to immerse himself for a while in a culture more sophisticated and cosmopolitan than New York's. By 1865, when he had become a National Academician, he would also have understood that a visit to Paris was virtually *de rigueur* for any painter who hoped not to seem provincial or parochial. But in 1866 he had an additional and more specific reason to visit Paris: two of his paintings were on exhibition at the Exposition Universelle, the great World's Fair of 1866–67.

He was thirty when he sailed in December 1866. He remained in France for eleven months, residing in Montmartre and at the village of Cernay-la-Ville, some twenty-five miles southwest of Paris.[1] His time in France involved no study, at least not insofar as study meant joining an atelier or otherwise acting to alter significantly what he had been doing as a painter. To the contrary, the evidence of his work suggests that he used his time in Paris to sharpen and intensify the French-founded style he had already developed in New York.[2] He had no compelling reason to change a style that had already made him a painter of growing repute.

His paintings at the Exposition were Civil War subjects: *Prisoners From the Front* (Metropolitan Museum of Art) and *The Bright Side* (Fine Arts Museums of San Francisco). Having been selected by an American committee to join a few dozen other paintings from the United States as representative of the nation's best work, they confirmed his status as a leading artist of the younger generation. (He must have been less than pleased, however, to find in one of the public reports of the American sec-

tion that his name had been misspelled as "Horner.") This recognition gave him further reason to build on what he had already been doing as a painter, though he undoubtedly absorbed and synthesized into his own method at least a few aspects of contemporary thought and practice in French painting. He probably also looked with a critical eye at the French pictorial weeklies, seeing them now in their own culture.

Homer had sailed to France with his friend Eugene Benson. Benson was both a painter and a critic and had been among Homer's most perceptive early champions.[3] He sailed home alone, borrowing the cost of his passage, and was back in New York by November 7, 1867.[4] In need of cash to repay the funds he had borrowed and to reestablish his studio in New York, he turned to *Harper's Weekly*. Parsons welcomed him back by buying four subjects of notable originality. Three of the subjects concerned Paris; one depicted his voyage home.

He had probably sketched the three Parisian subjects during his last weeks abroad in order to have roughs available for Parsons as soon as he returned. He must have drawn two of the subjects on woodblocks within a day or two following his arrival, for the *Weekly* had them engraved and published by November 16 in its number dated November 23. These illustrations were the first that Homer had drawn for any pictorial weekly in nearly two years.

The third and fourth of the illustrations reached print in December and January. Then, still dependent on income from the Harper firm, and evidently no longer viewing illustration as a somewhat demeaning sideline for a serious painter, he continued to bring drawings to Parsons. Perhaps his residence in a city that had long held popular illustration in high regard had made a difference. Paris was the city of Gavarni and Doré as woodblock artists and Daumier as a lithographer, and of Corot and Degas, who openly admired the magazine work of these graphic artists. Perhaps Homer's work as an illustrator was known by a few in Paris and brought him some appreciative comments. Something other than the need for cash revitalized his interest in drawing for the pictorial press, for the illustrations he drew for the Harper firm in the year following his return to New York are among the most original and adventurous of all his work for the weeklies.

The pair of subjects published directly after his arrival in New York in November introduced the *Weekly*'s audience to Parisian nightlife as it could be found in two popular upscale dance halls. These were *A Parisian Ball—Dancing at the Mabille, Paris* (*HW*, November 23, 1867, fig. 10.1) and *A Parisian Ball—Dancing at the Casino* (*HW*, November

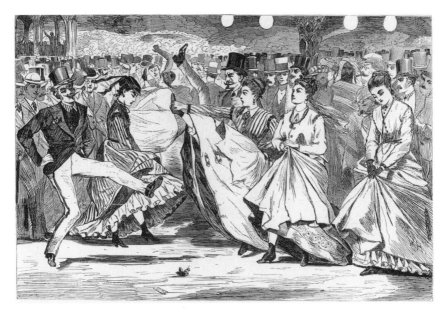

10.1. *A Parisian Ball—Dancing at the Mabille, Paris,* 9³/₁₆ x 13³/₄ in. HW, November 23, 1867. Syracuse University Art Collection

12, 1867, fig. 10.2). As was the case with the equally famous Moulin Rouge, polite society viewed both nightspots as vulgar places of popular entertainment. Accordingly, both dance halls attracted great numbers of visitors to the city.

In *Dancing at the Mabille* male and female dancers perform the cancan in the dance hall's outdoor pleasure garden. Initially developed from the quadrille and galop in working-class neighborhoods, the cancan by mid-nineteenth century had become an energetic dance for men and women performers in theatres and other places of public entertainment. Among its hallmarks were daringly high kicks and a maneuver in which a dancer pirouetted on one foot while holding the other at eye level. Though always an impudent dance even in professional performance, and meant as an affront to bourgeois propriety, more than a few members of the bourgeoisie found it enormously entertaining.[5]

Homer shows a cosmopolitan audience of finely dressed men, some in non-Western attire, crowding in to watch a performance. The women at right represent three stages in one of the cancan's basic passages. The first dancer gathers and lifts the front of her skirts, a provocative act in itself. The next prepares to run forward while shaking her uplifted skirts

10.2. *A Parisian Ball—Dancing at the Casino*, 9³/₁₆ x 13³/₄ in. *HW,* November 23, 1867. Syracuse University Art Collection.

saucily from side to side in a rhythm faster than her moving hips. The third, having executed a high kick—probably more than one—grasps her foot and begins to pirouette, allowing her audience glimpses under her jouncing skirts of legs, tight stockings, garters, and other unmentionables. The two high-kicking men will later join the women for provocatively close couple dancing. In the middle distance a female dancer performs the traditional trick of kicking the hat off an onlooker. Only in this small detail does Homer truly capture the dance's characteristic exuberance. Within the distant open rotunda a band plays under its leader. Homer's circle of voyeuristic spectators extends through the picture plane to embrace his *Harper's Weekly* readers.

That the cancan was a sensational subject for an American audience probably explains Homer's relatively restrained treatment of it. He shied from depicting women turning cartwheels or performing that most dramatic act for a female dancer, the split. Nor did his treatment convey the general atmosphere of refined licentiousness that typified these dance halls. His *Mabille* illustration has no undercurrent of erotic play of the kind that a decade earlier had suffused his corn-husking scenes. Parsons and Harper very likely had insisted on a relatively tame portrayal of the

subject, but even so Homer's illustration was racier than the *Weekly*'s usual contents. In its commentary the journal justified the publication of the two illustrations by stepping away from them: "We shall not venture to look into the abyss on the brink of which these frenzied men and women are dancing, and this too curious crowd of spectators is treading. This is work for the severe and steady eye of the preacher and moralist."[6]

Homer's depiction of dancing at the Casino de Paris must have been equally disconcerting to many viewers, for here he centered attention on close bodily contact between dancing partners. This aspect of the cancan had once been sufficiently shocking even in Paris to oblige some dancers to wear masks while performing on stage. A visiting German observed that "the couples dance it indecently close together . . . and the masked men approach the masked women, press close to them, and actually throw them backwards and forwards."[7] Homer shows some of this action as his male dancer lifts a young woman and spins her around in his arms, pulling her feet well off the floor and setting her skirts in motion. Looking on are a few women among many men. Some of the spectators seem to be individualized portraits, perhaps friends with whom Homer frequented these ballrooms. The mustachioed figure lifting his arm at left may be a self-portrait. While the *Weekly*'s viewers raised their eyebrows, they most likely tolerated the two illustrations on the grounds that they were reports from another culture. They depicted life in France where, as the American saying went, things were done differently. A generation later, Henri Toulouse-Lautrec treated dancers of this kind memorably in color posters using a distinctly more expressionistic style in addressing fin de siècle viewers.

Homer's third illustration from Paris moved from dance halls of doubtful propriety to an institution of impeccable respectability. In *Art Students and Copyists in the Louvre Gallery, Paris* (HW, January 11, 1868, fig. 10.3) he visits the Louvre Museum's Grande Gallerie. Copyists are hard at work, among them at center a tall young woman with a brush in one hand and a palette, maulstick, and more brushes in the other. This is almost certainly a depiction of the American artist Mary Cassatt, then a student in Paris.[8] Resting on the easel above her open paint box at left is a canvas whose smallness contrasts amusingly with the largeness of the adjacent work underway by a copyist who is just as certainly her friend and fellow Pennsylvanian Eliza Haldeman.[9] Both women were among a group of students from the Pennsylvania Academy of Fine Arts who had arrived in Paris in 1866. Thomas Eakins was among them.[10]

The illustration opens the possibility that Homer and Cassatt may

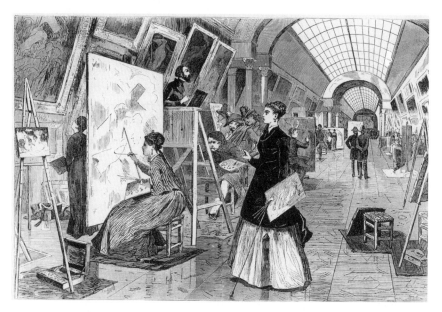

10.3. *Art Students and Copyists in the Louvre Gallery, Paris,* 9 x 13³/₄ in. *HW,* January 11, 1868. Syracuse University Art Collection.

have met in 1867. It is just as likely, however, that she was unaware that Homer was sketching her. To judge from his illustration, his interest was in Cassatt's attire as much as in her activity as a copyist. Indeed, her form dominates her surroundings, a tall, still, sharply defined cone of solid black and patterned white set among the less distinct twists, turns, and sharp angles of the rest of the scene. Yet the careful detailing of her face, full of alertness is among the more fetching of those Homer drew on the block in these years, and suggests an acquaintanceship. Homer's continuing interest in the pictorial possibilities offered by women's fashion of the mid-1860s coincidentally paralleled the attention of Claude Monet and James Tissot to the same subject. Many painters in these years exploited the potential of women's fashion to contribute organically to their compositions.

The Louvre illustration may have carried an ironic undercurrent to those who knew Homer well. His own art education had been the antithesis of copying old masters. As he had said early in his career: "If a man wants to be an artist, he should never look at pictures." [11] By this he meant that an artist should learn from nature rather than art. The evidence of his work makes it clear that by nature he meant not only the natural world but also the built environment and even human nature.

10.4. *Homeward-Bound*, 13⁹/₁₆ x 20¹/₂ in. *HW*, December 21, 1867. Mary and Mavis P. Kelsey Collection, Cushing Memorial Library and Archives, Texas A&M University.

A month earlier, the *Weekly* had published his striking *Homeward-Bound* (*HW*, December 21, 1867, fig. 10.4), composed from sketches made on shipboard. After his arrival in New York he refined and added figures, preserving in their braced postures a memory of their ship's rolling motions. His dramatic use of one-point perspective runs the ship's planks virtually underneath the viewer. The massing of figures in the foreground stabilizes the tilting space. By locating these figures close to the viewer, Homer encouraged a degree of empathy with the passengers' discomforts. The women's fashion may be Parisian, but even so, it may have come from sources in New York. At right a man with binoculars stands to observe a high-leaping fish off the port bow. Because Homer's initials appear on the boom above, it is easy to suppose that this is a self-portrait—a dryly humorous one that lacks a likeness. The position of the boom indicates that the wind is coming from lower left; the slant of the deck indicates the opposite. As always, Homer never hesitated to reconstruct the world to gain a good picture.

Having published four subjects from his trip abroad, Homer next contributed to the *Weekly* a scene that he had treated now and again for more than a decade: ice skating. *"Winter"—A Skating Scene* (*HW*, Janu-

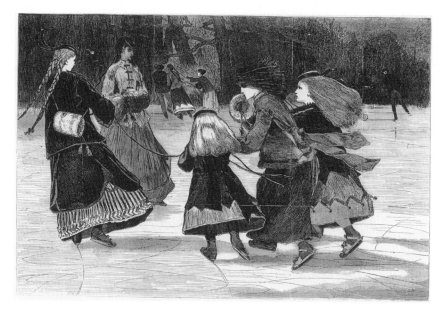

10.5. *"Winter"—A Skating Scene,* 9 x 13⁹/₁₆ in. *HW,* January 25, 1868.
Syracuse University Art Collection.

ary 25, 1868, fig. 10.5) is less a report on a popular winter sport than an aesthetically bold treatment of moving figures in notably pictorial costumes. As was true of *Homeward Bound,* this skating scene made *au courant* women's fashion an important part of the subject. He in a sense recorded the rush of American women in the late 1860s to attire themselves in French high style.

There had been intimations of this interest as early as 1861 in his *The War—Making Havelocks.* In that subject, however, the stylish young women were seated and still. His achievement in *"Winter"* was to set fashion plate costumes in motion and to achieve through them a sweeping dialogue of line, texture, pattern, and rhythm, all crisply set out. The young woman with a muff slung over her turkey-back cloak wears a looped overskirt revealing a pleated underskirt. The two skirts contrast light with dark and stripe against solid. The smaller girls wear zigzag hemmed jackets, a motif repeated in the trim of hanging braided balls on the skirt of the girl at right as well as in the skirt of a woman skating in the distance. Homer set this display of artifice in costume against a frieze of stately trees in the background. A near-anthropomorphic assemblage of limbs and trunks appears at its center.

It is possible to find in the flatness of *Winter*'s design—its strong diagonals, spare elegance, and expressive line—the influence of Japanese aesthetics as they were then understood in the West. By the mid-1860s *Japonisme* was in the air (though that term itself had not yet come into use), and Japanese objects, motifs, and customs were newly in vogue throughout the Western world. Homer is certain to have had some degree of interest in the Japanese *Ukiyo-e* woodcut prints of the eighteenth and nineteenth centuries. They corresponded in medium to his own wood-engraved work for the weeklies, though the Japanese works were printed directly from wood and not from electrotypes. By the late 1850s connoisseurs avidly collected these prints. Some of Homer's artist friends, including La Farge, had taken an interest in them.

Homer had most likely seen the selection of Japanese prints on display at the Exposition Universelle, but he would by then already have known their distinctive qualities. As early as February 1857, *Frank Leslie's Illustrated Newspaper* had reproduced two characteristic examples as illustrations to a Japanese story.[12] Homer demonstrated knowledge of the Japanese woodblock manner when he parodied it in a detail of his *St. Valentine's Day—The Old Story in All Lands—* (*HW*, February 22, 1868, fig. 10.6). In this illustration he put together, as if at a masquerade ball, couples in historical costume from different lands and times, all European or American except for the man and woman from Japan.

Homer's understanding of the conventions of Japanese woodblock prints very likely loosened his adherence to Euro-American conventions of illustration. His work became simpler and bolder in its forms. He used a greater variety of angles of vision and perspective. His provocative inconsistencies of scale and the expressionless, inscrutable faces that appear in his work with ever more frequency after the mid-1860s are in all likelihood products to some degree of the liberating influence of Japanese graphic art after it had reached the West in the 1850s. Homer surely valued Japanese pictorial design as a source of fresh air in a tradition-bound field.

While Homer was in Paris, Fletcher Harper had founded a second weekly pictorial magazine for the family firm: *Harper's Bazar*, a "repository of fashion, pleasure, and instruction." (The spelling of the magazine's title became *Bazaar* only in 1929.) He modeled his new pictorial on *Der Bazar*, a magazine of women's fashion published in Berlin. Indeed, he regularly bought and used electrotypes of that journal's fashion plates. In

10.6. *St. Valentine's Day—The Old Story in All Lands*, 13⅝ x 9 in. *HW*, February 22, 1868. Syracuse University Art Collection.

format, his *Bazar* followed the *Weekly*. Its contents centered on women's interests, and on high fashion above all, but it also included occasional features on men's attire and children's dress. Every number of the magazine contained one or more fashion plates as well as patterns and advice on needlework. Most issues also carried illustrated serial fiction, verse, and other things of general interest; some had little to do with the

women's sphere. The *Bazar* appeared in November 1867 and was an immediate success. Within two months it enjoyed a circulation of more than a hundred thousand copies each week.[13]

The *Bazar*'s editor, Mary Booth, was a widely respected historian of both New York and France.[14] Her knowledge of French culture was essential to the *Bazar* at a time when Paris more than ever was the great center of fashion for American women. This was the era of Charles Frederick Worth, the Anglo-French couturier and costumier who from his Parisian salon ruled over high style in women's attire throughout the Western world.

Other American periodicals had devoted themselves successfully to women's fashion, among them *Godey's Lady's Book* (founded 1830), *Peterson's Magazine* (1842), and *Frank Leslie's Ladies' Gazette of Fashion* (1854), but these were monthlies. The *Bazar* quickly outdistanced this group through its larger format and weekly periodicity. In a month its four issues offered more illustrations than its rivals, and its frequency kept its serialized fiction fresh in the minds of its readers.

When the magazine had been underway for four months, Homer made his first appearance in its pages. Parsons or Booth herself may have suggested the general subject, but the particulars of the concept were certainly Homer's. His double spread *Opening Day in New York* (HB, March 21, 1868, fig. 10.7) epitomized the *Bazar*'s policy of treating high fashion as a realm for the fortunate few while making that fashion available vicariously to all through illustrations. Its plates offered images of splendid garments to readers who would rarely, if ever, see such things in life.

In the whimsically allegorical upper half of *Opening Day,* stylish young ladies personify flowers. Below, young women in finery inspect cloaks, bonnets, and parasols on the first day of the new fashion season. With a touch of haughtiness the *Bazar* in its commentary on the illustration observed that this was the time "when the rooms of the fashionable *modistes* are thrown open to a select party of the elete [*sic*] of their patrons and the newly imported fashions are unveiled to their gaze."

Having already made high-style dress a major component of *Homeward Bound, "Winter"—A Skating Scene,* and a few others, Homer now with some regularity brought to life images hitherto seen in relatively lifeless and virtually two-dimensional fashion plates. He seems not to have copied individual costumes directly from such sources but instead borrowed components large and small from plates in many publications, from what he saw in upscale shops, and from life. He synthesized these sources into his own *au courant* designs.

10.7. *Opening Day in New York,* 13⅝ x 20⅛ in. *HB,* March 21, 1868. Mary and Mavis P. Kelsey Collection, Cushing Memorial Library and Archives, Texas A&M University.

In taking *bon ton* style off the rack and putting it into movement in interesting settings in his illustrations, he nearly always emphasized youthfulness. The matronly figures sometimes included in the *Bazar*'s fashion plates found no place in his work. His elegantly dressed young women pose naturally in visually interesting places. They seem to be psychologically engaged (quietly) with their companions. Their costumes are an organic part of Homer's design. Booth must have recognized not only Homer's affinity for high-style women's attire as a subject but also his engagement in his work with larger worlds of experience. From time to time she included in her magazine illustrations by him wholly unrelated to fashion.

The first of these was a Manhattan street scene in which the only adult woman most certainly was not dressed in high style. In *The Fourth of July in Tompkins Square, New York—"The Sogers Are Coming!"* (*HB,* July 11, 1868, fig. 10.8), a portly policeman amiably keeps in place a crowded rank of children who await the arrival of a militia unit with its marching band. The careworn woman with a child in her arms serves as

10.8. *The Fourth of July in Tompkins Square, New York—"The Sogers Are Coming!"* 9^{1}/$_{16}$ x 13^{11}/$_{16}$ in. *HW,* July 11, 1868. Mary and Mavis P. Kelsey Collection, Cushing Memorial Library and Archives, Texas A&M University.

a reminder, at least within the context of Homer's illustrations from these years, that the young *modistes* whom he drew seem altogether detached from the realities of domestic life.

The ragamuffins spread from one margin of the illustration to the other form an unbroken plane that with the empty foreground and deep recession of space in the background has no real counterpart among Homer's other woodblock compositions. His subject's location, between East 7th and 10th Streets, near 1st Avenue, was not far from his Washington Square studio. On a facing page the *Bazar* printed stanzas titled "The Fourth of July," but this doggerel verse has no connection to Homer's image.

Most of the drawings Homer sold to the *Bazar* involved *haute couture*. His most novel presentation of high style came with his *Blue Beard Tableau* (*HB,* September 5, 1868) in which he depicted the backs of the handsome costumes worn by a group of young women who poke their heads through openings in a curtain during an amateur theatrical. Four months later, his *Waiting for Calls on New-Year's Day* (*HB,* January 2, 1869) came closer to a conventional fashion plate in its arrangement of

sumptuously costumed women across the page. He transcended the limi-
tations of that genre, however, by locating figures in different planes and
supplying the scene with a mood of slight anxiousness among the women
who await their gentleman callers.

Booth and her *Bazar* specialized in women's fashion, but the subject
was of such widespread interest that it required attention also in other
magazines. Parsons took drawings for the *Weekly* that might easily have
had a place in the *Bazar*. They were by a host of illustrators, none of
whom brought as much fresh thought (and able drawing) to the task as
did Homer. The inventiveness of his varied treatments of fashion was re-
markable. In subject and style each illustration marked a conscious de-
parture from everything he had drawn on the block earlier. Nothing he
published before, for example, had been quite so dryly observed as *The
Morning Walk—The Young Ladies' School Promenading the Avenue*
(*HW*, March 28, 1868), in which even the young women's elegant cos-
tumes seem constrained. Only the slightest flicker of interest in the world
around them escapes their otherwise expressionless faces.

Homer drew illustrations relating to fashion because there was a de-
mand for them and he did it well, but he also drew other subjects. And
like most of what he drew in 1868, they show how refreshed, even ad-
venturous, his thinking as an illustrator had become following his time in
France. He had never before drawn anything like his *Fireworks on the
Night of the Fourth of July* (*HW*, July 11, 1868). Here he jammed to-
gether a veritable sea of heads, bringing the closest up to the picture
plane. Some faces are full of expression; a few are caricatures.

New England Factory Life—"Bell-Time" (*HW*, July 25, 1868, fig.
10.9) is more conventional in its design and more substantial in its sub-
ject than its immediate predecessors, but the subject departs from
Homer's past practice by giving attention to industrial America. He had
come to know this locale in Lawrence, Massachusetts, from visits to his
brother Charles, who in 1868 had completed about a decade as a chemist
at the Pacific Mills. Charles would soon move to New York to join the
Valentine Paint and Varnish Company, where he became an officer.
Homer's illustration shows the Washington Mills on the bank of the
Merrimac (the complex of buildings is so identified in the accompanying
text). It also shows a good deal of the mill's workforce, including many
women and a few children. Leaving work, they carry their lunch pails
home for refilling. It is a measure of Homer's respect for common labor-
ers that he managed, at considerable effort, to individualize so many of
the faces within this mass of wage earners. With a few notable excep-

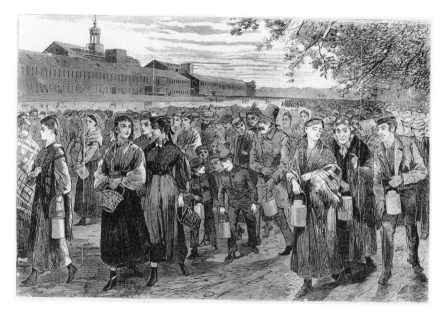

10.9. *New England Factory Life—"Bell-Time,"* 13¹⁵/₁₆ x 9³/₁₆ in. *HW,* July 25, 1868. Syracuse University Art Collection.

tions, the faces are bright. This is hardly a portrayal of downtrodden labor.

French pictorial weeklies had taken a more critical interest than their American counterparts in subjects depicting the industrial environment and its (usually deleterious) impact on modern life. Homer's choice of subject may have reflected his recent acquaintanceship with such illustrations on their home ground, but his approach was more positive. A leafy bough spreads protectively where more socially conscious artists would have placed a brick wall or a pile of refuse.

His last drawing for the *Weekly* in 1868, *"Our Next President"*—U. S. Grant (*HW*, October 11, 1868), took as its subject the impending election of Ulysses Grant while it also summoned up war memories. Muskets hang above a fireplace decorated with biblical tiles; these details echo what he had drawn for Leslie three years earlier in *Thanksgiving Day—Hanging Up the Musket.* A well-dressed party of five lifts *coupes* of champagne to toast the candidate, whose portrait hangs on the wall. The woman seen in lost profile with hair piled high on her head will reappear with minor variations in several other of Homer's illustrations in books

and magazines over the next few years; she derives from a figure drawn and painted by Homer in Paris.[15]

This picture of dignified celebration was the kind of tritely routine work that Homer had resisted since the end of the war. The novelty and variety that characterized the illustrations he had drawn since his return from France are much less evident here. More than his earlier subjects in 1868, the Grant illustration suggested that he was willing to undertake such relatively banal assignments as promoting his publisher's preferred candidate for president.

The Grant subject in a sense sent a signal that Homer was available, within reasonable limits, to draw subjects that suited a publisher's needs. Perhaps he meant to do so, for his revival of interest in drawing on the block coincided with a period of expansion within the American pictorial press. New magazines had begun to appear, all in need of able graphic artists. Their editors saw in Homer a bright prospect for their pages.

11

America at Leisure

1869–1872

THE LATE 1860s and early 1870s were boom years for the creation of new periodicals. In 1867, the *Round Table,* a New York journal of literature and current events, spoke of a "mania of magazine-starting."[1] Postwar affluence, advances in printing technology, cheaper paper, and an eager public sustained the steady arrival of new magazines until the economic crisis of 1873 brought this heady expansion to a close. Between 1865 and 1870 the number of periodicals of all kinds published in the United States rose from some seven hundred titles to more than twelve hundred.[2] Even *Harper's Weekly, Harper's Bazar,* and *Frank Leslie's Illustrated Newspaper* found themselves pressured as new pictorial weeklies attempted to crowd into their niches.

It is a fair measure of Homer's stature as an illustrator that three of the new weeklies, Boston's *Every Saturday* and New York's *Appleton's Journal* and *Hearth and Home,* sought his services. *Hearth and Home,* a "household journal" that gave little space to news or sensational matter, obtained only a single illustration from him.[3] Perhaps as a money-losing operation it found itself unable to afford his expected fee. By 1870 that fee probably ranged from seventy to a hundred dollars depending on a drawing's size, subject, and complexity. As offshoots of major publishing houses, *Appleton's* and *Every Saturday* had deeper pockets (though neither proved profitable). These two succeeded in securing from Homer extended sequences of illustrations. From time to time, the twenty-odd drawings he made for these new magazines interrupted his renewed association with the Harper firm. But in the course of one year, 1870, Homer drew on the block for four different pictorials: the *Weekly,* the *Bazar,* Ap-

pleton's, and *Every Saturday.* This effort amounted to sixteen original illustrations, most of high quality.

Far from withdrawing from the pictorial press, as he had apparently hoped to do in 1866–67, he now seems to have relished opportunities to draw on the block. He found time also to contribute illustrations to books and literary journals.[4] His income from all his efforts as a graphic artist was substantial, if not perhaps wholly sufficient to his needs. The sixteen illustrations he sold to the four pictorial weeklies in 1870 very likely brought him over a thousand dollars. This sum went not only to meet his living and travel expenses but also to help cover the cost of models, art supplies, and a studio for a painter whose work was not yet selling well. He was sometimes short of ready cash. In March 1869 he had found himself hard pressed to pay accumulated back rent on a studio. This was probably a space auxiliary to his main space.[5] Still, if money was the prime motive for his continuing involvement with pictorial weeklies, the opportunity to tackle new subjects and revisit old ones seems also to have attracted him. The illustrations he drew on the block in the late 1860s and early 1870s included some of his most ambitious and successful efforts as a graphic artist.

His subjects varied greatly. *Christmas Belles* (*HW,* January 2, 1869) depicts a cheerful group of young women sleighing. *The New Year— 1869* (*HW,* January 9, 1869) shows the then-traditional stage convention of having a child (or young woman) representing the arriving year burst through a paper screen on a velocipede while Father Time wheels the old year away in a barrow. Very different is a view of crew in rigging on a vessel in rough waters: *Winter at Sea—Taking in Sail Off the Coast* (*HW,* January 16, 1869). It may derive from sketches Homer made on his voyage to France. The documentary *Jurors Listening to Counsel, Supreme Court, New City Hall, New York* (*HW,* February 20, 1869) is devoid of narrative or much aesthetic interest, but it offered a view of an ordinary part of the interior of New York's newest civic building.

His paintings of the time had no such variety. Clearly enough in 1868 he viewed the two endeavors, painting for exhibition and drawing for the weeklies, as separate activities directed to different audiences. The diversity of his woodblock subjects in 1868 and early 1869 was impressive, but it pointed in no direction. Except in style, the illustrations have little central consistency, overall organizing theme, or shared point of view. More than ever before, Homer seemed to have been dependent on his editors for suggestions for subjects. If this dependence was the case, then, despite his freelance status, he had become a kind of artist for hire.

This situation changed, however, when in mid- 1869 he found a general subject that occupied him in a variety of manifestations for the next few years. This was the subject of leisure life among fashionably attired young adults in outdoor settings. At the same time he began regularly to use sketches and studies made in the field as the basis for both illustrations and paintings. His two realms of endeavor began to interplay in ways that grew more complex as time passed.

Like most artists who maintained studios in New York, he left the city in the summer. He traveled to mountains and shore throughout the Northeast. *The Summit of Mount Washington* (*HW,* July 10, 1869, fig. 11.1) places him in the White Mountains of New Hampshire, and it also marks the point at which he began with increasing frequency to adapt his paintings for use as illustrations. In his *Summit,* riders have come up the long Crawford Path from White Mountain summer hotels to the corral at the base of the mountain's summit cone. They will then hike up the final, steeper part of the trail through shattered rock to buildings atop the mountain's summit. The illustration makes use of layouts and details from two of Homer's oil paintings, *Bridle Path, White Mountains* of

11.1. *The Summit of Mount Washington,* 9¹/₁₆ x 13¹¹/₁₆ in. *HW,* July 10, 1869.
Syracuse University Art Collection.

1868 (Sterling and Francine Clark Art Institute) and *Mount Washington* of 1869 (Art Institute of Chicago).[6]

A young woman rider appears as a key element in each of the three works. In the *Weekly,* she is with another young woman. In the *Bridle Path* painting, she rides along the trail alone. In no case is she accompanied by a man. She is one of Homer's several depictions in paint and on the woodblock of the postwar generation of young, refined, fashionable, middle-class women. Breaking from older traditions of portraying women in American genre subjects as wives, daughters, sisters, or other dependent relationship to men, Homer presents them as independent, pleasure-seeking (within circumstances of propriety), and engaged in outdoor recreation.

His next illustration, *What Shall We Do Next?,* (*HB,* July 31, 1869), was also a variant of an oil painting, his *Croquet Match* (Terra Museum of American Art, Chicago). By the veranda of a summer hotel a group of young women play croquet in stylish summer attire. In *The Straw Ride* (*HB,* September 25, 1869), a similar group of women, now with parasols raised against the sun, have the company of men for a hayride. *At the Spring,* Saratoga, Homer's single illustration for *Hearth and Home* (*HH,* August 28, 1869), returns him to the spa town whose racetrack he had depicted for the *Weekly* in 1865. Four stylish young women and two nattily dressed men stand by the spring house holding glasses of the spa's famed mineral waters.

The next season, *On the Bluff at Long Branch, at the Bathing Hour* (*HW,* August 6, 1870, fig. 11.2) extended his survey of stylish life at popular resorts, now putting a much greater emphasis on women's fashion than on the setting. His oil painting of 1869, *Long Branch, New Jersey* (Museum of Fine Arts, Boston), depicts this site from a different vantage point, and with less attention to women's wear. In the *Weekly*'s illustration a stiff breeze whips skirts and ribbons about as the women prepare to descend the bluff to the beach. The distant figures on the sand have exchanged their finery for bathing costumes. Part of Homer's challenge in illustrating high fashion was to devise constantly changing sequences of visually interesting backgrounds for his splendidly costumed women. He did so through the early 1870s with little sign of tiring of the task.

During his attention to fashion in contexts of resort life, Homer drew a single image of a more serious and provocative tone. In his *Tenth Commandment* (*HW,* March 12, 1870, fig. 11.3), two elegantly dressed

11.2. *On the Bluff at Long Branch, at the Bathing Hour*, 13⁵/₈ x 8⁷/₈ in. *HW*, August 6, 1870. Syracuse University Art Collection.

women kneel in church with prayer books in their hands. Across the aisle, at a slightly higher level, a man in a pew interrupts his devotions to take a sidelong look at the women. Vignettes surrounding this trio depict all but one of the things that the biblical tenth commandment says shall not be coveted (Exod. 20:17). Clockwise from upper right, they are a neighbor's house, his manservant, his maidservant, his ox, and his ass. The figures at center, drawn in fuller detail, complete the list of proscribed behavior: "You shall not covet your neighbor's wife."

Homer's preliminary sketch for this illustration (private collection) includes designs for the outer vignettes that differ from the published versions without altering the work's basic concept.[7] For example, a nursemaid in the sketch becomes a housemaid in the illustration. The cow and ass remain, though reconfigured. Heavily inscribed along the lower part of the sketch, apparently in Homer's hand, is the work's original subtitle: "Good Lord help us to keep His law." By the time the illustration reached print this subtitle had been replaced and relocated by "Have mercy upon us and incline our hearts to keep this law."

The subject was so unusual for Homer, who was never a moralizing artist, that one supposes that the concept was not his, that the subject and

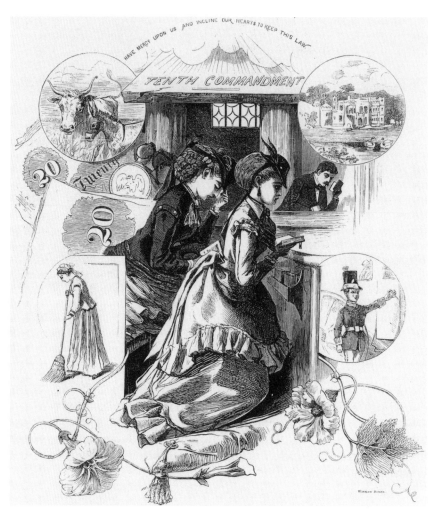

11.3. *Tenth Commandment*, 10³/₈ x 9 in. *HW,* March 12, 1870.
Syracuse University Art Collection

its handling came as a commission from Fletcher Harper or someone else
of authority at the Harper firm. The subject was an unusual one for the
Weekly's front page. The coveting of other people's wives was hardly un-
known in New York, nor was the adultery that sometimes resulted from
it, but it seems likely that only a specific case would have warranted a
cover illustration. The image alluded so discreetly to its target, however,
that present-day viewers are left to speculate about it.

One possibility bears special consideration. In 1870, two years before the general public learned of the scandal, a small but growing circle had become aware of an illicit affair between the nationally renowned preacher Henry Ward Beecher, pastor of Brooklyn's Plymouth Church, and a much younger married woman from his congregation, Elizabeth Tilton. Among those who had learned of the affair were such notable figures as the Women's Rights leaders Susan B. Anthony and Elizabeth Cady Stanton. Another person who almost certainly knew the rumor was George William Curtis, the *Weekly*'s editor since 1863. He knew Beecher and may have felt compelled to remind his famous friend, in a way at once discreet and bold, of the flagrant hypocrisy inherent in a violation of the tenth commandment by clergymen or others in high positions within churches. Miss Anthony, Mrs. Stanton, and others may have urged Curtis to take action. Two years later, when the relationship between Beecher and Mrs. Tilton at last reached the newspapers, Beecher became the central figure of the most sensational scandal of the era. Curtis and the *Weekly* paid little attention to the matter.[8]

Any conjectural association of Homer's illustration with the Beecher-Tilton case in its early stage rests on the assumption that Curtis, or Harper, or Parsons acting for him, asked Homer to treat the subject but did not indicate that the celebrated Brooklyn preacher was its subject. A clue suggesting that Homer may have been bemused by the task of drawing a subject without fully comprehending its import—if such were the case—exists in his signature. He placed his initials prominently on the ass. Such supposition aside, this illustration is distinctive among Homer's many depictions of young women dressed in high fashion in its psychological complexity. The gaze of the man (who bears no resemblance to Beecher) brings to the illustration a current of erotic feeling of a kind that had been absent from Homer's work since his rural subjects of the late 1850s. Its emotional charge, however, is at a more serious level. Whatever lay beneath the surface of this illustration, Curtis and Harper felt it important enough to place the subject on the *Weekly*'s front page.

The New York publishing house of D. Appleton brought out *Appleton's Journal* in early April 1869. In a statement to readers in the first number, dated April 3, the magazine took pains to distinguish itself from the news-oriented *Illustrated Newspaper* and the Republican party-aligned *Weekly*. It said: "omitting ordinary news and avoiding partisan advocacy, both political and sectarian, the *Journal* will be devoted to general

literature, to science, art, and education, and to the diffusion of valuable information on subjects of public importance."[9] Directing itself to a well-educated audience, it maintained a slightly more intellectual tone than its rivals. *Appleton's* differed from the other pictorial weeklies also in its appearance. Considerably smaller in format, it had more pages.

Most months it included in addition to its regular illustrations an "art supplement." This supplement was either a bound-in steel plate engraving or a folded, larger format wood engraving. It obtained drawings from many of the leading lights of American magazine illustration, including Homer's old colleague Alfred Waud and the ever-prolific Darley. Harry Fenn contributed many drawings to a series titled "Picturesque America." The series became the basis for the Appleton firm's acclaimed book of the same title, published in 1876.[10]

Appleton's Journal was not a financial success. By 1871 it had eliminated art supplements and cut back generally on the number of illustrations in each issue. It probably also reduced the fee it was willing to pay for a drawing. This helps to explain why Homer's work ceased to appear in the magazine after the summer of 1870. In 1876, after seven years as a weekly, the journal became a monthly. It ceased publication altogether in 1881.

Homer's association with the magazine began with a lifeless illustration for a poem, Alice Cary's "All in the Gay and Golden Weather."[11] A week later, however, his first original concept appeared on the journal's front page and set a high standard. *The Artist in the Country* (*AJ*, June 19, 1869, fig. 11.4) was scarcely more than six inches in each dimension; its compactness tightened the composition. In it a standing young woman watches a painter at his easel. He has set up a white umbrella of the kind then used by plein-air painters to shade their canvases. Homer developed the illustration from sketches made the previous year that resulted also in his oil painting *Artists Sketching in the White Mountains* (1868, Portland Museum of Art, Portland, Maine). He probably drew most of his *Appleton's* illustrations on blocks late in 1869 from sketches made during his travels the previous summer.

The four croquet-playing women in his *Summer in the Country* (*AJ*, July 10, 1869) are much like those he drew at about the same time for the *Bazar's What Shall We Do Next?*. A new location and a new emphasis of subject appear in *On the Road to Lake George* (*AJ*, July 24, 1869, fig. 11.5). In the middle ground a woman atop a stagecoach full of tourists returns the wave of one of the three country children in the foreground. Beginning with this illustration, children in rural settings steadily assumed a greater role in Homer's work for the weeklies.

11.4. *The Artist in the Country,* 6⁵/₁₆ x 6⁵/₈ in. *AJ,* June 19, 1869. Mary and Mavis P. Kelsey Collection, Cushing Memorial Library and Archives, Texan A&M University.

In most of the rest of his illustrations for *Appleton's* he depicted young, middle-class Americans in the open air. But occasionally a subject offered a contrast to these conspicuously pleasant moments in, from all we can see, idle lives. One exception is *The Last Load* (*AJ,* August 7, 1869) in which three farm workers have just completed a day's haying— their long shadows suggest a late hour. Homer's lifelong respect for the dignity of labor shines through in a subject that in other hands tended to be romanticized or sentimentalized. In the other subject well removed from leisure pursuits, *Danger Ahead* (*AJ,* April 30, 1870), a brakeman works between carriages to slow a train as it passes over water rising beneath a low bridge at night. Homer may have observed such a scene on

11.5. *On the Road to Lake George*, 6¹/₈ x 6⁵/₈ in. *AJ*, July 24, 1869.
Syracuse University Art Collection.

his travels. *Appleton's* contrived a short essay to accompany the illustra-
tion, part editorial and part invented narrative.

But mostly Homer carried his viewers into the world of resort
tourism, eliminating from that world children, older folks, and, when-
ever possible, anyone else who was less than stylish. In his *The Picnic Ex-
cursion* (*AJ*, August 14, 1869, fig. 11.6) young women tourists have filled
a White Mountain wagon, the lightweight, open-air vehicle distinctive to
the region. Tourist hotels had developed this type of wagon for ease of
pulling on mountain roads. An oil sketch by Homer of such a wagon sur-
vives (National Museum of American Art, Smithsonian Institution). A
mustachioed figure on the far side of the wagon engages in animated con-
versation with some of its occupants; it might be a self-portrait.

11.6. *The Picnic Excursion*, 9¹/₈ x 6¹/₂ in. *AJ*, August 14, 1869.
Syracuse University Art Collection.

Homer then brought his viewers from mountains to shore in *The Beach at Long Branch* (*AJ*, August 21, 1869, fig. 11.7). This was one of the two folded, larger-format art supplements he drew for *Appleton's*. Beyond the display of finery on the three women in the foreground stands a solitary well-dressed man so carefully articulated that Homer must have meant him as a portrait to be recognized by friends and family. Long Branch's great bluff and stairs rise in the background. A young woman draws Homer's initials in the sand with her parasol, suggesting, perhaps, that she wished him present. Despite the strength of some of its details, the illustration remains an unresolved pastiche. The foreground figures lack integration with the scene behind them. The prominence of the solitary male figure begs explanation.

In contrast, the second of Homer's art supplements, *The Fishing Party* (*AJ*, October 2, 1869, fig. 11.8), ranks among the finest of his contributions to the weeklies. He continued his attention to women's fashion in this work, but now with greater subtlety, integrating the figures more fully into their setting. The subject amounts to a modern pastoral in which four semiprone picnickers relax on the grassy verge of the stream's

11.7. *The Beach at Long Branch,* 13 x 19³/₈ in. *AJ,* August 21, 1869.
Syracuse University Art Collection.

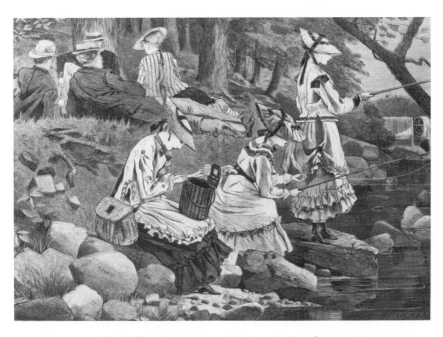

11.8. *The Fishing Party,* 9 x 12¹¹/₁₆ in. *AJ,* October 2, 1869.
Syracuse University Art Collection.

bank. (The stream is the Sawkill, a tributary of the Hudson, according to Homer's inscription on a rock at lower left.) Three young women fish, engaging in a sport only recently taken up by females in polite society. The dark stripes and light arcs of straw in the rendering of the women's hats act as a repetitive motif and bring the foreground figures to satisfying termination. The standing figure is at a point of rebatement from the left margin. That point measured from the right margin falls tellingly in the empty space that separates the woman in the striped jacket from the men with whom she sits. The women's tiny feet reflect an ideal more than the reality of the times. Homer's rendering is eloquent throughout.

A Homer family tradition holds that his last illustration for the *Journal, A Quiet Day in the Woods* (*AJ*, June 25, 1870, fig. 11.9), depicts his brother Charles and sister-in-law Martha. It is rare among his illustra-

11.9. *A Quiet Day in the Woods*, 6³/₁₆ x 6¹/₂ in. *AJ*, June 25, 1870. Mary and Mavis P. Kelsey Collection, Cushing Memorial Library and Archives, Texas A&M University.

tions in presenting a closely bonded couple without resort to sentiment or stock poses.

Exploiting its investment in artists and engravers, the Appleton company late in 1869 reused a dozen of the *Journal*'s illustrations in its *Appleton's Illustrated Almanac for 1870,* edited by Susan Fenimore Cooper. Homer's *Summer in the Country* and *The Last Load* were included, but because the format available for pictorial matter was smaller than the *Journal*'s, both illustrations were cropped.

Even before his final drawings for *Appleton's* had reached publication, Homer had begun again to sell drawings to Harper & Brothers' two weeklies. In the *Bazar,* he returned with *Another Year by the Old Clock* (HB, January 1, 1870). The seated figures portrayed at close quarters may be his parents. A week later, the *Weekly* published his composite *1860–1870* (HW, January 8, 1870, fig. 11.10). This illustration was a major accomplishment in both concept and execution. He had devised nothing quite so complex since the Civil War.

In this review of ten years in American life, the experience of the war dominates everything. Except for an allegorical wheel of time at center,

11.10. *1860–1870*, 13 7/16 x 20 1/2 in. HW, January 8, 1870. Mary and Mavis P. Kelsey Collection, Cushing Memorial Library and Archives, Texas A&M University.

all the vignettes concern the national conflict or its aftermath. For the most part the images are new, though he based some on wartime sketches. Political conflict unresolved in Congress (lower center) leads clockwise to a depiction of a Confederate shore battery in action. He had never before drawn such a scene for publication, nor had he shown the Confederacy's *Monitor* (upper left). Fort Sumter is on a distant horizon. As never before, he attempted to strike a balance between North and South in apportioning subjects. His views of Union soldiers firing and moving ahead at double time, based on his wartime field sketches, document the progress he had made as a draftsman in the last half of the decade. At top he drew again the observation balloon that in May 1862 he had taken pains to include in his *Union Cavalry and Artillery Starting in Pursuit of the Rebels.* Lincoln and the Emancipation Proclamation crown the design. The most telling vignettes are at lower right. The farmers who wear their old army caps as they reap grain echo Homer's painting of 1865, *A Veteran in a New Field* (Metropolitan Museum of Art), without precisely repeating its composition. Below that vignette Homer placed the nation's future not in the hands of returned veterans, nor in the administration of President Grant. He put it instead in the care of a young woman schoolteacher whose pupils are African American as well as white.[12] Perhaps to emphasize the importance of education, he signed his drawing on the teacher's instruction board.

With the arrival of warm weather, the *Weekly* published three outdoor subjects in successive months: *Spring Farm Work—Grafting* (*HW*, April 30, 1870); *Spring Blossoms* (*HW*, May 21, 1870); and *The Dinner Horn* (*HW*, June 11, 1870). The last of these was a variation on the image Homer had painted of a farm woman who blows a horn to call field workers to a meal.[13] He looked away from resort life in these works, but only briefly, for he returned to it in two subjects he drew for the *Bazar* in the same season.

The first of these, *The Coolest Spot in New England—Summit of Mount Washington* (*HB*, July 23, 1870, fig. 11.11) presents half a dozen tourists atop Mount Washington. Homer drew the two women at right at a scale and in a perspective inconsistent with the rest of the scene. This inconsistency was probably the result of his having copied or traced into his woodblock drawing at the last minute figures from sketches he had made elsewhere. At least three separate sketches contributed to this design, though he apparently had insufficient time (or interest) to unify them.[14] The drawing he brought Parsons may have included only four figures: the two men (who may be himself and, in the foreground, his

11.11. *The Coolest Spot in New England—Summit of Mount Washington*, 13³/₄ x 9¹/₈ in. *HB*, July 23, 1870. Private collection.

brother Charles) and two women in the background. Perhaps Parsons requested greater pulchritude for the *Bazar*'s readership, or Booth more finery, and Homer obliged with last-minute additions.

The successor to this work in the *Bazar, On the Beach at Long Branch* (*HB*, September 3, 1870), depicts three fashionable women in a fine open carriage. A touch of wry humor is in the title, for the women are not *on* the beach in the usual sense but pass over it. The carriage's wheels churn up sand. On its door Homer's initials are configured into a decorative detail.

Every Saturday began in January 1866 as a "Journal of Choice Reading Selected from Foreign Current Literature."[15] Brought out weekly by the Boston publishing house of Ticknor & Fields, it at first included no illustrations in its thirty-two octavo pages. Most of its "foreign" literature came from England, and in the absence of international copyright conventions, much of it was pirated. In January 1870, the publishers transformed *Every Saturday* into a pictorial weekly of the usual size and number of pages. It differed from the New York weeklies in its continuing emphasis on literature rather than current events and in the nature of its pictorial matter.

With few exceptions, its illustrations were full-page in size and pertained mostly to literary subjects. They included portraits of authors, scenes from fiction, and views of places with literary associations. The journal announced that "by special arrangement with first class foreign pictorial papers, electrotypes of their illustrations are procured *in advance* of their publication in Europe." In fact, most of the purchased electrotypes came from a single source: London's *Graphic*.

Within six months the publishers saw that this diet of English fiction and English-produced pictures had failed to attract a sufficiently large audience. The only illustration of an American subject in the magazine's first half year had come late in that period (May 26) with a drawing by the English artist Arthur Boyd Houghton of a group of Shakers he had seen on a visit to the United States. In July *Every Saturday* began an effort to interlace the pictures it obtained from the *Graphic* with a few by American illustrators of note. A work by Darley occupied the cover on July 16. A week later, Hoppin contributed the first of the several illustrations he drew for the journal. Less than a month after Hoppin's debut, Homer made his own entry into the magazine's pages and did so even more impressively with two illustrations in a single issue. Within a year, *Every Saturday* had published a total of twelve of his woodblock drawings. It might have published more had it not ceased publication as a pictorial at the close of 1871.

Homer had adapted his initial pair, *High Tide* and *Low Tide* (*ES*, August 6, 1870), from paintings. The figures in the former correspond closely to those in his oil of 1870, *Eagle Head, Manchester, Massachusetts* (Metropolitan Museum of Art). For *Low Tide* (*ES*, fig. 11.12), he adapted the figures in the water and by its edge from an oil of the same title, a work that, owing to criticism in the press following its first showing, he cut into sections.[16] The liveliness in drawing and activity of the background figures derives from the painting and contrasts with the more studied, often static figures throughout the rest of his work for the magazine. A trio of girls in the foreground presumably came from his portfolio of sketches.

Wholly original designs followed. *The Robin's Note* (*ES*, August 20, 1870) depicts a woman in a hammock on a veranda. *Chestnutting* (*ES*, October 29, 1870) shows children collecting on a sheet the nuts that a boy on a limb knocks down. *Trapping in the Adirondacks* (*ES*, December 24, 1870, fig. 11.13), the first of five illustrations that in two magazines

11.12. *Low Tide*, 8¹⁵/₁₆ x 11¹³/₁₆ in. *ES*, August 6, 1870. Mary and Mavis P. Kelsey Collection, Cushing Memorial Library and Archives, Texas A&M University.

11.13. *Trapping in the Adirondacks*, 8⁷/₈ x 11¹³/₁₆ in. *ES*, December 24, 1870.
Private collection.

between 1870 and 1874 constituted a report on his visits to that moun-
tainous region of northern New York State. While his White Mountains
subjects of the previous two years had portrayed the refined life of men
and women at resorts, his Adirondack scenes depicted the more rugged
existence of locals who lived in wilderness. A strong autobiographical el-
ement invigorates these illustrations. The trappers' boat is on Mink Pond
in Essex County, a locality to which he returned many times during the
rest of his life.[17]

Four subjects served *Every Saturday*'s cold weather months. *A Win-
ter Morning—Shovelling Out* (*ES*, January 14, 1871), *Deer Stalking in
the Adirondacks in Winter* (*ES*, January 21, 1871), and, also set in the
Adirondacks, *Lumbering in Winter* (*ES*, January 28, 1871, fig. 11.14).
The logging scene's interplay of weighty vertical forms with the sloping
diagonal plane of the snow-covered hillside makes a powerful composi-
tion of what could easily have been a mundane scene of winter labor. In
the double spread *Cutting a Figure* (*ES*, February 4, 1871, fig. 11.15, the
last and largest of his skating subjects, a solitary woman has the ice to

11.14. *Lumbering in Winter*, 11³/₄ x 8³/₄ in. *ES*, January 28, 1871.
Syracuse University Art Collection.

herself, save a few distant figures.) Homer's style is very different here
than in his busier, anecdotal skating subjects of the 1850s and 1860s. The
skater looks at the viewer with such directness that her eyes seem to stop
the passage of time. The engraving of the landscape succeeds in convey-
ing a sense of atmospheric perspective remarkable for the medium. It
conveys the bleakness of a cold winter day against which the young
woman's turning gaze acts as a warming foil.

11.15. *Cutting a Figure,* 11³/₄ x 18¹¹/₁₆ in. *ES,* February 4, 1871.
Syracuse University Art Collection.

The arrival of spring brought *A Country Store—Getting Weighed* (*ES*, March 25, 1871). It is in some ways a more conventional genre subject but also a display of women's finery. His next contribution could hardly have been more different. *At Sea—Signalling a Passing Steamer* (*ES*, April 8, 1871, fig. 11.16) presages his later painted marine subjects in its attention to the ocean's power. Homer had conveyed much of its character in his *Homeward Bound* three years earlier, and made this character even more evident in *Winter at Sea* in 1869, but in those works the sea was background for passengers and crew. Now human figures are much less discernable and the ship itself, though a large presence, is secondary to the stupendous power of the waves. His final illustration for *Every Saturday,* the well-studied *Bathing at Long Branch—"Oh, Ain't It Cold"* (*ES*, August 26, 1871), is by comparison a trivial work. As with his drawings for *Appleton's,* Homer's care in composition and attention to detail in nearly all his *Every Saturday* illustrations distinguishes them as a group from the variable quality of his work for the Harper firm's publications in the late 1860s and early 1870s.

Nearly a year passed before Homer published another illustration in the pictorial press. With the demise of *Every Saturday* as a pictorial, he appeared again in *Harper's Weekly.* Parsons purchased *Making Hay* (*HW*, July 6, 1872), a drawing whose background includes a finely en-

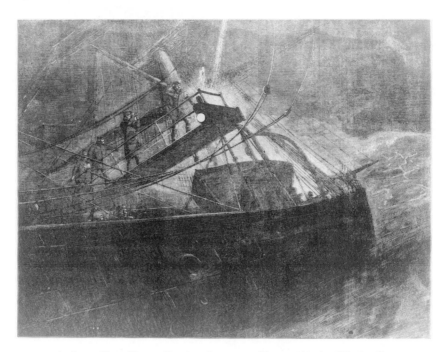

11.16. *At Sea—Signalling a Passing Steamer*, 8³/₄ x 11¹¹/₁₆ in. *ES*, April 8, 1871.
Syracuse University Art Collection.

graved landscape with a scything farmer (adapted from *Veteran in a New Field*). This subtlety is, however, subverted by the coarsely engraved face of the man with a scythe in the foreground and two children awkwardly inserted at lower right. More successful was *On the Beach—Two Are Company, Three Are None* (*HW*, August 17, 1872), adapted by Homer from his oil painting *On the Beach at Marshfield* (private collection). He reduced the painting's several figures to three to make the illustration the basis for the sentimental understanding of the scene spelled out by the title.

He avoided sentiment in his *Under the Falls, Catskill Mountains* (*HW*, September 14, 1872, fig. 11.17.) The caption states that the illustration is from a painting by Homer (unlocated). The setting is Catskill (or Katterskill) Falls, then a much visited site, approached by trails from both below and above. Women's fashion again plays a part, but now the magnificence of the setting all but overwhelms it. Homer exaggerated the overhang of the fall's ledges and their scale in relation to the tourists who visit them, contrasting the cyclopean rudeness of the stone with the deli-

11.17. *Under the Falls, Catskill Mountains,* 9¹/₈ x 13⁷/₈ in. *HW,* September 14, 1872. Syracuse University Art Collection.

cate refinement of the women and their costumes. Escaped from fashion plates into the wilderness, they are among the last of their type to appear in Homer's work.

A century later, when it had become convenient to think of Homer's illustrations not as graphic art so much as a body of images that document aspects of nineteenth-century American culture, it was easy to think of him as a kind of roving reporter. His illustrations seemed important primarily as snapshots of an age. Yet Homer's visual reports do not really illuminate that age very brightly. With few exceptions, he made little effort in his woodblock drawings to look beyond superficial appearances. His treatment of those appearances was masterful, but he saw no need to analyze or otherwise comment on his subjects. His postwar illustrations report what he saw and knew without saying much about what he thought or felt. Compared to Nast's exquisitely managed ferocity in political and social issues, Homer held no opinions, at least none that he chose to make apparent in his drawings. His taste in women's fashion, his feeling

for rural landscape, his growing comprehension of the power of the sea—such things brought forth exceptionally skillful drawings not only of distinctive style but also of an objectivity that sometimes approached remoteness. Perhaps he required this distance between himself and his subjects to attain the extraordinary level of observation so evident in the illustrations he drew in the late 1860s and early 1870s.

12

Innocence and Experience

1873–1875

IN APRIL 1873, Homer ended a seven-month absence from the pages of pictorial weeklies. In the preceding months he may have sold enough paintings to meet living expenses, maintain his studio, keep up his affiliation with the Century Association and other organizations, and attire himself as sprucely as usual, but he was hardly prosperous. Though his oils received a fair share of positive attention in the press, they continued to sell slowly, and for low prices. Some paintings earned only two or three times what he received for a woodblock drawing.[1] His plainspoken American subjects and his directness of statement in paint held little appeal to most serious collectors of art in the United States. Those collectors tended to prize subjects from abroad executed with greater elegance. Charles Homer's business partner, Lawson Valentine, had become a valued patron a few years earlier, but his purchases, presumably at modest prices, had not sufficed to keep Homer out of the pages of the pictorials.[2]

While critics praised much in Homer's paintings, they also continued to complain about what they saw as his work's sketchiness, its lack of "finish," and its inadequate development of content. Even at their most severe, however, they never doubted his status as an artist of major rank.[3] Their assessments pertained to his paintings, however, and not to his illustrations. If critics gave any serious thought to his work for the weeklies, they undoubtedly considered it to be ephemera, work of only passing interest. Because it addressed common rather than cultivated tastes, these graphic works fell outside the scope of serious criticism as it was practiced in the postwar years.

This attitude is regrettable, for it would be enlightening to have contemporary comments about Homer's dual enterprises. In his alternation

179

of audiences, his shuttling between what his era categorized as the fine art of painting and the lesser art of illustration, Homer had no close counterpart among other American artists. Since the late 1860s he, more than anyone, had managed to bridge the distinction between fine and popular art. He did so with greatest success between 1873 and 1875 when he adapted major elements from his paintings for use in woodblock drawings. He only occasionally sought to reproduce the image of an entire painting faithfully. Most often he disassembled and rebuilt the constituent parts of an image, sometimes combining details from two or more works. He constructed new works from old, seeking always to accommodate the limitations of the pictorials' monochromatic, relentlessly linear print medium and seeking also to create images even more immediately accessible to a general audience than were his source paintings. Beginning in the summer of 1873, when he began to use watercolor as a medium by itself, the transforming relationship between his paintings and his illustrations became richer still.

A century later, when many of Homer's oils and watercolors appeared in color reproduction in books, catalogues, and calendars, the sources for his late illustrations became readily apparent. It was possible to see how he had borrowed, combined, augmented, edited, and otherwise transformed recent paintings into woodblock drawings. Some degree of disappointment often accompanied such an examination of sources, for the wood-engraved images, lacking color and real tone, offer a lesser level of aesthetic appeal than their source paintings. But in Homer's time, when exceedingly few of the *Weekly*'s readers had any opportunity to see any of his paintings, the illustrations provided them with their only knowledge of Homer's work as an artist.

But little of this transformation applied to the illustration with which Homer ended his seven-month absence from the *Weekly*. He drew a subject altogether unrelated to anything he had painted. *The Wreck of the "Atlantic"—Cast Up by the Sea* (*HW*, April 26, 1873, fig. 12.1) served as a news illustration despite the fact that it was of necessity in part a product of Homer's imagination. He depicted a fisherman in oilskins who has come upon the body of a young woman washed ashore after a shipwreck. The *Weekly*'s accompanying text concerned one of the era's major marine disasters.

Early in the morning of April 1, the steamship *Atlantic*, bound for New York from Liverpool with nearly a thousand passengers and crew, struck a rock and foundered just off Halifax, Nova Scotia. Well over five hundred lives were lost, including all women passengers.[4] The next day

12.1. *The Wreck of the "Atlantic"—Cast Up by the Sea,* 9³/₁₆ x 13⁷/₈ in. *HW,*
April 26, 1873. Syracuse University Art Collection.

the tide cast up on the rocky coast many of the women's bodies. On April
5 the *New York Times* on its front page reported that the ship's captain
had observed that some of the washed-up forms "presented the appear-
ance of quiet sleep." None of them, however, can have seemed so peace-
ful as Homer's young woman who, indeed, seems asleep rather than
dead. The *Weekly* would have seen no point in publishing a realistic
image of a waterlogged corpse.

The magazine gave pictorial attention to a disaster that had gripped
the attention of the public for days. Parsons, who needed pictures of the
subject without delay, probably proposed the subject to Homer. As Par-
sons knew, he worked rapidly, was more versatile than most of the art
room's regular staff, and specialized in the human figure. With the arrival
of spring, and with summer travels in mind, Homer was also doubtless
on the lookout for extra cash.

It has been suggested in the Homer literature that in making his
drawing he adapted a book illustration that Daniel Huntington had
drawn nearly thirty years earlier for Longfellow's poem "The Wreck of
the Hesperus," but this was hardly the case.[5] In most respects the two
works have little in common other than a similar subject. Homer's pre-

liminary study for the figure of the woman (private collection), which he undoubtedly drew in his studio from a living model, survives to attest to both his source and the seriousness with which he approached his task.[6]

Once he had this atypical subject behind him, he began a sequence of ten images pertaining to life in the country or at the seaside. He shifted his emphasis from stylish tourists to local folk and, in particular, to children, though not in any sentimental or storytelling way. He set them in the out-of-doors; they play, pick berries, hunt for eggs, sit in moored boats, do nothing, and otherwise idle away hours, nearly always apart from adults. They have no need to converse or otherwise communicate actively with each other.

These young folk are homey elements in meticulously well-composed designs, but they also served other ends. As the first generation of Americans untainted by the Civil War, the children embodied their elders' hope that a quality of innocence might be restored to American life. Beyond this, childhood as an entity had become a central component of a reconceptualization of American culture in the nation's literature. Children were now increasingly viewed as beings whose innate innocence (in time to be subverted by experience) made their condition superior to adulthood. Children occupied the narrative center of works such as Louisa May Alcott's *Little Women* (1869), as they would later do in Mark Twain's *Tom Sawyer* (1876) and *Huckleberry Finn* (1885). Adults in these works play only supporting roles. In the 1870s Homer embraced this newer view of childhood in both his illustrations and his paintings.

There was, however, another reason that Homer included children in so many of his works of the 1870s. They were available to be sketched in the places where he had begun to spend the warm months of the year: farms, villages, and the seashore. In 1871 he visited Valentine and his family at the spacious farmhouse they used as a summer residence for a few seasons in Walden, north of Newburgh, New York, between the Catskills and the Hudson River.[7] He spent part of the next summer with friends at Hurley, further up the Hudson Valley. In 1873 he painted and sketched in and around Gloucester, Massachusetts, on Cape Ann. The summer of 1874 found him visiting Walden, East Hampton on Long Island, and Minerva in the Adirondacks. From time to time throughout these years he also visited Martha French Homer's family home in the small town of West Townsend, Massachusetts, where she and Charles spent part of each summer. Homer had exchanged the milieu of popular resorts for those of homes and family-oriented boarding houses.

Children abounded in these places. They belonged to his hosts, their

friends, household staff, and neighbors. Some of the children served him as models, probably for modest pay. When posing they were most likely accompanied by friends, siblings, or elders, and were in reality neither so isolated nor so quiet as Homer depicted them. The contemplative mood of the children in his paintings and illustrations owes something to artistic invention.

He continued to depict adults, at times following his older approach of imposing studio figures on a setting drawn elsewhere. This was the case in *The Bathers* (*HW*, August 2, 1873), in which two young women in wet bathing costumes of a new and daring style dominate the illustration. Their exposed arms and shoulders and their clinging leggings would have struck many in the older generation of readers as immodest. Homer took the boat, cloudy sky, and most of the background figures from his oil *By the Shore* (private collection).[8]

A hint of Homer's interest in high fashion lingered on in the attire he gave the teacher in his *The Noon Recess* (*HW*, June 28, 1873, fig. 12.2). The illustration follows his oil painting of the same year and title (Warner Collection of Gulf States Paper Corporation), a work that was itself an offshoot of his 1871 oil *The Country School* (St. Louis Museum of Art).[9]

12.2. *The Noon Recess*, 9¹/₁₆ x 13³/₄ in. *HW*, June 28, 1873.
Syracuse University Art Collection.

These works all depict the same schoolroom. In his illustration all but one of the children seen in *The Country School* are outside at play, some of them visible through the windows. The kept-in pupil attends to his book while his teacher looks outside, perhaps in daydream. The subject must have struck a nostalgic note for those in the *Weekly*'s readership who had attended one-room rural schoolhouses.

Children alone take center stage in *The Nooning* (*HW*, August 16, 1873, fig. 12.3). Three boys and a dog idle away the middle of a summer day in a grassy back yard. The illustration follows a same-titled oil painting of the previous year (Wadsworth Athenaeum).[10] The *Weekly*'s image preserves a dog that Homer painted over in his oil (twentieth-century *pentimenti* have brought a ghostly semblance of the animal to the surface). Perhaps expecting that Parsons would want more narrative-generating details than the painting offered, Homer added two additional boys, laundry on a clothesline, and in the far background, a woman feeding chickens. He would have known settings of this sort in Walden, Hurley, West Townsend, and the countryside around Gloucester.

Then, when Homer adopted watercolor as a serious medium of expression in the summer of 1873, the relationship between his paintings

12.3. *The Nooning*, $9^{1}/_{8}$ x $13^{7}/_{8}$ in. *HW*, August 16, 1873.
Syracuse University Art Collection.

and illustrations grew even closer. His use of the medium since the 1850s had been to sketch and add tone to drawings, but now he used it much more freely. It ceased to be a subsidiary tool and became a means of creating works for exhibition. He soon found that his watercolors sold more briskly than his oils.

He made his first painting campaign in the new medium during an extended stay in Gloucester early in the summer of 1873. Its impact on his illustrations was clear before the summer was over.[11] He took major details from two of his Gloucester watercolors and artfully combined them into a single drawing for the *Weekly: Sea-Side Sketches—A Clam-Bake* (*HW*, August 23, 1873, fig. 12.4). The watercolors were *A Basket of Clams* (private collection) and *The Clambake* (Cleveland Museum of Art).[12] In his illustration, as in *A Basket of Clams,* two boys carrying a bucket turn their heads away from a dead fish, not to avoid looking at it, for such fish were scarcely rare, but rather to avoid the stench of its decay on a warm day. He next developed *Gloucester Harbor* (*HW,* September 27, 1873), in which boys sit in and on dories moored side by side. He adapted part of this illustration from his watercolor *Seven Boys in a Dory* (private collec-

12.4. *Sea-Side Sketches—A Clam-Bake,* 9¼ x 13¹⁵/₁₆ in. *HW,* August 23, 1873. Syracuse University Art Collection.

tion). He added a background of boats in full sail coursing through the harbor to broaden the illustration's appeal to the *Weekly*'s readers.

But nothing in his summer-autumn transformation of watercolors into illustrations for the *Weekly* was quite so impressive as his *Shipbuilding, Gloucester Harbor* (*HW*, October 11, 1873, fig. 12.5). In this illustration he adapted oils and drawings as well as a watercolor. Major elements such as the schooner under construction and the vividly foreshortened pieces of lumber in the foreground came from an oil of 1871, *Shipbuilding at Gloucester* (Smith College Museum of Art). He took the two boys with model sailboats from a composition that he had executed in 1873 both as a highly finished pencil drawing (private collection) and as an oil painting (Indianapolis Museum of Art), each work titled *The Boat Builders* and dated 1873. The three boys seated on the ground derive from a watercolor sketch, probably also from 1873, *Four Boys on a Beach* (National Gallery of Art).[13] Reworking many details, he fused these elements into a composition more impressive than the sum of its sources. The weight and mass of the schooner, the pile of beams, and the untrimmed lumber become a setting of contained energy in which two kinds of boat building are underway. In the background shipwrights

12.5. *Ship-Building, Gloucester Harbor*, 9¼ x 13⅝ in. *HW*, October 11, 1873. Syracuse University Art Collection.

clamber over a partly built vessel while in the foreground two boys study their models and others sort through wood chips. Sunlight reflects brilliantly from the foreground planks and moves the viewer's eye toward the cloud-darkened hulk of the ship on its ways. Beyond it, right and left, light plays differently on two distant tall-masted vessels, one in full sail.

Homer's achievements in synthesizing new works from old testify to his faultless sense of form. He would continue this kind of borrowing, combining, and rebuilding for another year, with profoundly impressive results. But it was a gain accompanied by loss, for it diminished the wider-ranging inventiveness that had brought such fresh wonder to his earlier work. The abundant energy within his late illustrations comes not so much from his subjects as from the dynamic tensions of his lines and the rhythmic play of light and shade.

But while Homer was now for the most part altering, adapting, amplifying, and otherwise reshaping paintings into illustrations, he also on occasion replicated a painting's image closely. In drawing the double-spread *"Snap-the-Whip"* (*HW,* September 20, 1873, fig. 12.6) he took care to follow faithfully his oil painting of the same title (1872, Butler Institute of American Art), preserving with great fidelity its composition and details.[14] In no other illustration did he take quite such pains to re-

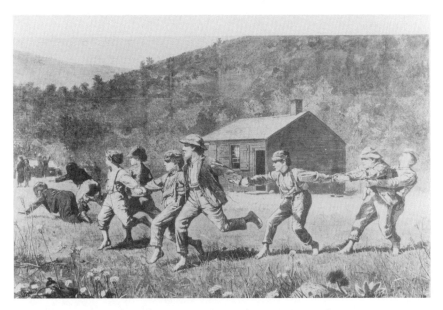

12.6. *"Snap-the-Whip,"* 9$^{1}/_{4}$ x 13$^{15}/_{16}$ in. *HW,* September 20, 1873. Private collection.

produce so precisely the details, large and small, of a painting. An outline drawing, which he almost certainly traced from the painted canvas, survives to document his transfer of the chain of figures to the block.[15]

The image has long served as an icon of American society's love of nature, youthfulness, and freedom. The schoolhouse behind the boys is for all practical purposes the one in which Homer set *The Noon Recess.* In the painting and illustration alike, *"Snap-the-Whip"* 's running figures appear as a frozen moment. In time he would develop in watercolor freer means of suggesting fluid motion, but even this frieze-like presentation manages to evoke a sense of movement and youthful energy.

Homer's image of barefoot country boys playing a vigorous fling-about game in resplendent light has long been one of his most popular works. Downes said of it in 1911: "Nothing . . . had been quite so racy of the soil as this sturdy picture. . . . There is something pungent and rude and bracing in the uncompromising naturalness of it."[16] But as Goodrich observed a generation later without invalidating Downes's commentary, "[Homer's] form did not have the full measure of substance, weight, and inner life that [Thomas] Eakins' did. Its movement was pictorial rather than plastic, achieving at best the quaint arrested motion of Snap-the-Whip. . . . But his work had a quality as engaging as it was rare in modern art—an innocent eye."[17]

Late in life when John Beatty asked Homer why he had stopped drawing for pictorial weeklies, he replied that he had been dissatisfied with the engraving of *"Snap-the-Whip."*[18] This explanation seems curious, for the illustration was as well engraved as any of Homer's to that point. Downes, who knew the painting well, described the wood-engraved version as "highly satisfactory."[19] It is possible nonetheless to see that Homer might have faulted the engraver (LaGarde) with respect to values—the wood engraving is somewhat higher keyed than the painting. Yet whatever reservations Homer felt concerning the reproduction, they did not, despite his comment to Beatty, end his association with the *Weekly.* Over the next two years another eighteen of his illustrations reached print in the Harper firm's publications.

Later in the fall, he adapted another oil painting for an illustration. He based his *"Dad's Coming!"* (*HW*, November 1, 1873, fig. 12.7) on an oil of the same title. Like *"Snap-the-Whip,"* he preserved the painting's general image and details, but now he made a single and telling adjustment to its composition. He moved the figure of the woman holding a child in her arms further away from the boy who sits on a beached boat and looks intently to sea. The increased separation intensifies the mood of anxiety that arises in part from the absence of communication among

12.7. *"Dad's Coming!"* 9³/₁₆ x 13³/₄ in. *HW,* November 1, 1873.
Syracuse University Art Collection.

the three figures. Each is silent and each looks away from the others, their stillness compounded by a setting in which little stirs. But the fundamental source of anxiety is the absence of the father mentioned in the work's title. That title, *Dad's Coming,* suggests that a safe return is in the offing, though nothing that Homer has painted or drawn supports such a reading. The title of a watercolor variant of the same composition, *Waiting for Dad* (Mills College Art Gallery), describes better what Homer drew and painted in all three works.[20] The Mills College watercolor replicates the general composition but omits the woman and child.

An implication of the *Waiting* title is the possibility that Dad might not return from the sea. Homer may well have meant his image to be elegiac, for in August 1873, while he was in Gloucester, more than a hundred of the town's fishermen had been lost at sea in a single storm.[21] Perhaps to soften the illustration's sense of foreboding, the *Weekly* commissioned from one of its house versifiers a short accompanying poem that includes the lines: "Nearer and nearer the light breeze is wafting/The wanderer back to the home of his love./'See! He is coming! Dad's coming! I see him!'/Shout, little Johnny! Shout loud in your glee!" But no such excited feeling informs Homer's work. There is no glee, only worry. Dad is not in sight.

Homer brought off unification of figure and setting less well in *The Last Days of Harvest* (*HW*, December 6, 1873). Here the two boys who shuck corn are disengaged from their background both spatially and in thought. No such problem of design touches the illustration that appeared a week later: *The Morning Bell* (*HW*, December 13, 1873, fig. 12.8). In this case Homer made use of his oil painting *The Old Mill*, long known also as *The Morning Bell* (Yale University Art Gallery). He preserved the structures and natural setting while substantially changing the figures who gather by or walk over a bridge that will take them to the new mill building that Homer has kept from sight.[22]

In publishing illustrations adapted from oils and watercolors, Homer in essence advertised his thinking as a painter to the public at large. His more recent illustrations were purer in their aims as art, and free largely from meretricious attention to such things as high fashion. He would continue to narrow the differences between what he was doing as a painter and as a woodblock artist, but first he headed in quite a different direction.

The Panic of 1873 began in mid-September. It closed the New York Stock Exchange for ten days and precipitated an economic depression

12.8. *The Morning Bell*, 9³/₁₆ x 13⁷/₁₆ in. *HW*, December 13, 1873.
Syracuse University Art Collection.

that ruined thousands of businesses nationwide over the next three years. Many magazines failed. Perhaps to attract new clientele, the *Weekly* for a while gave prominence in its pages to sensational matter of a kind that it earlier would have ignored. It may have been for this reason that in the early months of 1874 Homer drew three urban subjects unlike anything he had attempted before. Perhaps Parsons proposed the topics. Another illustrator might have considered a *Grand Guignol* approach to them, for they lent themselves to theatrical treatment, but Homer handled them with restraint and dignity. He became, briefly, a social realist. Perhaps a colleague goaded him in this direction, for the impression of postwar life in America that Homer had regularly conveyed in his illustrations was one of almost unmitigated wholesomeness.

In these three subjects he looked at city life with very different eyes than he had used in the late 1850s. Instead of lively street scenes, he depicted three sad interiors. One was a crowded holding cell in a jail; another a roomful of Asian immigrant gamblers and drug addicts; the third a refuge for homeless and battered women. He treated these subjects dispassionately.

In *Station-House Lodgers* (*HW*, February 7, 1874, fig. 12.9) a night's gathering of petty criminals, drunks, and derelicts fill a cell. These unfor-

12.9. *Station-House Lodgers*, 9¹/₈ x 13¹/₂ in. *HW*, February 7, 1874.
Syracuse University Art Collection.

tunates are asleep or senseless except for the man at left who intently watches the artist who draws his likeness. *The Chinese in New York— Scene in a Baxter Street Club-House* (*HW*, March 7, 1874, fig. 12.10) is a montage of gambling, incense, and opium set amid Chinese decorations and lettering. The accompanying text observes that "our artist looked in vain for the wives of the Chinese, who sometimes visit the smoking rooms, and are invariably English, Irish, or American girls."[23] It has been lost to history whether Homer made the visit alone or with friends, or even as a reporting artist for the *Weekly*. The keenly observed details suggest that he found much of interest in the clubhouse and little that shocked him.

The four delicately rendered vignettes that make up *New York Charities—St. Barnabas House, 304 Mulberry Street* (*HW*, April 18, 1874, fig. 12.11) include bowed heads and unhappy faces suggestive of the circumstances that warranted refuge with the Episcopalian Sisters of Mercy. The once-stylish dress of the young woman who knocks at the charity's door seems as tired as she does. A picture of the Good Samaritan hangs on the wall. Homer treats the subject of women in need with sympathetic feeling and without sentiment. His illustration does not quite explain itself, however. Even in its own time, most viewers would have required help from the *Weekly*'s accompanying text to comprehend adequately the meanings of what Homer had drawn. Robert Bross's sensitive engraving of Homer's drawing was an early instance of the finer work that had begun to appear in the *Weekly* in the mid-1870s.

Amid these three illustrations came *Watch-Tower, Corner of Spring and Varick Streets, New York* (*HW*, February 28, 1874). Despite a caption crediting the work to him, Homer probably had little if anything to do with it. A watchman in his elevated station looks through his spyglass for evidence of fires. His tower was one of nine that then stood throughout the city. Five vignettes tightly bordered in line depict the tower, its bell, the watchman at work, and the rear of an engine racing down a street at night. There is nothing of Homer's style to be seen anywhere in this stolid work, nor did he sign it. Perhaps he had given Parsons a set of sketches and, having lost interest in the project, let him assign an art room assistant to adapt them freely into the work that reached publication. The quality of engraving is below the standard Homer usually received.

In the spring of 1874 Homer contributed to the *Weekly* a series of warm-weather subjects chiefly based on watercolors and mostly depicting children. The first was his *Raid on a Sand-Swallow Colony—"How Many Eggs?"* (*HW*, June 13, 1874, see fig. 1.1), adapted from his water-

12.10. *The Chinese in New York—Scene in a Baxter Street Club-House,* 13³/₄ x 8¹⁵/₁₆ in. *HW*, March 7, 1874.
Syracuse University Art Collection.

color *How Many Eggs?* (private collection, see fig. 1.2). This was the il-
lustration that Parsons, Kelly, and others had watched him draw on the
block in the Harper firm's art room. By now Homer had a substantial
body of watercolors to choose from for his illustrations. He managed to

12.11. *New York Charities—St. Barnabas House, 304 Mulberry Street,* 9$^{1}/_{16}$ x 13$^{7}/_{16}$ in. *HW,* April 18, 1874. Syracuse University Art Collection.

12.12. *Gathering Berries,* 9$^{1}/_{16}$ x 13$^{5}/_{8}$ in. *HW,* July 11, 1874.
Syracuse University Art Collection.

preserve much of their immediacy of vision when he adapted them for the woodblock. With *Gathering Berries* (*HW*, July 11, 1874, fig. 12.12), adapted from a watercolor of 1873 (private collection), girls at last assume a greater presence than boys.[24] The rhythmic line of clouds in the distance loosely echoes the shapes of the rocks and figures in the foreground. The standing girl who holds a berry can is among Homer's more affecting depictions of children. *On the Beach at Long Branch—The Children's Hour* (*HW*, August 15, 1874) has less freshness of expression and mood, perhaps because it derived from Homer's portfolios of sketches rather than from a recent watercolor.

He adapted *Waiting for a Bite* (*HW*, August 22, 1874) from a watercolor (Addison Gallery of American Art, Phillips Academy) painted in the Adirondacks only a few weeks earlier. He developed an oil painting (Cummer Gallery of Art, Jacksonville) from it as well.[25] Each treatment differs from the others, but in all boys fish from an uprooted log. For *See-Saw—Gloucester, Massachusetts* (*HW*, September 12, 1874, fig. 12.13), he looked back to two watercolors from the previous summer: *The See-Saw* (Canajoharie Library and Art Gallery, fig. 12.14) and *A Fisherman's Daughter* (Cleveland Museum of Art, fig. 12.15). He combined them in ways that transformed each image. For his woodblock drawing he added

12.13. *See-Saw—Gloucester, Massachusetts*, 9⅛ x 13¾ in. *HW*, September 12, 1874. Syracuse University Art Collection.

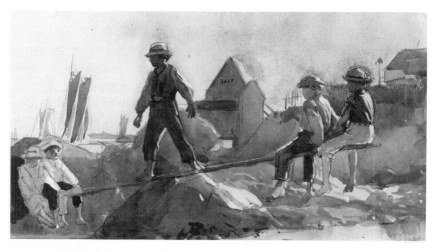

12.14. *The See-Saw*, 1873. Watercolor, 7$^{1}/_{8}$ x 13$^{3}/_{8}$ in. Canajoharie Library and Art Gallery.

12.15. *A Fisherman's Daughter*, 1873. Watercolor and gouache over graphite, 8$^{7}/_{8}$ x 12$^{1}/_{4}$ in. Cleveland Museum of Art, J.H. Wade Fund, 1943.660.

and altered details while also creating a new setting, an energized world of wind-driven clouds above a busy harbor, with everything now in strong contrasts of light and shade. A lobster held by a girl in the watercolor became a game of cat's cradle in the illustration.

Flirting on the Seashore and on the Meadow (HW, September 19, 1874, fig. 12.16) has a unique (for Homer) horizontal division into dual images. He probably adapted the upper part from his 1874 watercolor *Moonlight* (Canajoharie Library and Art Gallery), or from a variant of it painted or drawn at East Hampton.[26] A windmill rises in silhouette on the horizon. In the lower part of the illustration, two boys prone on the sunlit grass converse amiably with the seated girl who faces them. A family of ducks passing by serves as a reminder of the domestic end to which flirting may lead. Homer borrowed the ducks from his drawing *Two Boys in a Meadow* (private collection).[27] The boys, fence, and trees may have come from the same source, though they are reconfigured. Virtually every significant element in one scene has a corresponding detail in the other. The full moon echoes the girl's round hat; the line of rooftops equates with the parade of ducks. This was the last of Homer's treat-

12.16. *Flirting on the Sea-Shore and on the Meadow*, 9¹/₈ x 13¹/₂ in. HW, September 19, 1874. Syracuse University Art Collection.

ments of childhood for the pictorial press, and in many ways his most charming.

He drew the last of his five Adirondack subjects, *Camping Out in the Adirondack Mountains* (*HW*, November 7, 1874), soon after he returned from the second of his visits to the region that year.[28] It contains no self-portrait but is autobiographical in the sense that it reports the kind of outdoor life that Homer savored. Two men sit by a smoldering campfire at an improvised shelter and relax at the end of a day of fishing on Mink Pond. The nearby string of fish attests to their success. Nothing in this work is more closely observed or happily rendered than the dog.

Homer was again absent from the *Weekly* for more than half a year. Income from the sale of his watercolors presumably enabled him to forgo Parsons' fees. Nonetheless, he twice again appeared in the pages of the Harper firm's weeklies. Parsons or Booth may have suggested the subjects. Homer invested them with a freshness of concept and fineness of drawing that set them apart from anything he had done earlier. His engravers responded with exceptional sensitivity. One illustration, a historical subject, came forth in the *Weekly*. The other, set for all practical purposes in the present, also spoke of the past, but pointed to the future as well. In both subjects Homer rendered human feeling with a depth and complexity previously unseen in his illustrations.

The first of the two, *The Battle of Bunker Hill—Watching the Fight from Copp's Hill, in Boston* (*HW*, June 26, 1875, fig. 12.17) commemorated the centennial of this event. Homer was well acquainted with Copp's Hill in Boston's busy North End; it stood only a few minutes' walk from his birthplace on Friend Street. It was not far from Constitution Wharf where in 1857 he had depicted the happy landing of Irish immigrants.

Over the years, illustrations of the battle had appeared in countless American books and magazines. Seventeen years earlier, in the *Companion* for June 13, 1857, Alfred Waud (as A. Hill) had depicted the advance of the British troops up the slope toward the defending Minutemen. (Waud's illustration shared the issue with Homer's first woodblock drawing for the magazine, his portrait of Captain Watkins). But Waud and nearly all other artists set their works at the battle site in Charlestown. They depended on accounts of the conflict and conventions of battle art. Homer broke with this practice by showing the hill only as a distant detail. He centered attention instead on the alarm and anxiety aroused among Bostonians in their British-occupied city.

12.17. *The Battle of Bunker Hill—Watching the Fight from Copp's Hill, in Boston,* 9³/₁₆ x 13¹¹/₁₆ in. *HW*, June 26, 1875.
Syracuse University Art Collection.

At the time of the battle, the North End was home to prosperous merchants, shopkeepers, mariners, and artisans. The neighborhood's highest point, Copp's Hill, contained a burial ground surrounded by a few large houses with spacious gardens and many smaller cottages. These had largely disappeared by the time Homer knew the locality, replaced by more tightly packed streets of row houses and shops. In his illustration, a saltbox cottage and a timbered gable suggest the nature of the area's earlier architecture. His historical approximation of how the buildings of the North End might have looked a century earlier is reasonable. It would be instructive to know what sources he consulted.

In composing the foreground, he arranged the figures and the sloping edge of the roof into a triangular shape to anchor the composition. This arrangement gave stability to a setting of tilting planes and drifting smoke. Now that Parsons could ensure wood engraving of a more delicate and sensitive kind, Homer drew the faces of the foreground figures in finer detail. In their variety of expressions (within the narrow range the subject allowed), these visages still serve as reminders of how subtle and

empathetic a face artist Homer could be. The hands and postures rein-force what the faces say. In assembling the rooftop figures right of center and leaving the left as open space, Homer intensified the feeling of dis-tance from the battle-wracked hill.

On the street below, a cow runs loose. Terrified by the roar of can-nons, it gives vent to feelings that the spectators on the roof suppress. An ornate coach of olden style reinforces the period setting. Beyond a visible sliver of the burial ground rises the spire of North Church. But these are subsidiary details around figures whose emotional control constitutes an essential part of Homer's meaning. In 1875, the stoic resolve of Colonial Americans in a great struggle would have been refracted in the still-fresh memories of another national conflict.

Two months later the *Bazar* published *The Family Record* (HB, Au-gust 28, 1875, fig. 12.18). Accompanying it was a bit of sentimental dog-gerel verse contrived to fit a story to what Homer had drawn. His scene has an unspecified time; it might be past or present. Time is more mean-ingful in the case of the infant in its cradle; the child signifies the future just as surely as its old-style cradle summons up the past. Continuity, both familial and cultural, is the work's leading idea. The room's furnish-ings come from past generations. The couple thinks of the future.

The portrait on the wall tells of Homer's acquaintanceship with the style of the patroon painters, those limners active in the Hudson River Valley during the first half of the eighteenth century. The growing interest in such artifacts of the American past generated by the approaching American Centennial celebrations had begun to shape a body of ideas that in time would be known as the Colonial Revival. It brought new at-tention to Colonial and Federal material culture, especially to furniture and architecture. The furnishings in the illustration show that such his-torical pieces had already caught Homer's eye.

The man's dress and the room's exposed beams suggest a country set-ting. But unlike nearly all of Homer's earlier oils, watercolors, and illus-trations of rural life, this image deals with the domestic closeness of two adults. Homer has supplied them with thoughts and feelings of more ap-parent substance than he had allowed any of his tourists, farmers, or chil-dren. His rendering of the man attests to close study; it is among the finest of his woodblock figures. Less can be seen of the woman, but he drew her with no less care. Only the baby (like the cow in *The Battle of Bunker Hill*) is a summary rather than a studied detail. The striated floor moves the viewer's eye to and beyond the figures. The wash-like passages of vir-tual tone on the wall draw the eye elsewhere. The interior space contains nothing extraneous to the subject or the composition. At every level the

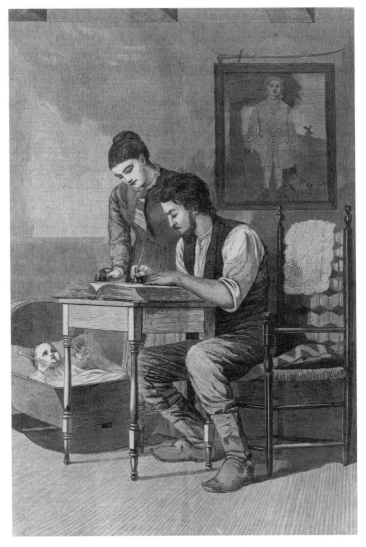

12.18. *The Family Record,* 12 x 18¹/₈ in. *HB,* August 28, 1875.
Brooklyn Museum of Art, 1998.105.197, gift of Harvey Isbitts.
Photograph by Dean Brown.

complexities of the design fall into place to make *The Family Record* a
quiet masterwork of American woodblock illustration.

Like the Bunker Hill subject, *The Family Record* had no relationship
to Homer's work as a painter. The two illustrations showed him to be
looking, almost for the first time, to the American past for subjects. He
was not alone. Other illustrators had also begun to look with fresh eyes

to American history for subjects. The young Howard Pyle would soon make a specialty of historical subjects in his work for pictorial weeklies and books, and he then mined this vein with rich results in the course of a long career as an illustrator. His student, N. C. Wyeth, explored the past even more deeply, and with more impressive results. But Homer's interest in historical subjects soon faded. His *Bunker Hill* and *Family Record* marked an ending as much as a beginning.

Parsons may have sensed that after *The Family Record* Homer would bring no more drawings to Franklin Square. Perhaps this is why he added to Homer's name in the caption: "N.A." This was the only time that a caption for an illustration by Homer in a pictorial magazine referred to him as a National Academician. With *The Family Record* the woodblock artist and the fine artist became one as Homer at last closed his association with the pictorial press.

Ten years after his final contributions to the weeklies Homer had left New York and settled permanently into his new studio-home at Prout's Neck on the coast of Maine. Ten years following that, in the mid-1890s, he was a very distinguished painter indeed. He still saw *Harper's Weekly* from time to time, and other pictorials as well, but he no longer had vital connections to the world of magazines. Fletcher Harper had died in 1877; Mary Booth in 1889, Alfred Waud in 1891. Parsons had retired, Nast was in decline. Beyond the steady disappearance of persons he had known in the field, new methods of pictorial reproduction had arrived to take the place of those he had known. As the era of the halftone opened, the age of the woodblock artist and wood engraver closed.

That age had lasted from about 1840 to about 1890. There had been wood engravers earlier, and a few would flourish into the twentieth century, but only in the years of Ingram, Gleason, Ballou, Leslie, Harper, and their publications was the engraver so absolutely essential to industrial-scale mass visual communication. And only in these years had artists learned to draw specifically for the constraints of the engravers' medium. As teams of engravers began to disappear from the pictorial press, so too did the freelance artists whose drawings they had cut. Homer missed that exodus. That he had been in the field in its earlier, freer, most exciting years is clear enough from the quite remarkable verve and variety within his published work.

As a painter he had carried with him into the more rarified world of the fine arts much of the mindset that had brought him success in the

pages of the weeklies. Self-reliance played a major role in this mindset; he needed always to be independent. But his thinking also reflected an innocence of vision and a directness of statement along with his extraordinary powers of observation. These qualities had spelled great success in the weeklies. His unwillingness (or inability) to break from the patterns of picture-making he had formed on the woodblock was surely one reason why his style as a painter remained unique.

But another reason for his uniqueness was just as surely his continuing belief that he should address his work in oil or watercolor to a broad general audience, rather than only to such *cognoscenti* as then existed in America. He had always differentiated between the two audiences, the popular and the cultivated. But he expressed a lifelong fundamental precept for all picture-making when, late in his career, he wrote to one of his dealers in response to a request for an interpretation of his oil *The Gulf Stream* (1899, Metropolitan Museum of Art). He said, "I regret very much that I have painted a picture that requires any description." [29] This belief that an original work of visual art needs to speak for itself had been a given in the world of the pictorial press. In the world of the fine arts the same belief made him, in time, the most accessible of great American painters.

*Checklist of Works Drawn by
Winslow Homer for Publication
in Weekly Pictorial Magazines*

Notes

Bibliography

Index

Checklist of Works Drawn by Winslow Homer for Publication in Weekly Pictorial Magazines

*T*HIS LIST includes the portraits and original subjects that Homer drew for publication in pictorial weeklies.[1] In each entry, the title of the work is followed by the form of Homer's signature or credit line, with text references given in quotations; the name of the engraver when known; the dimensions of the image given in inches, height before width; and the facts of publication. "Caption" indicates that the illustration's caption credits Homer with authorship of the work. Though such credit appears often after 1862, it is noted in this list only when an illustration lacks a signature in the block or a statement of authorship in accompanying text. The original captions of nearly all the illustrations appeared in uppercase letters. Homer's signature, and those of his engravers, were sometimes all uppercase and sometimes not. In the entries below, this style has been regularized. Following the checklist proper is a list of illustrations claimed to be by Homer, or to be possibly by him, but not accepted in the present study.

As in the preceding text, the following abbreviations are used:

AJ *Appleton's Journal*
BP *Ballou's Pictorial Drawing-Room Companion*
CC *Frank Leslie's Chimney Corner*
ES *Every Saturday*
FL *Frank Leslie's Illustrated Newspaper*
HB *Harper's Bazar*
HH *Hearth and Home*
HW *Harper's Weekly*

1. *Captain J. Watkins,*
 WH (lower left)
 Peirce (lower right)

4¹/₄ x 3⁷/₈

BP 12 (June 6, 1857): 364.

2. *Corner of Winter, Washington and Summer Streets, Boston* (fig. 6.1)
WH (lower left); "by Mr. Winslow Homer" (text)
Damoreau (lower right)
7 x 9³/₈

BP 12 (June 13, 1857): 369.

3. *Hon. William Haile, Governor of New Hampshire*
"by Mr. Homer" (text)
Peirce (lower left)
3³/₄ x 3¹/₄

BP 13 (July 4, 1857): 12.

4. *The Match Between Sophs and Freshmen—The Opening* (fig. 7.4)
W. Homer
5¹/₂ x 20¹/₄

HW 1 (August 1, 1857): 488–89.

N.B. Items 5–8 constitute a subset of item 4, and may be understood to share its signature.

5. *Freshmen*
Unsigned, see item 4.
6¹/₄ x 4¹/₂

HW 1 (August 1, 1857): 488.

6. *Sophs*
Unsigned, see item 4.
6¹/₄ x 4¹/₂

HW 1 (August 1, 1857): 488.

7. *Juniors*
Unsigned, see item 4.
6³/₈ x 4⁹/₁₆

HW 1 (August 1, 1857): 489.

8. *Seniors*
Unsigned, see item 4.
6³/₈ x 4⁹/₁₆

HW 1 (August 1, 1857): 489.

9. *The Fountain on Boston Common*
HOMER (lower left); "Mr. Homer" (text)
Damoreau (lower right)
6⁷/₈ x 9¹/₂

BP 13 (August 15, 1857): 97.

10. *Pierre-Jean de Beranger*
WH (left)
5⁹/₁₆ x 5¹¹/₁₆

BP 13 (September 5, 1857): 145.

11. *A Boston Watering-Cart* (fig. 6.2)
 WH lower right; "Mr. Homer" (text)
 $6^3/_8$ x $9^1/_2$
 BP 13 (September 12, 1857): 161.
12. *The Late William Wood*
 WH (lower center)
 Peirce (lower left)
 $4^3/_{16}$ x $3^5/_8$
 BP 13 (September 9, 1857): 188.
13. *View in South Market Street, Boston* (fig. 6.3)
 HOMER (lower left)/"Mr. Homer"
 Damoreau (lower right)
 $6^7/_{16}$ x $9^1/_2$
 BP 13 (October 3, 1857): 209.
14. *Hon. Robert I. Burbank*
 unsigned/"by Homer"
 Peirce (lower center)
 $4^3/_8$ x $3^{13}/_{16}$
 BP 13 (October 3, 1857): 220.
15. *Rembrandt Peale*
 W Homer (lower left)/"by Homer"
 Peirce (lower right)
 $6^{13}/_{16}$ x $5^{15}/_{16}$
 BP 13 (October 17, 1857): 241.
16. *Emigrant Arrival at Constitution Wharf, Boston* (fig. 6.4)
 Homer (lower left)
 Damoreau (lower right)
 $5^3/_8$ x $9^5/_{16}$
 BP 13 (October 31, 1857): 273.
17. *Boston Evening Street Scene, at the Corner of Court and Brattle Streets*
 (fig.6.5)
 Homer (lower center)/"Mr. Homer"
 $6^3/_8$ x $9^3/_8$
 BP 13 (November 7, 1857): 289.
18. *Blindman's Buff*
 Unsigned, but part of the Thanksgiving set, items 18–21.
 $4^7/_{16}$ x $6^{13}/_{16}$
 BP 13 (November 28, 1857): 344.
19. *Husking Party Finding the Red Ears* (fig. 6.7)
 Homer (lower left)
 Damoreau (lower right)
 $6^3/_8$ x $9^3/_8$
 BP 13 (November 28, 1857): 344.

20. *Family Party Playing at Fox and Geese* (fig. 6.6)
 HOMER (lower left)
 Damoreau (lower right)
 5³/₈ x 9³/₈
 BP 13 (November 28, 1857): 345.
21. *Coasting Out of Doors*
 W HOMER (lower right)
 Fox (lower left)
 4¹/₂ x 6⁷/₈
 BP 13 (November 28, 1857): 345.
22. *The "Cold Term," Boston—Scene, Corner of Milk and Washington Streets* (fig. 7.1)
 H (lower right); "Mr. Homer"
 6⁷/₈ x 9³/₈
 BP 14 (March 27, 1858): 193.
23. *Spring in the City* (fig. 7.5)
 WH (lower left)
 9³/₁₆ x 13³/₄
 HW 2 (April 17, 1858): 248.
24. *The Boston Common* (fig. 7.6)
 Homer (lower left)
 9¹/₄ x 13¹⁵/₁₆
 HW 2 (May 22, 1858): 329.
25. *Class Day, At Harvard University, Cambridge, Mass.*
 "Mr. Homer"
 5¹/₂ x 9³/₈
 BP 15 (July 3, 1858): 1.
26. *Camp Meeting Sketches: Landing at the Cape* (fig. 7.2)
 "Mr. Homer"
 5 x 9³/₈
 BP 15 (August 21, 1858): 120.
27. *Camp Meeting Sketches: Morning Ablutions*
 "Mr. Homer"
 Peirce (lower left)
 5 x 9³/₈
 BP 15 (August 21, 1858): 120.
28. *Camp Meeting Sketches: Cooking*
 "Mr. Homer"
 5 x 9³/₈
 BP 15 (August 21, 1858): 121.
29. *Camp Meeting Sketches: The Tent* (fig. 7.3)
 H (lower right); "Mr. Homer"

5 x 9³/₈
BP 15 (August 21, 1858): 121.

30. *The Bathe at Newport*
Homer (lower left)
9³/₁₆ x 13³/₄
HW 2 (September 4, 1858): 568.

31. *Picknicking in the Woods* (fig. 7.7)
Homer (lower right)
9¹/₈ x 13³/₄
HW 2 (September 4, 1858): 569.

32. *Theodore Parker*
Homer (lower left); "Mr. Homer"
Hayes (lower center)
8 x 5³/₄
BP 15 (November 6, 1858): 289.

33. *Husking the Corn in New England* (fig. 7.8)
HOMER (lower right)
9³/₁₆ x 13¹³/₁₆
HW 2 (November 13, 1858): 728.

34. *Driving Home the Corn*
Homer (lower left)
5⁷/₈ x 9¹/₄
HW 2 (November 13, 1858): 729.

35. *The Dance after the Husking*
WH (lower left)
6 x 9¹/₄
HW 2 (November 13, 1858): 729.

36. *Thanksgiving Day—Ways and Means* (fig. 7.9)
Homer (lower left). This signature applies also to the other items in this set (38–40).
6¹³/₁₆ x 9¹/₈
HW 2 (November 27, 1858): 760.

37. *Thanksgiving Day—Arrival at the Old Home*
For signature, see item 37.
6¹/₂ x 9¹/₈
HW 2 (November 27, 1858): 760.

38. *Thanksgiving Day—The Dinner* (fig. 7.10)
For signature, see item 37.
6⁷/₈ x 9¹/₄
HW 2 (November 27, 1858): 761.

39. *Thanksgiving Day—The Dance* (fig. 7.11)
For signature, see item 37.

$6^7/_{16}$ x $9^1/_8$

HW 2 (November 27, 1858): 761.

40. *William E. Burton, Esq., Comedian*
 Homer (lower left); "by Homer" (text)
 Damoreau (lower right)
 $7^1/_2$ x 6
 BP 15 (December 4, 1858): 353.

41. *Henry Wadsworth Longfellow*
 WH (lower left); "by Homer" (text)
 Peirce (lower center)
 $7^1/_2$ x $5^{15}/_{16}$
 BP 15 (December 25, 1858): 401.

42. *Christmas—Gathering Evergreens*
 Homer (lower left)
 $5^7/_8$ x $9^1/_8$
 HW 2 (December 25, 1858): 820.

43. *The Christmas-Tree*
 WH (lower left)
 $5^7/_8$ x $9^1/_8$
 HW 2 (December 25, 1858): 820.

44. *Santa Claus and His Presents* (fig. 7.12)
 WH (on ribbon, right bedpost)
 $5^{13}/_{16}$ x $9^1/_8$
 HW 2 (December 25, 1858): 821.

45. *Christmas Out of Doors* (fig. 7.13)
 WH (lower left)
 $5^{15}/_{16}$ x $9^3/_{16}$
 HW 2 (December 25, 1858): 821.

46. *Hon. Stephen A. Douglas*
 "by Mr. Homer"
 Damoreau (lower left)
 $7^7/_8$ x $5^3/_4$
 BP 16 (January 8, 1859): 17.

47. *Hon. Charles Hale, Speaker of the House,*
 Massachusetts Legislature
 "by Homer"
 Peirce (lower center)
 $7^5/_8$ x $5^{13}/_{16}$
 BP 16 (January 22, 1859): 49.

48. *Skating on Jamaica Pond, Near Boston*
 Homer (lower right)/"by Mr. Homer"
 HAYES (lower left)

$5^3/_8$ x $9^3/_8$

BP 16 (January 29, 1859): 65.

49. *Sleighing in Haymarket Square, Boston*
 WH (lower left)
 Hayes (lower center)
 5 x $9^3/_8$
 BP 16 (January 29, 1859): 72.

50. *Sleighing on the Road, Brighton, Near Boston*
 "Mr. Homer"
 Damoreau (lower right center)
 5 x $9^3/_8$
 BP 16 (January 29, 1859): 72.

51. *Ralph Waldo Emerson*
 WH (lower left)/"by Homer"
 Peirce (lower center)
 $7^5/_{16}$ x $5^{13}/_{16}$
 BP 16 (February 5, 1859): 81.

52. *Mrs. Cunningham, Boston Museum*
 "by Mr. Homer"
 Peirce (lower left)
 $4^3/_8$ x $3^7/_8$
 BP 16 (February 19, 1859): 120.

53. *Maria Piccolomini*
 "Mr. Homer"
 Peirce (lower left)
 $7^7/_8$ x $5^{15}/_{16}$
 BP 16 (February 26, 1859): 129.

54. *Nahum Capen, Esq., Postmaster of Boston*
 "Homer"
 $7^1/_2$ x $5^7/_8$
 BP 16 (March 5, 1859): 145.

55. *La Petite Angelina and Miss C. Thompson, at the Boston Museum*
 Homer (lower left)/"Mr. Homer"
 $4^1/_2$ x $6^{13}/_{16}$
 BP 16 (March 12, 1859): 168.

56. *Evening Scene at the Skating Park, Boston*
 "Mr. Homer" (text)
 5 x $9^3/_8$
 BP 16 (March 12, 1859): 168.

57. *Fletcher Webster, Esq., Surveyor of Boston*
 "Mr. Homer"
 Peirce (lower right)

$7^{15}/_{16}$ x $5^{15}/_{16}$

BP 16 (March 19, 1859): 177.

58. *Samuel Masury, Daguerreotypist and Photographer*
"Mr. Homer"
Peirce (lower left)
$4^{1}/_{16}$ x 4
BP 16 (March 26, 1859): 205.

59. *March Winds* (fig. 7.18)
W. Homer (lower left)
$5^{15}/_{16}$ x $9^{1}/_{16}$
HW 3 (April 2, 1859): 216.

60. *April Showers* (fig. 7.19)
Homer (lower left)
$5^{15}/_{16}$ x $9^{1}/_{16}$
HW 3 (April 2, 1859): 216.

61. *A Superb Lion and Lioness, Now Exhibiting in Boston*
"Mr. Homer . . . his first attempt at drawing wild animals"
Fox (lower right)
7 x $9^{7}/_{16}$
BP 16 (April 9, 1859): 233.

62. *Hon. James A. Pearce, U.S. Senator from Maryland*
"Homer"
$7^{5}/_{16}$ x $5^{13}/_{16}$
BP 16 (April 23, 1859): 257.

63. *The New Town of Belmont, Massachusetts*
Homer (lower right)/"Mr. Homer"
Damoreau (lower left)
$4^{7}/_{8}$ x $9^{5}/_{16}$
BP 16 (April 23, 1859): 264.

64. *May-Day in the Country*
Unsigned; attributed to Homer on grounds of style.
$9^{1}/_{8}$ x $13^{3}/_{4}$
HW 3 (April 30, 1859): 280.

65. *The Late Col. Samuel Jaques*
WH (lower left); "Mr. Homer"
Peirce (lower center)
$6^{5}/_{16}$ x $5^{7}/_{8}$
BP 16 (May 7, 1859): 289.

66. *The Wonderful Dutton Children*
WH (lower left); "Mr. Homer"
Tarbell Sc. (lower right)
$6^{9}/_{16}$ x $4^{7}/_{8}$
BP 16 (May 14, 1859): 305.

67. *Scene on the Back Bay Lands, Boston* (fig. 7.14)
 WH (lower left)/"Mr. Homer"
 Tarbell (lower right)
 5 x 9$^{7}/_{16}$
 BP 16 (May 21, 1859): 328.

68. *The Aquarial Gardens, Bromfield Street, Boston*
 W. Homer (lower left); "Mr. Homer"
 Damoreau (lower right)
 6$^{7}/_{16}$ x 9$^{3}/_{8}$
 BP 16 (May 28, 1859): 335.

69. *Cricket Players on Boston Common* (fig. 7.15)
 "Mr. Homer"
 5$^{3}/_{8}$ x 9$^{7}/_{16}$
 BP 16 (June 4, 1859): 360.

70. *Madame Laborde, The Prima Donna*
 "Homer"
 7$^{3}/_{4}$ x 6
 BP 16 (June 25, 1859): 401.

71. *Paul Morphy, The Chess Champion*
 WH (lower left)/"Homer"
 Hayes (lower right)
 7$^{7}/_{16}$ x 5$^{15}/_{16}$
 BP 17 (July 2, 1859): 1.

72. *Cambridge Cattle Market* (fig. 7.16)
 WH (lower center)/"Mr. Homer"
 Peirce (lower right)
 6 x 9$^{1}/_{2}$
 BP 17 (July 2, 1859): 8.

73. *Fourth of July Scene, on Boston Common*
 "Mr. Homer"
 5$^{1}/_{2}$ x 9$^{7}/_{16}$
 BP 17 (July 9, 1859): 17.

74. *Boston Street Characters* (fig. 7.17)
 W Homer (center)/HOMER (lower right); "Homer"
 13$^{7}/_{16}$ x 9$^{1}/_{2}$
 BP (July 9, 1859): 24.

75. *Captain Robert B. Forbes*
 WH (lower left); "Mr. Homer" (text)
 Peirce (lower right)
 7$^{7}/_{8}$ x 5$^{15}/_{16}$
 BP 17 (August 20, 1859): 113.

76. *August in the Country—The Sea-Shore* (fig. 7.20)
 W Homer (lower center)

$9^{1}/_{8}$ x $13^{7}/_{8}$
HW 3 (August 27, 1859): 553.
77. *A Cadet Hop at West Point*
Homer (lower left)
$9^{1}/_{8}$ x $13^{7}/_{8}$
HW 3 (September 3, 1859): 568.
78. *The Grand Review at Camp Massachusetts, Near Concord, September 9, 1859*
W. Homer (lower left)
$13^{7}/_{8}$ x $20^{3}/_{8}$
HW 3 (September 24, 1859): 616–17.
79. *Fall Games—The Apple-Bee* (fig. 7.21)
W. Homer (lower left)
$9^{1}/_{8}$ x $13^{7}/_{8}$
HW 3 (November 26, 1859): 761.
80. *Hon. John F. Potter, of Wisconsin*
"Mr. Homer"
Peirce (lower left)
$7^{3}/_{4}$ x 6
BP 17 (December 3, 1859): 353.
81. *A Merry Christmas and a Happy New Year* (fig. 8.2)
W. Homer (lower left)
$13^{3}/_{4}$ x $20^{1}/_{4}$
HW 3 (December 25, 1859): 824–25.
82. *Union Meetings in the Open Air, Outside the Academy of Music, December 19, 1859* (fig. 8.4)
WH (lower left)
$10^{3}/_{4}$ x $9^{1}/_{8}$ 1/8
HW 4 (January 7, 1860): 1.
83. *The Sleighing Season-The Upset*
W Homer (lower left)
$9^{3}/_{16}$ x $13^{13}/_{16}$
HW 4 (January 14, 1860): 24.
84. *A Snow Slide in the City* (fig. 8.1)
Homer (lower left)
$9^{1}/_{8}$ x $13^{3}/_{4}$
HW 4 (January 14, 1860): 25.
85. *Skating on the Ladies' Skating-Pond in the Central Park, New York* (fig. 8.3)
W. Homer (lower left)
$13^{13}/_{16}$ x $20^{5}/_{16}$
HW 4 (January 28, 1860): 56–57.

86. *Hon. J. L. M. Curry, of Alabama*
 H (lower left)
 $8^{13}/_{16}$ x $5^{7}/_{8}$
 HW 4 (February 18, 1860): 100.
87. *Hon. Elihu B. Washburne, of Illinois, Chairman of the Committee on Commerce*
 H (lower left)
 $8^{1}/_{2}$ x $5^{7}/_{8}$
 HW 4 (March 17, 1860): 172.
88. *Scene in Union Square, New York, on a March Day*
 Homer (lower left)
 $4^{3}/_{4}$ x $6^{3}/_{4}$
 HW 4 (April 7, 1860): 224.
89. *Chime of Thirteen Bells for Christ Church, Cambridge, Massachusetts, Manufactured by Messrs. Henry N. Hooper & Co., of Boston*
 H (lower left)
 $10^{7}/_{8}$ x $9^{1}/_{4}$
 HW 4 (May 26, 1860): 324.
90. *The Drive in the Central Park, New York, September, 1860*
 W. Homer (lower right)
 $13^{11}/_{16}$ x $20^{1}/_{2}$
 HW 4 (September 15, 1860): 584—85.
91. *Welcome to the Prince of Wales* (fig. 8.5)
 Unsigned, but attributed to Homer on grounds of style.
 $10^{5}/_{8}$ x $9^{1}/_{8}$
 HW 4 (October 20, 1860): 657.
92. *Hon. Abraham Lincoln, Born in Kentucky, February 12, 1809* (fig. 8.6)
 H (lower right)
 $10^{13}/_{16}$ x $9^{1}/_{8}$
 HW 4 (November 10, 1860): 705.
93. *General Guiseppi [sic] Garibaldi and Two Favorite Volunteers* (fig. 8.8)
 WH (lower left)
 $11^{5}/_{8}$ x 9
 HW 4 (November 17, 1860): 721.
94. *Thanksgiving Day—The Two Great Classes of Society*
 W. Homer (lower left)
 $13^{7}/_{8}$ x $20^{5}/_{16}$
 HW 4 (December 1, 1860): 760–61.
95. *Hon. Roger B. Taney, Chief-Justice of the United States*
 WH (lower left)
 9 x $5^{7}/_{8}$
 HW 4 (December 8, 1860): 769.

96. *Expulsion of Negroes and Abolitionists from the Tremont Temple,*
 Boston, Massachusetts, on December 3, 1860 (fig. 8.10)
 WH (lower right)
 6¹⁵/₁₆ x 9¹/₈
 HW 4 (December 15, 1860): 788.

97. *The Seceding South—Carolina Delegation*
 H (lower left)
 10³/₄ x 9¹/₈
 HW 4 (December 15, 1860): 801.

98. *The Georgia Delegation in Congress*
 Homer (lower left)
 10³/₄ x 9¹/₈
 HW 5 (January 5, 1861): 1.

99. *Seeing the Old Year Out—Watch Night*
 Homer (lower left)
 13¹³/₁₆ x 20³/₈
 HW 5 (January 5, 1861): 8–9.

100. *The Seceding Mississippi Delegation in Congress*
 Homer (lower left)
 10³/₄ x 9¹/₁₆
 HW 5 (February 2, 1861): 65.

101. *The Late Rev. Dr. Murray*
 H (lower left)
 6³/₄ x 5⁷/₈
 HW 5 (February 23, 1861): 117.

102. *Lt. Slemmer*
 H (lower left)
 4¹/₄ x 4³/₈
 HW 5 (February 2, 1861): 125.

103. *Abraham Lincoln, the President Elect, Addressing the People from the*
 Astor House Balcony, February 19, 1861 (fig. 8.11)
 H (upper left)
 10⁷/₈ x 9¹/₈
 HW 5 (March 2, 1861): 129

104. *The Inauguration of Abraham Lincoln as President of the United*
 States, at the Capitol, Washington, March 4, 1861 (fig. 8.12)
 Unsigned: the foreground figures are attributed to Homer on the basis
 of style.
 20¹/₈ x 13³/₄
 HW 5 (March 16, 1861): 168–69.

105. *General Beauregard*
 H (lower left)

$6^7/8$ x 5
HW 5 (April 27, 1861): 269

106. *Colonel Wilson of Wilson's Brigade*
H (lower left)
9 x $5^7/8$
HW 5 (May 11, 1861): 289.

107. *The Seventy-Ninth Regiment (Highlanders) New York State Militia*
Homer (lower right)
$9^3/_{16}$ x $13^3/4$
HW 5 (May 25, 1861): 329.

108. *The War—Making Havelocks for the Volunteers* (fig. 8.13)
Homer (lower right)
$10^{15}/_{16}$ x $9^3/_{16}$
HW 5 (June 29, 1861): 401.

109. *Crew of the United States Steam-Sloop "Colorado," Shipped at Boston, June, 1861*
Homer (lower left)
$9^1/8$ x $13^3/4$
HW 5 (July 13, 1861): 439.

110. *Filling Cartridges at the United States Arsenal, at Watertown, Massachusetts*
Homer (lower right in upper vignette)
$10^{15}/_{16}$ x $9^3/_{16}$
HW 5 (July 20, 1861): 449.

111. *Flag-Officer Stringham*
H (lower left)
$4^7/8$ x $4^7/_{16}$
HW 5 (September 14, 1861): 577.

112. *A Night Reconnaissance* (fig. 9.1)
Unsigned, but attributed to Homer on grounds of style.
$6^7/8$ x $9^1/4$
HW 5 (October 26, 1861): 673

113. *The Songs of the War* (fig. 9.2)
Homer (lower center)
14 x 20
HW 5 (November 23, 1861): 744–45.

114. *A Bivouac Fire on the Potomac* (fig. 9.3)
Homer (lower left)
$13^{13}/_{16}$ x $20^3/_{16}$
HW 5 (December 21, 1861): 808–9.

115. *Great Fair Given at the City Assembly Rooms, New York, December, 1861, in Aid of the City Poor*

W. Homer (lower left)

13³/₈ x 20³/₈

HW 5 (December 28, 1861): 824–25.

116. *Christmas Boxes in Camp—Christmas, 1861*
Homer (lower left)

10¹³/₁₆ x 9¹/₈

HW 6 (January 4, 1862): 1.

117. *Our Army Before Yorktown, Virginia—from Sketches by Mr. A. R. Waud and Mr. W. Homer* (fig. 9.4)
Caption. Four of the unsigned vignettes are by Homer: "Rebel Works," "Reconnaissance in Force," and probably "Berdan's Sharpshooters" and "Religious Services."

13³/₄ x 20³/₄

HW 6 (May 3, 1862): 280—81.

118. *Rebels Outside Their Works at Yorktown Reconnoitering with Dark Lanterns—sketched by Mr. Winslow Homer*

10¹⁵/₁₆ x 9³/₁₆

HW 6 (May 17, 1862): 305.

119. *The Union Cavalry and Artillery Starting in Pursuit of the Rebels Up the Yorktown Pike*
WH (lower right)

9¹/₄ x 13⁷/₈

HW 6 (May 17, 1862): 308.

120. *Charge of the First Massachusetts Regiment on a Rebel Rifle Pit Near Yorktown*
Caption

6⁷/₈ x 9¹/₈

HW 6 (May 17, 1862): 309.

121. *The Army of the Potomac—Our Outlying Picket in the Woods*
Caption

6⁷/₈ x 9³/₁₆

HW 6 (June 7, 1862): 359.

122. *News from the War* (fig. 9.5)
Homer (center)

13⁵/₁₆ x 20³/₈

HW 6 (June 14, 1862): 376–77.

123. *The War for the Union, 1862—A Cavalry Charge*
Homer (lower left)

13⁵/₈ x 20⁵/₈

HW 6 (July 5, 1862): 424–25.

124. *The Surgeon at Work at the Rear During an Engagement* (fig. 9.7)
Homer (lower left)

$9^{3}/_{16}$ x $13^{7}/_{8}$
HW 6 (July 12, 1862): 436.
125. *The War for the Union, 1862—A Bayonet Charge* (fig. 9.6)
Homer (lower left)
$13^{5}/_{8}$ x $20^{5}/_{8}$
HW 6 (July 12, 1862): 440–41.
126. *Our Women and the War* (fig. 9.8)
Unsigned but long accepted as by Homer on grounds of style.
$13^{7}/_{16}$ x $20^{7}/_{16}$
HW 6 (September 6, 1862): 568–69.
127. *Army of the Potomac—A Sharpshooter on Picket Duty* (fig. 9.9)
Homer (lower right)
$9^{1}/_{8}$ x $13^{3}/_{4}$
HW 6 (November 15, 1862): 724
128. *Thanksgiving in Camp*
Homer (lower right)
$9^{1}/_{8}$ x $13^{13}/_{16}$
HW 6 (November 29, 1862): 764.
129. *A Shell in the Rebel Trenches* (fig. 9.11)
Homer (lower right)
$9^{1}/_{8}$ x $13^{13}/_{16}$
HW 7 (January 17, 1863): 36.
130. *Winter-Quarters in Camp—The Inside of a Hut*
"Mr. W. Homer"
$9^{1}/_{8}$ x $13^{7}/_{8}$
HW 7 (January 24, 1863): 52.
131. *Pay-Day in the Army of the Potomac*
Homer (lower right)
$13^{9}/_{16}$ x $20^{1}/_{2}$
HW 7 (February 28, 1863): 136—37.
132. *Great Sumter Meeting in the Union Square, New York, April 11, 1863*
Unsigned, but attributed to Homer on grounds of style.
$9^{1}/_{8}$ x $13^{3}/_{4}$
HW 7 (April 25, 1863): 260.
133. *The Approach of the British Pirate "Alabama"*
Homer (lower left)
$13^{13}/_{16}$ x $9^{1}/_{8}$
HW 7 (April 25, 1863): 268.
134. *Home from the War*
H (lower left)
$9^{1}/_{4}$ x $13^{15}/_{16}$
HW 7 (June 13, 1863): 381.

135. *The Russian Ball—in the Supper-Room*
 Unsigned, but attributed to Homer on grounds of style and its
 association with the following item.
 10³/₄ x 9¹/₈
 HW 7 (November 21, 1863): 737.

136. *The Great Russian Ball at the Academy of Music, November 5, 1863*
 Homer (lower right)
 13³/₁₆ x 20¹/₄
 HW 7 (November 21, 1863): 744–45.

137. *Halt of a Wagon Train* (fig. 9.12)
 Unsigned, but attributed to Homer on grounds of style.
 13³/₈ x 20¹/₂
 HW 8 (February 6, 1864): 88–89.

138. *"Anything for Me, if You Please?"—Post-Office of the Brooklyn Fair
 in Aid of the Sanitary Commission*
 Homer (left center)
 13⁵/₈ x 9¹/₁₆
 HW 8 (March 5, 1864): 156.

139. *Floral Department of the Great Fair*
 Unsigned, but attributed to Homer on grounds of style
 10⁷/₈ x 9³/₁₆
 HW 8 (April 16, 1864): 241.

140. *Thanksgiving-Day in the Army—After Dinner: The Wish-Bone*
 Caption
 9¹/₄ x 13⁷/₈
 HW 8 (December 3, 1864): 780.

141. *Holiday in Camp—Soldiers Playing "Foot-Ball"* (fig. 9.13)
 Caption
 9¹/₄ x 13¹³/₁₆
 HW 9 (July 15, 1865): 444.

142. *Our Watering-Places—The Empty Sleeve at Newport* (fig. 9.15)
 Unsigned, but attributed to Homer on grounds of style.
 9³/₁₆ x 13¹³/₁₆
 HW 9 (August 26, 1865): 532.

143. *Our Watering-Places—Horse-Racing at Saratoga* (fig. 9.14)
 Caption
 9¹/₈ x 13¹³/₁₆
 HW 9 (August 26, 1865): 533.

144. *Looking at the Eclipse* (fig. 9.16)
 Caption
 J. Davis
 10³/₄ x 9¹/₄
 CC 2 (December 16, 1865): 37.

145. *Thanksgiving Day—Hanging Up the Musket* (fig. 9.17)
 Unsigned; attributed to Homer on grounds of style.
 14³/₁₆ x 9³/₁₆
 FL 21 (December 23, 1865): 216.

146. *Thanksgiving Day—the Church Porch* (fig. 9.18)
 Unsigned; attributed to Homer on grounds of style.
 13¹⁵/₁₆ x 9¹/₈
 FL 21 (December 23, 1865): 217.

147. *Our National Winter Exercise—Skating* (fig. 9.19)
 Unsigned; attributed to Homer on grounds of style.
 13⁷/₈ x 20³/₈
 FL 21 (January 13, 1866): 264–65.

148. *A Parisian Ball—Dancing at the Mabille, Paris* (fig. 10.1)
 WH (lower right)
 9³/₁₆ x 13³/₄
 HW 11 (November 23, 1867): 744.

149. *A Parisian Ball—Dancing at the Casino* (fig. 10.2)
 WH (lower right)
 9³/₁₆ x 13³/₄
 HW 11 (November 23, 1867): 745.

150. *Homeward-Bound* (fig. 10.4)
 WH (upper right)
 13⁹/₁₆ x 20¹/₂
 HW 11 (December 21, 1867): 808–9.

151. *Art Students and Copyists in the Louvre Gallery, Paris* (fig. 10.3)
 WH (upper left)
 9 x 13³/₄
 HW 12 (January 11, 1868): 25.

152. *"Winter"—A Skating Scene* (fig. 10.5)
 Caption
 9 x 13⁹/₁₆
 HW 12 (January 25, 1868): 52.

153. *St. Valentine's Day—The Old Story in All Lands* (fig. 10.6)
 WH (lower right)
 13⁵/₈ x 9
 HW 12 (February 22, 1868): 124.

154. *Opening Day in New York* (fig. 10.7)
 WH (lower right in central vignette)
 "Mr. Homer"
 13⁵/₈ x 20¹/₈
 HB 1 (March 21, 1868): 328–29

155. *The Morning Walk—Young Ladies' School Promenading the Avenue*
 WH (center right)

$9^1/_{16}$ x $13^{11}/_{16}$

HW 12 (March 28, 1868): 201.

156. *The Fourth of July in Tompkins Square, New York—"The Sogers Are Coming!"* (fig. 10.8)
WH (lower left)
$9^1/_{16}$ x $13^{11}/_{16}$
HB 1 (July 11, 1868): 588.

157. *Fire-Works on the Night of the Fourth of July*
WH (lower right)
$9^1/_8$ x $13^3/_4$
HW 12 (July 11, 1868): 445.

158. *New England Factory Life—"Bell-Time"* (fig. 10.9)
Caption
$13^{15}/_{16}$ x $9^3/_{16}$
HW 12 (July 25, 1868): 472.

159. *Blue Beard Tableau: Fatima Enters the Forbidden Closet*
"Mr. Winslow Homer"
$9/16$ x $4^1/_2$
HB 1 (September 5, 1868): 717.

160. *Blue Beard Tableau: What She Sees There*
WH (lower left)/"Mr. Winslow Homer"
4 x $9^1/_4$
HB 1 (September 5, 1868): 717

161. *Blue Beard Tableau: Disposition of the Bodies (Invisible to the Spectators)*
WH (lower left); "Mr. Winslow Homer"
$4^1/_4$ x $4^9/_{16}$
HB 1 (September 5, 1868): 717.

162. *"Our Next President"*
WH (lower right)
$10^7/_8$ x $9^1/_8$
HW 12 (October 31, 1868): 689.

163. *Waiting for Calls on New-Year's Day*
Unsigned; attributed to Homer on grounds of style.
$9^1/_{16}$ x $13^3/_4$
HB 2 (January 2, 1869): 9.

164. *Christmas Belles*
WH in cipher on sleigh
$9^1/_8$ x $13^{13}/_{16}$
HW 13 (January 2, 1869): 8.

165. *The New Year—1869*
WH (lower left)

$9^1/_{16}$ x $13^5/_8$

HW 13 (January 9, 1869): 20.

166. *Winter at Sea—Taking in Sail Off the Coast*
Homer (lower left)
$9^1/_8$ x $13^{13}/_{16}$
HW 13 (January 16, 1869): 40.

167. *Jurors Listening to Council, Supreme Court, New City Hall, New York—Drawn by Mr. Winslow Homer*
"Mr. Winslow Homer's characteristic drawing"
$8^{15}/_{16}$ x $13^3/_4$
HW 13 (February 20, 1869): 120.

168. *The Artist in the Country* (fig. 11.4)
WH (lower right)
J. KARST. (lower left)
$6^5/_{16}$ x $6^5/_8$
AJ 1 (June 19, 1869): 353.

169. *Summer in the Country*
"Mr. Winslow Homer"
J. Karst (lower left)
$4^1/_2$ x $6^9/_{16}$
AJ 1 (July 10, 1869): 465.

170. *The Summit of Mount Washington* (fig. 11.1)
WH (lower right)
$9^1/_{16}$ x $13^{11}/_{16}$
HW 13 (July 10, 1869): 441.

171. *On the Road to Lake George* (fig. 11.5)
WH (upper right)
$6^1/_8$ x $6^5/_8$
AJ 1 (July 24, 1869): 513.

172. *What Shall We Do Next?*
WH (lower center)
$9^1/_{16}$ x $13^3/_4$
HB 2 (July 31, 1869): 488.

173. *The Last Load*
"Mr. Homer's"
J. Filmer (lower right)
$4^1/_2$ x $6^1/_2$
AJ 1 (August 7, 1869): 592.

174. *The Picnic Excursion* (fig. 11.6)
H (lower left)
$6^1/_2$ x $9^3/_{16}$
AJ 1 (August 14, 1869): 624.

175. *The Beach at Long Branch* (fig. 11.7)
WH (lower center)
J. Karst (lower left)
13 x 19³/₈
AJ 2 (August 21, 1869): 128.

176. *At the Spring: Saratoga*
WH (lower left)
N. ORR (lower right)
9³/₁₆ x 8¹/₂
HH 1 (August 28, 1869): 561.

177. *The Straw Ride*
WH (lower left)
9¹/₈ x 13⁷/₈
HB 2 (September 25, 1869): 620.

178. *The Fishing Party* (fig. 11.8)
Caption
J Filmer (lower right)
9 x 12¹¹/₁₆
AJ 2 (October 2, 1869): unpaginated plate.

179. *Another Year by the Old Clock*
Unsigned; attributed to Homer on grounds of style.
15¹/₂ x 11
HB 3 (January 1, 1870): 1.

180. *1860–1870* (fig. 11.10)
Homer (lower right)
13⁷/₁₆ x 20¹/₂
HW 14 (January 8, 1870): 24–25.

181. *Tenth Commandment* (fig. 11.3)
WH (upper left)/WINSLOW HOMER (lower right)
10³/₈ x 9
HW 14 (March 12, 1870): 161.

182. *Danger Ahead*
WH (lower right)
6¹/₈ x 6⁷/₁₆
AJ 3 (April 30, 1870): 477.

183. *Spring Farm Work—Grafting*
WH (lower left)
6⁷/₈ x 9¹/₁₆
HW 14 (April 30, 1870): 276.

184. *Spring Blossoms*
WH (lower right); WH (lower left)
9¹/₁₆ x 13¹³/₁₆
HW 14 (May 21, 1870): 328.

185. *The Dinner Horn*
 WH (lower left)
 13³/₄ x 9
 HW 14 (June 11, 1870): 377.
186. *A Quiet Day in the Woods* (fig. 11.9)
 WH (upper right)
 J Karst (lower right)
 6³/₁₆ x 6¹/₂
 AJ 3 (June 25, 1870): 701.
187. *The Coolest Spot in New England—Summit of Mount Washington*
 (fig. 11.11)
 WH (lower right)
 13³/₄ x 9¹/₈
 HB 3 (July 23, 1870): 473.
188. *High Tide*
 Homer (lower left)
 8¹⁵/₁₆ x 11¹³/₁₆
 ES 1 (August 6, 1870): 504.
189. *Low Tide* (fig. 11.12)
 WH (lower right)
 Kingdon (lower left)
 8¹⁵/₁₆ x 11¹³/₁₆
 ES 1 (August 6, 1870): 505.
190. *On the Bluff at Long Branch, at the Bathing Hour* (fig. 11.2)
 WH (lower left)
 8⁵/₈ x 13¹¹/₁₆
 HW 14 (August 6, 1870): 504.
191. *The Robin's Note*
 Homer (lower left)
 9¹/₈ x 8⁷/₈
 ES 1 (August 20, 1870): 529.
192. *On the Beach at Long Branch*
 WH (as part of the carriage door)
 9 x 13³/₄
 HB 3 (September 3, 1870): 569.
193. *Chestnutting*
 Homer (lower left)
 J ANDREW (lower right)
 11⁷/₈ x 8⁷/₈
 ES 1 (October 29, 1870): 700.
194. *Trapping in the Adirondacks* (fig. 11.13)
 Homer (lower left)
 J Davis (lower right)

$8^7/_8$ x $11^{13}/_{16}$
ES 1 (December 24, 1870): 849.
195. *A Winter-Morning—Shovelling Out*
WH (lower right)
G. Avery (lower left)
$8^7/_8$ x $11^{13}/_{16}$
ES 2 (January 14, 1871): 32.
196. *Deer-Stalking in the Adirondacks in Winter*
Homer (lower left)
[Lagarde?]FL (lower right)
$8^3/_4$ x $11^3/_4$
ES 2 (January 21, 1871): 57.
197. *Lumbering in Winter* (fig. 11.14)
J. Davis (lower left)
$11^3/_4$ x $8^3/_4$
ES 2 (January 28, 1871): 89.
198. *Cutting a Figure* (fig. 11.15)
Homer (lower left)
W MORSE (lower right)
$11^3/_4$ x $18^{11}/_{16}$
ES 2 (February 4, 1871): 116–17.
199. *A Country Store—Getting Weighed*
WH (middle left)
W. Linton (lower center)
$8^{13}/_{16}$ x $11^5/_8$
ES 2 (February 4, 1871): 272.
200. *At Sea—Signalling a Passing Steamer* (fig. 11.16)
Caption
$8^3/_4$ x $11^{11}/_{16}$
ES 2 (April 8, 1871): 321.
201. *Bathing at Long Branch—"Oh, Ain't It Cold"*
WH (lower right)
WM (lower left)
$11^{13}/_{16}$ x $8^3/_4$
ES 3 (August 26, 1871): 213.
202. *Making Hay*
"Mr. Winslow Homer" (text)
$9^3/_{16}$ x $13^7/_8$
HW 16 (July 6, 1872): 529.
203. *On the Beach—Two Are Company, Three Are None*
WH (lower right)
$9^3/_{16}$ x $13^7/_8$

HW 16 (August 17, 1872): 636.
204. *Under the Falls, Catskill Mountains* (fig. 11.17)
Caption
9⅛ x 13⅞
HW 16 (September 14, 1872): 721.
205. *The Wreck of the "Atlantic"—Cast Up by the Sea* (fig. 12.1)
WH (upper left)
9³/₁₆ x 13⅞
HW 17 (April 26, 1873): 345.
206. *The Noon Recess* (fig. 12.2)
WH (on blackboard)
9¹/₁₆ x 13¾
HW 17 (June 28, 1873): 549.
207. *The Bathers*
Caption
Redding (lower right)
13¹³/₁₆ x 9³/₁₆
HW 17 (August 2, 1873): 668.
208. *The Nooning* (fig. 12.3)
WH (lower left)
9⅛ x 13⅞
HW 17 (August 16, 1873): 725.
209. *Sea-Side Sketches—A Clam-Bake* (fig. 12.4)
Homer (lower right)
Redding (lower left)
9¼ x 13¹⁵/₁₆
HW 17 (August 23, 1873): 740.
210. *"Snap-the-Whip"* (fig. 12.6)
Homer (lower right)
Lagarde (lower left)
9¼ x 13¹⁵/₁₆
HW 17 (September 20, 1873): 824–25.
211. *Gloucester Harbor*
HW (lower left)
9¼ x 14
HW 17 (September 27, 1873): 844.
212. *Ship-Building, Gloucester Harbor* (fig. 12.5)
WH (lower right)
9¼ x 13⅝
HW 17 (October 11, 1873): 900.
213. *"Dad's Coming!"* (fig. 12.7)
Caption

$9^3/_{16}$ x $13^3/_4$
HW 17 (November 1, 1873): 969.
214. *The Last Days of Harvest*
Caption
$9^1/_4$ x $13^5/_{16}$
HW 17 (December 6, 1873): 1092.
215. *The Morning Bell* (fig. 12.8)
Caption
$9^3/_{16}$ x $13^7/_{16}$
HW 17 (December 13, 1873): 1116.
216. *Station-House Lodgers* (fig. 12.9)
Caption
$9^1/_8$ x $13^1/_2$
HW 18 (February 7, 1874): 132.
217. *The Chinese in New York—Scene in a Baxter Street Club-House* (fig.
12.10)
Caption
$13^3/_4$ x $8^{15}/_{16}$
HW 18 (March 7, 1874): 212.
218. *New York Charities—St. Barnabas House, 304 Mulberry Street* (fig.
12.11)
WH (lower left)
Bross (lower right)
$9^1/_{16}$ x $13^7/_{16}$
HW 18 (April 18, 1874): 336.
219. *Raid on a Sand-Swallow Colony—"How Many Eggs?"* (fig. 1.1)
WH (lower right)
Lagarde (lower left)
$13^3/_8$ x $9^1/_8$
HW 18 (June 13, 1874): 496.
220. *Gathering Berries* (fig. 12.12)
Caption
Lagarde (lower left)
$9^1/_{16}$ x $13^5/_8$
HW 18 (July 11, 1874): 584.
221. *On the Beach at Long Branch—The Children's Hour*
Caption
J. Langridge (lower left)
$9^3/_{16}$ x $13^5/_8$
HW 18 (August 15, 1874): 672.
222. *Waiting for a Bite*
WH (lower right end of log)

Lagarde (lower right)

9^1/$_{16}$ x 13^3/$_4$

HW 18 (August 22, 1874): 693.

223. *See-Saw—Gloucester, Massachusetts* (fig. 12.13)

WH (lower right)

9^1/$_8$ x 13^3/$_4$

HW 18 (September 12, 1874): 757.

224. *Flirting on the Sea-Shore and on the Meadow* (fig. 12.16)

WH (lower left of upper image)

9^1/$_8$ x 13^1/$_2$

HW 18 (September 19, 1874): 780.

225. *Camping out in the Adirondack Mountains*

WH (lower left)

Lagarde (lower right)

9^1/$_8$ x 13^3/$_4$

HW 18 (November 7, 1874): 920.

226. *The Battle of Bunker Hill—Watching the Fight from Copp's Hill, in Boston* (fig. 12.17)

WH (lower right)

9^3/$_{16}$ x 13^{11}/$_{16}$

HW 19 (June 26, 1875): 517.

227. *The Family Record* (fig. 12.18)

Caption

12 x 18^1/$_8$

HB 8 (August 28, 1875): 561.

A List of Works Previously Attributed to Winslow Homer
but Not Accepted in the Present Study

A Picnic by Land. (*HW* 2, June 5, 1858: 360.) The drawing of the female figures in the foreground encouraged the author to attribute the illustration to Homer in 1970 (Tatham, "Winslow Homer in Boston"), but the male figures are uncharacteristic. The middle-ground figures seem to be by quite a different hand than Homer's.

Trotting on the Milldam, Boston. (*BP* 16, February 12, 1859: 105.) The figure drawing is uncharacteristic of Homer, as is the composition of unrelieved parallel planes. In 1977 Kelsey observed that if the work were by Homer it would be "the only one of his early works which treats the major elements of the composition strictly in profile."[2]

Skating at Boston. (*HW* 3, March 12 1859: 173.) The *Weekly*'s accompanying text says that the work is "by a correspondent residing in Boston," but neither the drawing style nor the loosely organized composition is

typical of Homer. In style, the illustration supports an attribution to W. J. Champney.

Inauguration of President Jefferson Davis of the Southern Confederacy, at Montgomery, Alabama, February 18, 1861. (HW 5, March 5, 1861: 157.) Nothing in the drawing style or in the subject supports an attribution to Homer.

The Inaugural Procession at Washington Passing the Gate of the Capitol Grounds. (HW 5, March 16, 1861: 161.) Neither the drawing style nor the composition is Homer's. Both are closer to the work of Arthur Lumley.

Presidents Buchanan and Lincoln Entering the Senate ChamberBefore the Inauguration. (HW 5, March 16, 1861: 165.) This ill-drawn subject has none of Homer's qualities. It is perhaps the work of an amateur, redrawn to no great advantage in the Harper firm's art room.

General Thomas Swearing-In the Volunteers Called into the Service of the United States at Washington, D.C. (HW 5, April 27, 1861: 257) Nothing in this illustration's style suggests that Homer had any involvement with it.

The Advance Guard of the Grand Army of the United States Crossing the Long Bridge over the Potomac at 2 A.M. on May 24, 1861. (HW 5, June 8, 1861: 356.) The awkward composition and characterless execution militate against an attribution to Homer

The Skating Season—1862. (HW 6, January 18, 1862: 44.) This illustration has been attributed to Homer only because he drew other skating subjects during his career, but it lacks altogether the energy of line and spirit that vitalizes his work and is not in his distinctive drawing style.

Army of the Potomac—Sleeping on their Arms. (HW 8, May 28, 1864: 344.) This work has perhaps been attributed to Homer because its title shares with two of Homer's illustrations the generic prefatory title "Army of the Potomac," but *Harper's Weekly* used that title repeatedly throughout the war, never limiting it to the work of a single artist. Nothing characteristic of Homer's style informs this illustration.

Our Minister's Donation Party. (HB 1, December 19, 1868: 952) This has been attributed to Homer on the basis of a signature that reads "W.H.D.," perhaps in the belief that the "D" stands for *delineavit*. But the form of the signature is wholly unlike any of Homer's. The sentimental treatment of the subject is alien to his sensibilities, especially in the postwar years. The drawing style is not his.

A Note on Works Possibly Drawn on the Woodblock by Homer

Excluded from the above lists are illustrations that Homer may have drawn on the block, though no substantial evidence has come to light to confirm his authorship. He may well have drawn the wood engraved reproduc-

tion of his painting *The Veteran in a New Field* (FL, July 13, 1867, 268) but it is also possible that one of Leslie's staff artists made the adaptation. The accompanying text says only that it is "an illustration of Mr. Homer's . . . picture." More problematic, and much less likely, are a very few illustrations that contain, to a modest degree, some aspects of Homer's distinctive drawing style. One instance is the illustration *Shipment of Military Stores on Board the Steamship "Baltic" at New York, April 8, 1861* (HW, 5, April 20, 1861, 252), with its relatively strong composition and energetic figures, but the similarities to Homer's known work of the time are not sufficient to warrant attribution.

Notes

Introduction

1. In referring to these publications as magazines rather than as weekly newspapers, I follow the rationale of Frank Luther Mott in his *History of American Magazines, 1850–1865* (Cambridge, Mass.: Harvard Univ. Press, 1938), 43. There he observed that "they were all very much more than newspapers, and they placed the emphasis on features of appeal which belonged more characteristically to the magazine than to the newspaper—namely, pictures and belles-lettres." They followed newspapers chiefly in arranging type into columns, using newsprint, and limiting themselves to eight pages or less. The term *pictorial press* had entered standard usage as a term of reference for mass circulation weekly pictorial magazines well before 1885 when Mason Jackson utilized it in the title of his *The Pictorial Press: Its Origins and Progress* (London: Hurst and Blackett).

2. William Howe Downes, *The Life and Works of Winslow Homer* (Boston: Houghton Mifflin, 1911), 28–80.

3. Ibid., 80.

4. Edgar P. Richardson, "Winslow Homer's Drawings in *Harper's Weekly*," *Art in America* 19 (Dec. 1930): 38–47.

5. Allen Evarts Foster, "Checklist of Illustrations by Winslow Homer in *Harper's Weekly* and Other Periodicals," *Bulletin of the New York Public Library* 40 (Oct. 1936): 842–52; Foster, "Checklist of Illustrations by Winslow Homer Appearing in Various Periodicals: A Supplement," *Bulletin of the New York Public Library* 44 (July 1940): 537–39.

6. Lloyd Goodrich, *Winslow Homer* (New York: Macmillan, 1944) 6–10, 13–17, 42–45).

7. Mary Bartlett Cowdrey, *Winslow Homer, Illustrator* (Northampton, Mass.: Smith College Museum of Art, 1951).

8. Albert Ten Eyck Gardner, *Winslow Homer, American Artist: His World and His Work* (New York: Clarkson Potter, 1961).

9. Lloyd Goodrich, *The Graphic Art of Winslow Homer* (New York: Museum of Graphic Art, 1968).

10. Lloyd Goodrich, *Winslow Homer's America* (New York: Tudor Publishing, 1969).

11. Barbara Gelman, *The Wood Engravings of Winslow Homer* (New York: Crown Books, 1969). This book's title incorrectly implies that Homer himself engraved the illustrations.

12. David Tatham, "Winslow Homer in Boston, 1854–1859" (Ph.D. diss., Syracuse Univ., 1970).

13. Mavis Parrott Kelsey, *Winslow Homer Graphics* (Houston, Tex.: Museum of Fine Arts, 1977).

14. Raphael Fernandez, "Winslow Homer, Printmaker," in *Winslow Homer in the Clark Collection*, ed. Alexandra Murphy (Williamstown, Mass.: Sterling and Francine Clark Art Institute, 1986), 14–16.; Lloyd Goodrich, introduction to *Winslow Homer in Monochrome*, by Lloyd Goodrich and Abigail Booth Gerdts (New York: M. Knoedler & Co., 1986), 7–11.

15. Marilyn S. Kushner, Barbara Dayer Gallati, and Linda S. Ferber, *Winslow Homer: Illustrating America* (New York: Brooklyn Museum of Art, 2000).

1. The Painter as an Illustrator

1. Kelly's reminiscences never reached publication. The typescript is available on Archives of American Art microfilm reels 1876–1877. All further references to Kelly's association with Homer come from this source. For Kelly's career see Robert Bruce, *Art and Sculpture of James Edward Kelly, 1855–1933* (New York: privately printed, 1934).

2. Goodrich, *Winslow Homer* (1944) remains a highly useful account of Homer's life and work. Later accounts include Gordon Hendricks, *The Life and Work of Winslow Homer* (New York: Abrams, 1979); and Nicolai Cikovsky, Jr., *Winslow Homer* (New York: Abrams, 1992). The fullest summary chronology of the artist's life and career yet to appear is Charles Brock's "Chronology," in *Winslow Homer,* by Nicolai Cikovsky, Jr. and Franklin Kelly (Washington, D.C.: National Gallery of Art, 1995), 391–413.

3. Abigail Booth Gerdts, "A Newly Identified Winslow Homer Wood Engraving," *Imprint* 20, no. 1: 32–33.

4. *HW,* June 13, 1874, 496.

5. The watercolor *How Many Eggs?* is reproduced in color in Helen Cooper, *Winslow Homer Watercolors* (Washington, D.C.: National Gallery of Art, 1986), 24.

6. Eugene Exman, *The House of Harper* (New York: Harper & Row, 1967), 102–20.

7. For a comprehensive account of the reception of Homer's paintings by critics between the late 1860s and 1880, see Margaret C. Conrads, *Winslow Homer and the Critics* (Princeton, N.J.: Princeton Univ. Press, 2001).

8. Quoted in Albert Ten Eyck Gardner, *Winslow Homer, American Artist: His World and His Work* (New York: Clarkson Potter, 1961), 157–58.

9. W. Lewis Fraser, "Winslow Homer," *Century* (Aug. 1893): 637.

10. For Nast, see Albert Bigelow Paine, *Thomas Nast: His Period and His Pictures* (New York: Harper, 1904); Morton Keller, *The Art and Politics of Thomas Nast* (New York: Oxford Univ. Press, 1968); and Felicia A. Piscitelli, "Thomas Nast," in *American Book and Magazine Illustrators to 1920,* ed. Stephen E. Smith, Catherine A. Hastedt, and Donald H. Dyal, *Dictionary of Literary Biography,* vol. 188 (Detroit: Gale Research, 1998), 205–20. For Nast as a painter, see Lloyd Goodrich, *Five Paintings from Thomas Nast's Grand Caricaturama* (New York: Swann Collection, 1970).

2. Homer and the Woodblock

1. Walter Muir Whitehill, *Boston: A Topographic History* (Cambridge, Mass.: Harvard Univ. Press, 1959), xi.

2. *BP,* June 28, 1856, 413, and Dec. 6, 1856, 352.

3. *Boston Directory,* June 1858 and June 1859.

4. David Tatham, "John Henry Bufford, American Lithographer," *Proceedings of the American Antiquarian Society* 86, part 1 (1976): 47–73.

5. Though he jettisoned lithographic drawing as a career, he did not quite abandon it altogether as an activity. During the Civil War he drew war-related subjects on stone for his friend Louis Prang, the Boston lithographer and print publisher: *Campaign Sketches* (1863) and *Life in Camp* parts 1 and 2 (1864). For reproductions, see Goodrich, *Graphic Art,* figs. 13–24.

6. Beatty, John, "Recollections of an Intimate Friendship," in Goodrich, *Homer* (1944), 214. Homer's *Massachusetts Senate* (1856) is reproduced in Goodrich, *Graphic Art,* fig. 3. Homer's high standing as an apprentice may be inferred from this lithograph's prominent signature in the stone, "W. Homer." As a rule, apprentices signed only with initials, if at all. He probably copied most if not all likenesses from photographs taken by John A. Whipple in 1855,

now in the collections of the Boston Public Library. See Sally Pierce, *Whipple and Black: Commercial Photographers in Boston* (Boston: Boston Athenaeum, 1987), 20.

7. The processes of drawing on woodblocks and engraving the block are described in Jackson, *Pictorial Press*, 315–40. See also William J. Linton, *The History of Wood-Engraving in America* (Boston: Estes & Lauriat, 1882), 27–33; and Geoffrey Wakeman, *Victorian Book Illustration: The Technical Revolution* (Detroit: Gale Research, 1973), 20–22.

8. The method of bolting is described and illustrated in Jackson, *Pictorial Press*, 316–17.

9. *HW*, May 27, 1880, 324.

10. For an example of the Harper firm's method of immediate payment see Exman, *House of Harper*, 106.

11. Downes, *Life and Works of Winslow Homer*, 29.

12. No documentation of Homer's pay in these years seems to have survived, but Alfred Waud received fees in this range. Harry Katz, "Love, Lies, and Wood Engravings: Alfred Waud in Boston, 1856–1860," *Imprint* 22, no. 2 (autumn 1997): 8–9.

13. This is the sum remembered many years later by Homer's friend and fellow artist Roswell Shurtleff. "Correspondence: Shurtleff Recalls Homer," *American Art News* 9 (Oct. 29, 1910), 4.

14. From 1858 to 1860, Homer's father, Charles Savage Homer, Sr., owned a house and eighteen acres on Old Concord Road, now Center Avenue, residing there with his wife, Henrietta Benson Homer, and his sons Winslow and Arthur. After the sale of this property in 1860, the Homer family apparently moved next door to the home of Captain John Benson, where the Homer parents resided until 1863 or 1864. Homer Family File, Belmont Memorial Library, Belmont, Mass.

3. The Rise of the Pictorial Press in England

1. *Illustrated London News*, May 21, 1842. For a reproduction of the magazine's depiction of the parade of placards, see Leonard De Vries, *Panorama, 1842–1865* (London: John Murray, 1967), 14.

2. The *Illustrated London News* flourished both at home and abroad. The 26,000 copies of its first issue had sold quickly. Jackson, *Pictorial Press*, 291. Its initial circulation was very largely within Great Britain but a few months later, when the weekly's circulation had risen to 60,000, the subscription list began rapidly to add growing numbers of overseas addresses throughout the English-speaking world and in foreign countries as well. Still struggling to meet demand, in Dec. 1843 the *News* reported and illustrated two new presses capable of printing two thousand impressions each hour. *Illustrated London News*, Dec. 2, 1843, 364. A decade later, with still newer and further improved presses at work, the magazine's circulation exceeded a quarter of a million.

3. Jackson, *Pictorial Press*, 311–14, 361–63.

4. At Harper and Brothers, Parsons kept in his office "all the foreign periodicals." Exman, *House of Harper*, 103.

5. Jackson, *Pictorial Press*, 308–11.

6. For Ingram, see Selena Fox, *Graphic Journalism in England During the 1830s and 1840s* (New York: Garland, 1988), 267–80. See also Jackson, *Pictorial Press*, 306–11; Henry Vizetelly, *Glances Back Through Seventy Years* (London, 1893).

7. Other publishers had preceded Ingram in London in attempting to exploit these ideas, but without much success. Their publications, such as the *Weekly Chronicle* and the *Observer*, constitute a prehistory of the pictorial press.

8. Illustrated in De Vries, *Panorama*, 13.

9. Ibid.

10. W. Turner Berry and H. Edmund Poole, *Annals of Printing: A Chronological Encyclopedia* (London: Blandford, 1966), 228; Wakeman, *Victorian Book Illustration*, 74–76.

11. Jackson, *Pictorial Press,* 315–26.

12. *Captain J. W. Watkins. BP,* June 6, 1857, 364.

13. Gleeson White, *English Illustration: The "Sixties"* (1897. New edition Bath (U.K.): Kingsmead Reprints, 1970), 18–19.

14. For Leslie, see Budd Gambee, *Frank Leslie and His Illustrated Newspaper, 1855–1860* (Ann Arbor: Univ. of Michigan Department of Library Science Studies, 1964). See also George Everett, "Frank Leslie," *American National Biography,* vol. 13: 517–18.

15. Mott, *Magazines 1885–1905,* 1–14, 57–59.

4. The Pictorial Press Begins in America

1. *Gleason's Pictorial Drawing-Room Companion,* May 3, 1851, 13. For a concise history of the beginnings of the magazine and valuable documentation concerning its production methods and costs, see Sally Pierce, *"Gleason's Pictorial:* Elevating and Celebrating American Life," *Ephemera Journal* 5 (1992): 12–24.

2. For Billings, see James O'Gorman, *Accomplished in All Departments of Art: Hammatt Billings of Boston: 1818–1874* (Amherst: Univ. of Massachusetts Press, 1998). For the states and history series, see pp. 76–83.

3. Mott, *Magazines 1850–1865,* 35.

4. For Ballou, see Ann W. Engar, "Maturin Murray Ballou," *American National Biography,* vol. 2: 86–88.

5. Mott, *Magazines 1850–1865,* 437, 445–55.

6. Charles Gattey, *The Bloomer Girls* (New York: Coward-McCann, 1968), 57–58.

7. *Gleason's Pictorial Drawing-Room Companion,* May 3, 1851, 13.

8. Goodrich, *Homer* (1944), 7–8.

9. Damoreau appears in the Toronto City Directory from 1864 through 1872, listed as an "artist or wood engraver" with an address on Yonge Street.

10. For a history of the medium in Boston with representative examples, see Sally Pierce and Catherina Slautterback, *Boston Lithography* (Boston: Boston Athenaeum, 1991).

11. For a concise introduction to the firm's prints, see Alexandra Bonfante-Warren, *Currier & Ives: Portraits of a Nation* (New York: Metro Books, 1998).

12. In its examination of Billings' life and work, O'Gorman's *Accomplished in All Departments* stands as a model for the kind of scholarly study of individual graphic artists widely needed in the field of nineteenth-century American illustration.

13. Homer and Billings both contributed six illustrations to a finely produced volume of the verse of the Dorset poet William Barnes, *Rural Poems* (Boston: Roberts Brothers, 1869). Each artist very likely worked independently with the publisher. Nothing in the illustrations themselves suggests that the two men collaborated closely on the project. See David Tatham, *Homer and the Illustrated Book* (Syracuse, N.Y.: Syracuse Univ. Press, 1992), 94–98, 298.

14. Barry's publications on art include the books *How to Draw* (Boston: James R. Osgood, 1871) and *Primer of Design* (Boston: Lee & Shepard, 1878), both of which address young readers. By 1878 Barry held the title Supervisor of Drawing in the Boston Public Schools.

15. For an example of Barry's limitations as a figure artist, see his illustration *Boston Street Characters, BP,* Jan. 27, 1855, 64, and *Sketches from the Highways and Byways of New York, BP,* Dec. 20, 1856, 200.

16. As an apprentice lithographer Homer had copied onto stone a drawing by Champney, a sign that Champney himself had no training in that medium. In copying this drawing (now lost), Homer had placed his own initials prominently above the part of the imprint that credited Champney with the design, probably to assert that he (Homer) had improved upon the original. See David Tatham, "Some Apprentice Lithographs of Winslow Homer: Ten Pictorial Title Pages for Sheet Music," *Old-Time New England* 59 (Apr.-June 1969): 96, 101.

17. The Archives of the Commonwealth of Massachusetts, Department of Vital Statistics, Boston, records Champney's death in 1880 at age 46 in a "lunatic asylum."

18. Harry L. Katz, "Love, Lies, and Wood Engravings," 2–10.
19. I thank Eric Rudd for calling this association to my attention.
20. Mott, *Magazines 1850–1865*, 411–12, 437, 453.

5. The Corpus

1. "Winslow Homer Prints Stolen from Colleges," *New York Times*, Apr. 16, 1976. Among local reports of thefts of Homer illustrations was one concerning losses from periodicals at both Cornell and Syracuse University Libraries in central New York. Cornell's librarian reported the loss of 156 pages. *Syracuse Herald-Journal*, Apr. 20, 1976.
2. Gelman, *Wood Engravings*, 198. Gelman's estimate of prices reflected those of New York City print dealers in the late 1960s. Prices varied more widely across the nation in offerings from book dealers as well as in antiques shops and flea markets.
3. *HW*, Dec. 12, 1857, 488–89.
4. In conversations with the author, two collectors unacquainted with each other both found reasons to construe Thwait's initials as Homer's, though with less than wholehearted confidence.
5. The notion expressed in Foster ("Checklist: A Supplement," 1940), 537, that the "WH" in this illustration might be read as "WJH," is insupportable. Both the graphic structure of the initials and the character of the figure drawing are Homer's and not Hennessy's.
6. *HW*, Feb. 13, 1858, 104–5.
7. For Hoppin, see Georgia Barnhill, "Augustus Hoppin," in *American Book and Magazine Illustrators to 1920*, ed. Stephen E. Smith, Catherine A. Hastedt, and Donald H. Dyal, *Dictionary of Literary Biography*, vol. 188 (Detroit: Gale Research, 1998), 166–72.
8. Goodrich, *Homer* (1944), 10.
9. Hugh Kenner, "Winslow Homer: The Accurate Illustrator Who Defied—and Defined—America's Nineteenth Century." *Art and Antiques* (Dec. 1986): 112.

6. City and Country: 1857

1. For Harry, see Pierce and Slautterback, *Boston Lithographs*, 57, 173.
2. D. C. Johnston, *Scraps*. Four etched plates in wrappers, sometimes with pages of letterpress, self-published annually in Boston in most years from 1828 to 1840, with a single number in a new series in 1848.
3. Mott, *Magazines 1850–1865*, 177–85.
4. *BP*, Jan. 31, 1857, 73.
5. Typical examples from the *Companion* in the two years preceding Homer's street scenes are Warren's *Views of Harvard* (Jan. 6, 1855) and Rowse's *New York in 1855*, *BP*, Apr. 21, 1855, a view of Wall Street.
6. His *Captain J. W. Watkins*, a portrait copied from a photograph, had preceded it a week earlier. Reproduced in Gelman, *Wood Engravings*, 1.
7. Piscitelli, Felicia, "Thomas Nast," 211. For numerous examples of Nast's biases, see the reproductions in Keller, *Thomas Nast*.
8. Pierce and Slautterback, *Boston Lithography*, 68.
9. *BP*, Nov. 28, 1857, 345.
10. *BP*, June 13, 1857, 369.

7. Boston to New York: 1858–1859

1. *The Illuminated Bible* (New York: Harper & Brothers, 1843–46). Issued in parts from 1843 to 1846, and then as a bound volume, the bible contained some 1,600 wood-engraved illustrations and ornamental letters. Nearly all the illustrations were drawn by John Gadsby Chapman (1808–1889).

2. Pierce and Slautterback, *Boston Lithography,* 178.

3. Reproduced in *Auction,* Oct. 1970, 9.

4. Alumni Records, Harvard Univ. Archives.

5. *HW,* Sept. 4, 1858, 570.

6. For examples, see Bonfante-Warren, *Currier & Ives.*

7. For examples, see Barry's treatment of the subject in *BP,* Jan. 27 and Mar. 31, 1855.

8. Mott, *Magazines 1850–1865,* 31.

9. Downes, *Life and Works of Winslow Homer,* 29.

10. Goodrich, *Homer* (1944), 25.

11. As in, for example, his illustrations for *Proceedings of the Reception and Dinner in Honor of George Peabody, Esq., of London, by the Citizens of the Old Town of Danvers* (Boston: H. W. Dutton, 1856). Tatham, *Homer and the Illustrated Book,* 141.

8. New York and the Advent of War: 1860–1861

1. Goodrich, *Homer* (1944), 6.

2. Ibid., 11.

3. The illustration was first reported in David Tatham, "Winslow Homer's *General Giuseppe Garibaldi:* An Unrecorded *Harper's Weekly* Illustration," *Imprint* 26, no. 2 (autumn 2001): 32–33.

4. *HW,* Nov. 17, 1860.

5. *The Liberator* 30 (Dec. 7, 1860), 195. See also Lawrence Lader, *The Bold Brahmins* (New York: Dutton, 1961), 255–56.

6. Foster, in prefatory comments to his checklist's supplement, expressed doubt that the signatures on certain *Harper's Weekly* illustrations of 1860 were in fact Homer's. He harbored a suspicion that the elongated *H* with smaller attached *W* might belong to William J. Hennessey "or some other artist." But Hennessey's initialed signature was distinctively different from Homer's. Foster's hesitancy to admit the Taney portrait came from his belief that the portraits that Homer drew for pictorial weeklies were "certainly without artistic merit and even if they were drawn by Homer they are only interesting in showing that in his early twenties he was willing to do that sort of hack work to earn his livelihood." Foster, "Checklist: A Supplement," 537. But there can be no doubt whatever that the elongated *H* is Homer's signature and that his augmenting it with a *W* signaled his pleasure with the outcome of a drawing. Homer's original additions to the Garibaldi portrait and his development of *Expulsion of Negroes and Abolitionists,* probably from another person's sketches, are both in his highly distinctive style as an illustrator. Each has significant merit as an illustration.

7. Tatham, *Homer and the Illustrated Book,* 126–27, 284.

8. *The Inaugural Procession at Washington Passing the Gate of the Capitol Grounds (HW,* Mar. 16, 1861) seems on grounds of style to be the work of Arthur Lumley.

9. Brock, "Chronology," 392.

10. William P. Campbell, *The Civil War: A Centennial Exhibition of Eyewitness Drawings.* (Washington, D.C.: National Gallery, 1961), 107–8.

11. *HW,* July 6, 1861, 431.

12. Campbell, *Civil War,* 107–8.

13. Ibid.

14. The more prolific, in addition to Alfred Waud and Davis, were Edwin Forbes (1839–1895) and Henri Lovie (act. c. 1859–1865), both of whom drew for *Leslie's;* William Waud, who drew for both *Leslie's* and the *Weekly;* and Arthur Lumley (c. 1837–1912), who drew for *Leslie's* and the *New York Illustrated News.* Campbell, *Civil War,* 107–9.

15. Ibid., 10–12.

16. Ibid.

17. Ibid.

18. Quoted in Sally Mills, "A Chronology of Winslow Homer's Early Career," in *Winslow Homer Paintings of the Civil War,* by Marc Simpson et al. (San Francisco: Fine Arts Museums, 1988), 17.

19. Ibid., 18.

20. Ibid.

21. Ibid.

22. Ibid.

9. The War and Its Aftermath: 1861–1866

1. An assembly of Parson's generals may be seen in *HW,* Oct. 12, 1861, 648–49.

2. The preliminary sketch is reproduced in Peter H. Wood and Karen C. C. Dalton, *Winslow Homer's Images of Blacks: The Civil War and Reconstruction Years* (Austin: Univ. of Texas Press, 1988), 24.

3. For an interpretation of the cask as a powder keg, see ibid., 26–27.

4. For Homer's wash drawing of this figure, see ibid., 25.

5. Homer's quick sketch of this figure is in the Cooper-Hewitt National Museum of Design, New York.

6. Homer consulted the sketches he drew in 1861 in Virginia for later projects. For example, he returned to the sketch he had used for *Bivouac Fire*'s seated card players when he drew *A Pass Time: Cavalry Rest* for the set of six Civil War lithographs titled *Campaign Sketches,* published by Louis Prang in Boston in 1863. He then used the sketch (or possibly the lithograph) again much later for a detail in his *Union Camp Scene—A Quiet Game,* one of the group of illustrations he drew in about 1887 for the four-volume *Battles and Leaders of the Civil War* by Robert Underwood Johnson (New York: Century, 1887–1889). Tatham, *Homer and the Illustrated Book,* 123, 272–73.

7. For reproductions of a representative selection of Homer's drawings of dead and wounded soldiers, see Julian Grossman, *Echo of a Distant Drum* (New York: Abrams, 1974).

8. Mills, "Chronology," 19. The letter is quoted from Lucretia Giese, "Winslow Homer, Painter of the Civil War" (Ph.D. diss., Harvard Univ., 1986).

9. For Barlow, see Simpson, "Prisoners from the Front," in *Winslow Homer Paintings of the Civil War,* ed. Marc Simpson et al. (San Francisco: Fine Arts Museums, 1988), 247–55.

10. Beatty, "Recollections," 215.

11. Reproduced in Grossman, *Echo,* 61–62.

12. Reproduced in Hendricks, *Life and Work of Winslow Homer,* 47.

13. It would be interesting to know to what extent the war had diminished the staff of Harper's art room.

14. Mills, "Chronology," 19.

15. David Tatham, "Winslow Homer at the Front in 1862," *American Art Journal* 11, no. 3 (1979): 86–87.

16. Ibid., 87.

17. Ibid.

18. Goodrich *Homer* (1944), 32.

19. For examples of battle-scene framing prints, see Mark E. Neely, Jr., and Harold Holzer, *The Union Image; Popular Prints of the Civil War North* (Chapel Hill: Univ. of North Carolina Press, 2000), plates 10–21.

20. For the painting, see Christopher Kent Wilson, "Marks of Honor and Death: Sharpshooter and the Peninsular Campaign of 1862," in Simpson et al., *Winslow Homer,* 24–45; see also Cikovsky and Kelly, *Winslow Homer,* 21–22, 39–40.

21. Wilson, "Masks of Honor," 31–35; and Mark Simpson, "Sharpshooter, 1862/63," 123–27, in Simpson et al., *Winslow Homer.*

22. Wilson, "Masks of Honor," 38.

23. Both are reproduced in Simpson, *Winslow Homer,* 154–56.

24. *HW,* May 10, 1862, 289.

25. *"The Teamsters' Duel,"* reproduced in Marc Simpson, "The Bright Side: Humorously Conceived and Truthfully Executed," in Simpson et al., *Paintings of the Civil War,* 58.

26. *HW,* Jan. 24, 1863, 56–57.

27. For the *Alabama,* see Raimondo Luraghi, *A History of the Confederate Navy* (Annapolis, Md.: Naval Institute Press, 1996), 224–33, 317–20. Manet's *Battle of the Kearsarge and the Alabama,* 1864, in is the Philadelphia Museum of Art.

28. Manuscript Collections, Pierpont Morgan Library, New York.

29. Parson's allegorical *Uprising of the North,* commemorating the anniversary of the bombardment of Fort Sumter *(HW,* Apr. 19, 1862, 248–49) and his equestrian group portrait, *Our Generals (HW,* Oct. 12, 1861, 648–49), are purely studio works.

30. Shurtleff, "Correspondence," 4. In the year 2000 a rough equivalent of Homer's 1863 price would amount to slightly more than a thousand dollars.

31. For this series of illustrations, and a reproduction of *He Sees the Rigid Features,* see Tatham, *Homer and the Illustrated Book,* 63–66, 187, 295–96.

32. *New York Times,* Oct. 18 and 20, 1865.

33. Lucretia Giese, "Winslow Homer's Civil War Painting *The Initials,*" *American Art Journal* 18, no. 3 (1986): 4–19.

34. For this illustration and its iconographic program, see Christopher Kent Wilson, "Winslow Homer's *Thanksgiving Day—Hanging Up the Musket,*" *American Art Journal* 18, no. 4 (1986): 76–83.

35. For the croquet paintings, see David Park Curry, *Winslow Homer: The Croquet Game* (New Haven: Yale Univ. Art Gallery, 1984).

10. Paris and Its Influences: 1867–1868

1. Brock, "Chronology," 393–94.

2. For the French (rather than English) foundations of Homer's style as a painter, see Cikovsky and Kelly, *Winslow Homer,* 26–37.

3. Ibid.

4. Brock, "Chronology," 394.

5. David Price, *Cancan* (London: Cygnus Arts, 1999), 21–44.

6. *HW,* Nov. 23, 1867, 738.

7. Price, *Cancan,* 29.

8. David Sellin first adduced the identity of this figure in *The First Pose* (New York: Norton, 1976), 10–13.

9. Ibid.

10. Ibid.

11. Goodrich, *Homer* (1944), 6.

12. "The Folding Screen," *FL,* Feb. 7, 1857, 149.

13. Mott, *Magazines 1865–1885,* 388–90; Exman, *House of Harper,* 121–26.

14. Maurine H. Beasley, "Mary Louise Booth," in *American Magazine Journalists, 1850–1900,* ed. Sam G. Riley, *Dictionary of Literary Biography,* vol. 79 (Detroit: Gale Research, 1980), 69–73. Booth remained editor of the *Bazar* until her death in 1889.

15. For examples of Homer's reuse of this detail in his book illustrations, see Tatham, *Homer and the Illustrated Book,* 82–83, 212–13.

11. America at Leisure: 1869–1872

1. *Round Table* 6 (Nov. 23, 1867): 337. This non-illustrated weekly described itself as "a journal of politics, the arts, literature, everything that can legitimately enter into the table talk of a refined and intelligent circle."

2. Mott, *Magazines, 1865–1885*, 5.

3. For *Hearth and Home*, see ibid., 99.

4. For a checklist of his illustrations for books and literary journals, see Tatham, *Homer and the Illustrated Book*, 289–305.

5. Conrads, *Homer and the Critics*, 212, n. 57.

6. For a consideration of several of these works, see David Tatham, "From Paris to the Presidentials: Winslow Homer's *Bridle Path, White Mountains*," *American Art Journal* 30, nos. 1 and 2 (1999): 36–49.

7. Reproduced in Goodrich, *Graphic Art*, fig. 46.

8. For the Tilton-Beecher affair, see Richard Wightman Fox, *Trials of Intimacy: Love and Loss in the Beecher-Tilton Scandal* (Chicago: Univ. of Chicago Press, 1999).

9. *AJ*, Apr. 3, 1869, 22.

10. Sue Rainey, *Creating Picturesque America: Monument to the Natural and Cultural Landscape* (Nashville, Tenn.: Vanderbilt Univ. Press, 1994.

11. For this illustration of a text, see Tatham, *Homer and the Illustrated Book*, 98.

12. Homer used this seated figure also as the basis for his *George Blake's Letter*, published in *Galaxy* (Jan. 1870) as an illustration for the serialized novel *Susan Fielding* by Annie Edwards. Tatham, *Homer and the Illustrated Book*, 84–85, 299.

13. For a discussion of this subject, and reproductions of some of Homer's varied treatments of it, see Cikovsky and Kelly, *Winslow Homer*, 108–9.

14. Homer's sources for the reclining figure (a drawing and a painting developed from it) are reproduced in Cikovsky and Kelly, *Winslow Homer*, 78. Cikovsky doubts Homer's authorship of the other figures, but they seem certain to be by Homer's hand. He bears responsibility for the work's multiple inadequacies.

15. Mott, *Magazines 1865–1885*, 357–60.

16. For a discussion of the paintings and their relation to the illustrations, see Cikovsky and Kelly, *Winslow Homer*, 81–85.

17. David Tatham, "Winslow Homer's Adirondack Prints," in *Adirondack Prints and Printmakers: The Call of the Wild*, ed. Caroline Welsh (Syracuse, N.Y.: Syracuse Univ. Press, 1998), 125–37. See also Tatham's *Winslow Homer in the Adirondacks* (Syracuse, N.Y.: Syracuse Univ. Press, 1996).

12. Innocence and Experience: 1873–1875

1. Goodrich, *Homer* (1944), 49–50.

2. For Valentine as a patron, see Linda Ayres, "Lawson Valentine, Houghton Farm, and Winslow Homer," in *Winslow Homer in the 1870s*, ed. John Wilmerding and Linda Ayres, (Princeton, N.J.: The Art Museum, Princeton Univ., 1990), 18–26, 73–75. Lawson's brother Henry acquired Homer's work, but less frequently and for the most part after 1874.

3. Conrads, *Homer and the Critics*, 197–200. This concluding chapter briefly summarizes the critics' puzzlement and the other circumstances that conditioned their acceptance of his work between 1868 and 1880. The preceding chapters of Conrads' study richly document the nature of the critics' concerns and the grounds for their praise, however tempered and irregular.

4. *New York Times*, Apr. 3, 1873, 1.

5. Beam, *Winslow Homer's Magazine Illustrations* (New York: Harper & Row, 1979), 12. The notion that Homer copied his illustration from the much earlier (1845) Huntington image "almost line for line" is not supported by even a cursory comparison of the two. Longfellow himself did not like the Huntington illustration. He wrote to his publisher about it: "The only one I really dislike is the 'Wreck of the Hesperus'. . . . I suppose you would hardly consent to throw it overboard; yet I think the volume would be better without it." Longfellow to Abraham Hart, Oct. 18, 1845, in *The Letters of Henry Wadsworth Longfellow*, vol. 3, ed. Andrew Hilen (Cambridge, Mass.: Harvard Univ. Press, 1972), 88–89. Homer, who seems never to have copied from other illustrators, would have found nothing of merit in Huntington's image.

6. The drawing, *Study for 'The Wreck of the Atlantic'*, is reproduced in Goodrich and Gerdts, *Winslow Homer in Monochrome,* 38. It leaves no doubt that Homer drew the figure in his illustration from life and not from Huntington's engraving.

7. Ayres, "Lawson Valentine," 20.

8. Reproduced in Cikovsky and Kelly, *Winslow Homer,* 84.

9. Both paintings are reproduced in ibid., 90.

10. The oil is reproduced in ibid., 111.

11. He had used watercolor monochromatically since the 1850s for sketching and for indicating tone in woodblock drawings, but he now used it as an independent medium, painting in a full spectrum of hues. He distilled light, air, and mood into bold and increasingly free washes. The brilliance of light in these works, attained by allowing the whiteness of the watercolor paper to show through translucent hues, corresponded to the values he sought when he drew on the whitened surfaces of woodblocks.

12. Both works are reproduced in Goodrich, *Graphic Art,* figs. 63 and 64.

13. The sources are reproduced in Cikovsky and Kelly, *Winslow Homer,* 139–41.

14. A smaller version of this oil, without a background of forested hills, is in the Metropolitan Museum of Art.

15. The drawing, in the Butler Institute, is reproduced in Goodrich, *Graphic Art,* fig. 67.

16. Downes, *Life and Works of Winslow Homer,* 74.

17. Goodrich, *Homer* (1944), 34.

18. Ibid., 45.

19. Downes, *Life and Works of Winslow Homer,* 73.

20. The watercolor is reproduced in Cikovsky and Kelly, *Winslow Homer,* 136.

21. Cikovsky and Kelly, 136; John Wilmerding, "Winslow Homer's *Dad's Coming,*" in *Essays in Honor of Paul Mellon, Collector and Benefactor,* ed. John Wilmerding (Washington, D.C.: National Gallery of Art, 1986), 388–401.

22. Nicolai Cikovsky, Jr. "Winslow Homer's (So-Called) *Morning Bell,*" *American Art Journal* 29 (1998): 4–17.

23. *HW,* Mar. 7, 1874, 222.

24. Reproduced in Cooper, *Winslow Homer Watercolors,* 23.

25. Tatham, *Homer in the Adirondacks,* 49–54.

26. For a reproduction, see Cooper, *Winslow Homer Watercolors,* 49.

27. Reproduced in Goodrich and Gerdts, *Winslow Homer in Monochrome,* 26.

28. Tatham, *Homer in the Adirondacks,* 137.

29. Goodrich, *Winslow Homer* (1944), 162.

Checklist of Works Drawn by Winslow Homer
for Publication in Weekly Pictorial Magazines

1. A few of his illustrations of literary texts appeared in pictorial weekly magazines; for these see Tatham, *Winslow Homer and the Illustrated Book* (1992).

2. Kelsey, *Winslow Homer Graphics,* 23.

Bibliography

Manuscripts

Archives of the Commonwealth of Massachusetts, Department of Vital Statistics, Boston.
Harvard University Archives, Cambridge, Mass.
Homer Family Papers, Belmont Historical Society, Belmont, Mass.
Kelly, James Edward. "Memoirs." Microfilm reels 1876–77, Archives of American Art, Washington, D.C.
Pierpont Morgan Library, New York.

Books, Dissertations, and Exhibition Catalogues

Barry, Charles. *How to Draw.* Boston: James R. Osgood, 1871.
———. *Primer of Design.* Boston: Lee & Shepard, 1878.
Beam, Philip. *Winslow Homer's Magazine Illustrations.* New York: Harper & Row, 1979.
Berry, W. Turner, and H. Edmund Poole. *Annals of Printing: A Chronological Encyclopedia.* London: Blandford, 1966.
Bonfante-Warren, Alexandra. *Currier & Ives: Portraits of a Nation.* New York: Metro Books, 1998.
Boston Directory. Boston: Damrell & Moore, 1858 and 1959.
Bruce, Robert. *Art and Sculpture of James Edward Kelly, 1855–1933.* New York: privately printed, 1934.
Campbell, William P. *The Civil War: A Centennial Exhibition of Eyewitness Drawings.* Washington, D.C.: National Gallery, 1961.
Cikovsky, Nicolai, Jr. *Winslow Homer.* New York: Abrams, 1992.
Cikovsky, Nicolai, Jr., and Franklin Kelly. *Winslow Homer.* Washington, D.C.: National Gallery of Art, 1995.
Conrads, Margaret C. *Winslow Homer and the Critics: Forging A National Art in the 1870s.* Princeton, N.J.: Princeton Univ. Press, 2001.
Cooper, Helen. *Winslow Homer Watercolors.* Washington, D.C.: National Gallery of Art, 1986.
Cowdrey, Mary Bartlett. *Winslow Homer, Illustrator.* Northampton, Mass.: Smith College Museum of Art, 1951.

Curry, David Park. *Winslow Homer: The Croquet Game.* New Haven: Yale Univ. Art Gallery, 1984.

De Maré, Eric. *The Victorian Woodblock Illustrators.* London: Gordon Fraser, 1980.

De Vries, Leonard. *Panorama, 1842–1865.* London: John Murray, 1967.

Downes, William Howe. *The Life and Works of Winslow Homer.* Boston: Houghton Mifflin, 1911.

Exman, Eugene. *The House of Harper: One Hundred and Fifty Years of Publishing.* New York: Harper & Row, 1967.

Fox, Celina. *Graphic Journalism in England During the 1830s and 1840s.* New York: Garland, 1988.

Fox, Richard Wightman. *Trials of Intimacy: Love and Loss in the Beecher-Tilton Scandal.* Chicago: Univ. of Chicago Press, 1999.

Gambee, Budd. *Frank Leslie and His Illustrated Newspaper, 1855–1860.* Ann Arbor: Univ. of Michigan Department of Library Science, 1964.

Gardner, Albert Ten Eyck. *Winslow Homer, American Artist: His World and His Work.* New York: Clarkson Potter, 1961.

Gattey, Charles. *The Bloomer Girls.* New York: Coward-McCann, 1968.

Gelman, Barbara. *The Wood Engravings of Winslow Homer.* New York: Crown, 1969.

Giese, Lucretia. "Winslow Homer, Painter of the Civil War." Ph.D. diss., Harvard Univ., 1986.

Goodrich, Lloyd. *Winslow Homer.* New York: Macmillan, 1944.

———. *Winslow Homer.* New York: George Braziller, 1959.

———. *The Graphic Art of Winslow Homer.* New York: Museum of Graphic Art, 1968.

———. *Winslow Homer's America.* New York: Tudor Publishing, 1969.

———. *Five Paintings from Thomas Nast's Grand Caricaturama.* New York: Swann Collection, 1970.

Goodrich, Lloyd, and Abigail Booth Gerdts. *Winslow Homer in Monochrome.* New York: M. Knoedler & Co., 1986.

Grossman, Julian. *Echo of a Distant Drum.* New York: Abrams, 1974.

Hamilton, Sinclair. *Early American Book Illustrators and Wood Engravers, 1670–1870.* 2 vols. Princeton, N.J.: Princeton Univ. Press, 1958 and 1968.

Harper, J. Henry. *The House of Harper: A Century of Publishing in Franklin Square.* New York: Harper & Brothers, 1912.

Hendricks, Gordon. *The Life and Work of Winslow Homer.* New York: Abrams, 1979.

Hilen, Andrew. *The Letters of Henry Wadsworth Longfellow.* Vol. 3. Cambridge, Mass.: Harvard Univ. Press, 1972.

Jackson, Mason. *The Pictorial Press: Its Origins and Progress.* London: Hurst & Blackett, 1885.

Johnson, Robert Underwood, and Clarence Clough Buel, eds. *Battles and Leaders of the Civil War.* 4 vols. New York: Century, 1887–1889.

Keller, Morton. *The Art and Politics of Thomas Nast.* New York: Oxford Univ. Press, 1968.

Kelsey, Mavis Parrott. *Winslow Homer Graphics.* Houston, Tex.: Museum of Fine Arts, 1977.

Kushner, Marilyn S., Barbara Dayer Gallati, and Linda S. Ferber. *Winslow Homer: Illustrating America.* New York: Brooklyn Museum of Art, 2000.

Lader, Lawrence. *The Bold Brahmins.* New York: Dutton, 1961.

Linton, William J. *The History of Wood-Engraving in America.* Boston: Estes & Lauriat, 1882.

Luraghi, Raimondo. *A History of the Confederate Navy.* Annapolis, Md.: Naval Institute Press, 1966.

Jackson, Mason. *The Pictorial Press.* 1885. Reprint, Detroit, Mich.: Gale Research, 1968.

Mott, Frank Luther. *A History of American Magazines: 1850–1865.* Cambridge, Mass.: Harvard Univ. Press, 1938.

———. *A History of American Magazines: 1865–1885.* Cambridge, Mass.: Harvard Univ. Press, 1938.

———. *A History of American Magazines: 1885–1905.* Cambridge, Mass.: Harvard Univ. Press, 1957.

Neely, Mark E., Jr., and Harold Holzer. *The Union Image: Popular Prints of the Civil War North.* Chapel Hill: Univ. of North Carolina Press, 2000.

O'Gorman, James. *Accomplished in All Departments of Art: Hammatt Billings of Boston, 1818–1874.* Amherst: Univ. of Massachusetts Press, 1998.

Paine, Albert Bigelow. *Thomas Nast: His Period and His Pictures.* New York: Harper, 1904.

Pierce, Sally. *Whipple and Black: Commercial Photographers in Boston.* Boston: Boston Athenaeum, 1987.

Pierce, Sally, and Catherina Slautterback. *Boston Lithography, 1825–1880.* Boston: Boston Athenaeum, 1991.

Price, David. *Cancan.* London: Cygnus Arts, 1999.

Rainey, Sue. *Creating Picturesque America: Monument to the Natural and Cultural Landscape.* Nashville, Tenn.: Vanderbilt Univ. Press, 1994.

Sellin, David. *The First Pose.* New York: Norton, 1976.

Simpson, Marc, et al., eds. *Winslow Homer Paintings of the Civil War.* San Francisco: Fine Arts Museums, 1988.

Sinnema, Peter W. *Dynamics of the Printed Page: Representing the Nation in the* Illustrated London News. Aldershot (UK): Ashgate, 1998.

Tatham, David. "Winslow Homer in Boston, 1854–1859." Ph.D. diss., Syracuse Univ., 1970.

————. *Winslow Homer and the Illustrated Book.* Syracuse, N.Y.: Syracuse Univ. Press, 1992.

————. *Winslow Homer in the Adirondacks.* Syracuse, N.Y.: Syracuse Univ. Press, 1996.

Vizetelly, Henry. *Glances Back Through Seventy Years.* London, 1893.

Wakeman, Geoffrey. *Victorian Book Illustration: The Technical Revolution.* Detroit, Mich.: Gale Research, 1973.

Welsh, Caroline, ed. *Adirondack Prints and Printmakers: The Call of the Wild.* Syracuse, N.Y.: Syracuse Univ. Press, 1998.

White, Gleeson. *English Illustration: "The Sixties": 1855–1870.* 1897. New edition, Bath (UK): Kingsmead Reprints, 1970.

Whitehill, Walter Muir. *Boston: A Topographic History.* Cambridge, Mass.: Harvard Univ. Press, 1959.

Wilmerding, John, and Linda Ayres. *Winslow Homer in the 1870s.* Princeton, N.J.: Princeton Univ. Art Museum, 1990.

Wood, Peter H., and Karen C. C. Dalton. *Winslow Homer's Images of Blacks: The Civil War and Reconstruction Years.* Austin: Univ. of Texas Press, 1988.

Articles

Ayres, Linda. "Lawson Valentine, Houghton Farm, and Winslow Homer." In *Winslow Homer in the 1870s,* ed. John Wilmerding and Linda Ayres. Princeton, N.J.: Princeton Univ. Art Museum, 1990.

Balge-Crozier, Marjorie P. "Through the Eyes of the Artist: Another Look at Winslow Homer's *Sharpshooter.*" *Imprint* 21 (spring 1996): 2–9.

Barnhill, Georgia. "Augustus Hoppin." In *American Book and Magazine Illustrators to 1920,* ed. Stephen E. Smith, Catherine A. Hastedt, and Donald H. Dyal, 166–72. *Dictionary of Literary Biography.* Vol. 188. Detroit, Mich.: Gale Research, 1998.

Beasley, Maurine H. "Mary Louise Booth." In *American Magazine Journalists, 1850–1900,* ed. Sam G. Riley. *Dictionary of Literary Biography.* Vol. 79. Detroit, Mich.: Gale Research, 1980.

Beatty, John. "Recollections of an Intimate Friendship." Appendix in *Winslow Homer,* by Lloyd Goodrich, 203–6. New York: MacMillan, 1944.

Brock, Charles. "Chronology." In *Winslow Homer,* ed. Nicolai Citkovsky, Jr. and Franklin Kelly, 391–413. Washington, D.C.: National Gallery of Art, 1995.

Cikovsky, Nicolai, Jr. "Winslow Homer's (so-called) *Morning Bell.*" *American Art Journal* 29 (1998): 4–17.

Engar, Ann W. "Maturin Murray Ballou." *American National Biography* 2: 86–88.

Everett, George. "Frank Leslie." *American National Biography* 13: 517–18.

Fernandez, Rafael. "Winslow Homer, Printmaker." In *Winslow Homer in the Clark Collection,* ed. Alexandra R. Murphy, 14–16. Williamstown, Mass.: Sterling and Francine Clark Art Institute, 1986.

Foster, Allen Evarts, "Checklist of Illustrations by Winslow Homer in *Harper's Weekly* and Other Periodicals." *Bulletin of the New York Public Library* 40 (Oct. 1936): 842–52.

———. "Checklist of Illustrations by Winslow Homer Appearing in Various Periodicals: A Supplement." *Bulletin of the New York Public Library* 44 (July 1940): 537–39.

Fraser, W. Lewis. "Winslow Homer." *Century,* Aug. 1893, 637.

Gerdts, Abigail Booth. "A Newly Identified Winslow Homer Wood Engraving." *Imprint* 20, no. 1: 32–33.

Giese, Lucretia. "Winslow Homer's Civil War Painting *The Initials.*" *American Art Journal* 18, no. 3 (1986): 4–19.

Katz, Harry. "Love, Lies, and Wood Engravings: Alfred Waud in Boston, 1856–1860." *Imprint* 22, no. 2 (autumn 1997): 2–10.

Kenner, Hugh. "Winslow Homer: The Accurate Illustrator Who Defied— and Defined—America's Nineteenth Century." *Art and Antiques,* Dec. 1986, 112.

Mills, Sally. "A Chronology of Homer's Early Career: 1859–1866 With Particular Reference to the Civil War Paintings." In *Winslow Homer Paintings of the Civil War,* ed. Marc Simpson et al., 16–23. San Francisco: Fine Arts Museums, 1988.

Pierce, Sally. "*Gleason's Pictorial:* Elevating and Celebrating American Life." *Ephemera Journal* 5 (1992): 12–24.

Piscitelli, Felicia A. "Thomas Nast." In *American Book and Magazine Illustrators to 1920,* ed. Stephen E. Smith, Catherine A. Hastedt, and Donald H. Dyal, 205–220. *Dictionary of Literary Biography.* Vol. 188. Detroit, Mich.: Gale Research, 1998.

Richardson, Edgar P. "Winslow Homer's Drawings in *Harper's Weekly.*" *Art in America* 19 (Dec. 1930): 38–47.

Schrock, Nancy Carlson. "William James Linton and his Victorian History of Wood Engraving." In *The History of American Wood Engraving,* ed. William J. Linton, i-ix. 1882. New edition, Watkins Glen, N.Y.: American Life Foundation, 1976.

Shurtleff, Roswell. "Correspondence: Shurtleff Recalls Homer." *American Art News* 9 (Oct. 29, 1910): 4.

Simpson, Marc. "Prisoners from the Front." In *Winslow Homer Paintings of the Civil War,* ed. Marc Simpson et al. San Francisco: Fine Arts Museums, 1988.

———. "Sharpshooter, 1862/63." In *Winslow Homer Paintings of the Civil War,* ed. Marc Simpson et al. San Francisco: Fine Arts Museums, 1988.

Tatham, David. "From Paris to the Presidentials: Winslow Homer's *Bridle Path, White Mountains.*" *American Art Journal* 30, nos. 1 and 2 (1999): 36–49.

———. "John Henry Bufford, American Lithographer." *Proceedings of the American Antiquarian Society* 86, part 1 (1976): 47–73.

———. "Some Apprentice Lithographs of Winslow Homer: Ten Pictorial Title Pages for Sheet Music." *Old-Time New England* 59 (Apr.-June 1969): 87–104.

———. "Winslow Homer at the Front in 1862." *American Art Journal* 11, no. 3 (summer 1979): 86–87.

———. "Winslow Homer's Adirondack Prints." In *Adirondack Prints and Printmakers: The Call of the Wild,* ed. Caroline Welsh, 125–37. Syracuse, N.Y.: Syracuse Univ. Press, 1998.

———. "Winslow Homer's *General Giuseppe Garibaldi:* An Unrecorded *Harper's Weekly* Illustration." *Imprint* 26, no.2 (autumn 2001): 32–33.

Wilmerding, John. "Winslow Homer's *Dad's Coming.*" In *Essays in Honor of Paul Mellon, Collector and Benefactor,* ed. John Wilmerding, 388–401. Washington, D.C.: National Gallery of Art, 1986.

Wilson, Christopher Kent. "Winslow Homer's *Thanksgiving Day—Hanging Up the Musket.*" *American Art Journal* 18, no. 4 (1886): 76–83.

———. "Marks of Honor and Death: *Sharpshooter* and the Peninsular Campaign of 1862." In *Winslow Homer Paintings of the Civil War,* ed. Marc Simpson et al., 24–45. San Francisco: Fine Arts Museums, 1988.

Index